ARCHITECTURAL DRAWING COURSE

Mo Zell

ARCHITECTURAL DRAWING COURSE

SECOND EDITION

BARRON'S

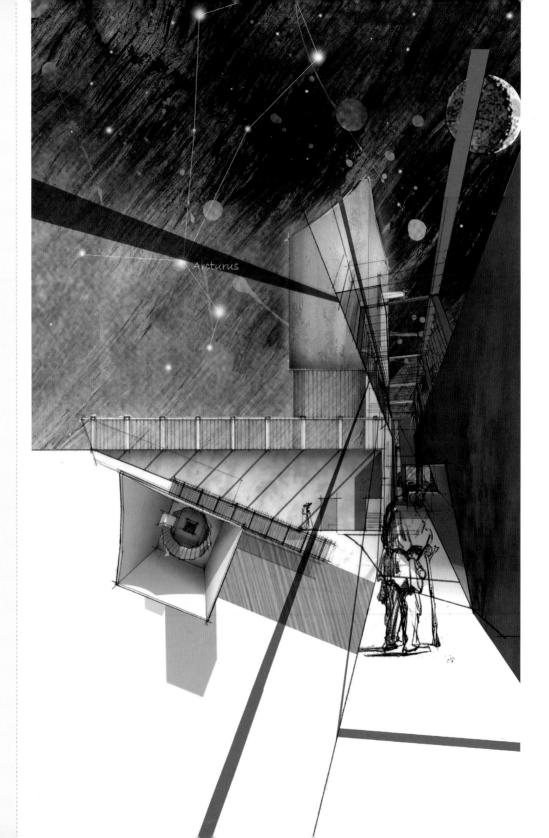

The Architectural Drawing Course:
Second Edition

Second edition for the United States
and Canada published in 2018
by Barron's Educational Series, Inc.

A QUARTO BOOK

All inquiries should be addressed to:
Barron's Educational Series, Inc.
250 Wireless Boulevard
Hauppauge, New York 11788
www.barronseduc.com

ISBN: 978-1-4380-1115-8

Library of Congress Control No:
2017940420

QUAR.ADC2

Conceived, designed,
and produced by
Quarto Publishing plc.
The Old Brewery
6 Blundell Street
London N7 9BH
www.quartoknows.com

Editor: Kate Burkett
Designer: John Grain
Photographer: Eli Liebnow (University
of Wisconsin-Milwaukee)
Picture researcher: Sarah Bell
Art director: Caroline Guest
Creative director: Moira Clinch
Publisher: Samantha Warrington

Printed in China

9 8 7 6 5 4 3 2 1

CONTENTS

FOREWORD

The study of architecture is an intellectual and physical endeavor. That is, the design of architecture is the amalgamation of intention (idea) with iteration (the process of problem solving with each investigation building upon the preceding one) manifested in a building or space. Architects illustrate and study their intentions and ideas through drawings and models. These architectural representations exemplify a visual language with rules, conventions, and meanings. They convey ideas and reinforce concepts. They are essential tools for designing, describing, and exploring the built environment.

This book is an introduction to the visual language of architectural representation supplemented with examples, references, and research recommendations to develop necessary skill sets. It will challenge preconceptions about architecture, while enabling readers to critically evaluate the built environment. Architectural representation is foregrounded from the point of view of a designer. As a foundation course book, it is ideal for someone who is thinking about attending architecture school, beginning architecture studies, or generally interested in the creative aspects of architectural design.

Through a series of three-dimensional design problems, the reader will explore issues of proportion/scale, space/volume, composition/sequence, and material/texture, while simultaneously learning the language of architectural representation. In addition, a series of exercises is provided that explains the process of conceptualizing architectural ideas and how to represent those ideas in drawings and models. Much like the process of architectural design, the approach of this book is cumulative in nature. Skills are taught incrementally and build upon prior exercises.

Architectural representations are utilized, both for processing ideas and documenting those ideas for presentation. They are a means to an end and an end in themselves. Design ideas are translated onto paper to be tested. When these ideas are manifest in physical form (on paper or as a model), the designer can react, question, modify, and make revisions. This suggests a process of recording all thoughts and ideas in a physical manner. While making representations of ideas, ask the question "Why?"—why this size, this shape, this many, and so on. At the end of the iterative process, models and drawings are finalized and presented to various audiences.

Architecture is taught through design, process, and technique. With the use of precedents, research (background information), clear instruction, examples, and exercises, this book encourages curious observers to investigate their surroundings. The goal is to urge you to think and see spatially in three dimensions, while imagining a new built environment.

ABOUT THIS BOOK

This book is divided into seven chapters that cover architectural representational techniques supplemented by design problems that are based on a college-level beginning design curriculum. Each chapter emphasizes the process of design and is further broken down into units that include step-by-step tutorials to explain the processes of representation. Hands-on exercises allow you to practice and refine your new skills, from the conceptualization of a space to visualizing it two- and three-dimensionally to describing it through sections, elevations, and fully-realized perspective drawings.

This book also includes professional examples of architectural projects. These real-life scenarios demonstrate building techniques and materials that impact design decisions. Case studies show different designers' interpretations of a range of project statements. You will also find professional advice about entering the architecture profession and what to expect when you get there. Common myths about architecture will also be dispelled.

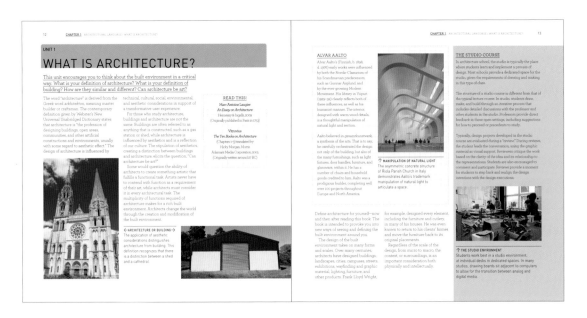

Read this!/websites
Reading material and useful websites will be referenced for a variety of units in the book.

Advice
Advice boxes are interspersed throughout the book to provide additional observations and instruction related to architectural design. Drawing techniques, research methods, and comparative assessment are all found here.

Biographies
These parts provide opportunities to highlight an important figure in architecture.

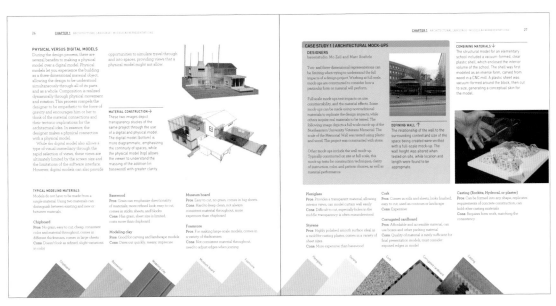

Case studies

These sections will highlight professional projects that exemplify the topic being introduced. Professional examples ground the representational assignments with real-world applications.

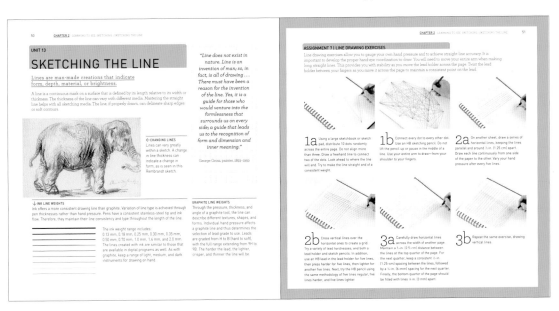

Assignments

Each chapter includes a number of project assignments that provide opportunities for you to test your skills and challenge your creative thinking. Student examples will provide lessons and strategies to design approaches.

CHAPTER 1

ARCHITECTURAL LANGUAGE

This chapter establishes a foundation for architectural education. It is divided into a series of units that describe in detail architectural drawing types and representation methods, while establishing fundamental architectural terminology.

A knowledge of fundamental architectural language facilitates the clear communication of the architectural ideas, basic concepts, representation types, and conventions used to create and disseminate architectural ideas. You will learn about a multitude of architectural representations, what is used to create the representations, why and when to draw and model, and how to communicate with various audiences.

Prevailing digital technologies are changing the way we communicate with colleagues, designers, consultants, and contractors, but architects require two- and three-dimensional thinking through sketches, models, and drawing. Although many more activities are conducted using digital software, universal drawing types remain fundamental to understanding and describing architecture. Evolutions and even revolutions in technology change the techniques and skills architectural students learn, but skills in foundational thinking and drawing remain necessary.

UNIT 1

WHAT IS ARCHITECTURE?

This unit encourages you to think about the built environment in a critical way. What is your definition of architecture? What is your definition of building? How are they similar and different? Can architecture be art?

The word "architecture" is derived from the Greek word *arkhitekton*, meaning master builder or craftsman. The contemporary definition given by Webster's New Universal Unabridged Dictionary states that architecture is "the profession of designing buildings, open areas, communities, and other artificial constructions and environments, usually with some regard to aesthetic effect." The design of architecture is influenced by technical, cultural, social, environmental, and aesthetic considerations in support of a transformative user experience.

For those who study architecture, buildings and architecture are not the same. Buildings are often referred to as anything that is constructed, such as a gas station or shed, while architecture is influenced by aesthetics and is a reflection of our culture. The stipulation of aesthetics, creating a distinction between buildings and architecture, elicits the question, "Can architecture be art?"

Some would question the ability of architects to create something artistic that fulfills a functional task. Artists never have to contend with function as a requirement of their art, while architects must consider it in every architectural task. The multiplicity of functions required of architecture makes for a rich built environment. Architects change the world through the creation and modification of the built environment.

READ THIS!

Marc Antoine Laugier
An Essay on Architecture
Hennessy & Ingalls, 2009
(Originally published in Paris in 1753)

Vitruvius
The Ten Books on Architecture
(Chapters 1–3) translated by
Hicky Morgan, Morris
Adamant Media Corporation, 2005
(Originally written around 27 BC)

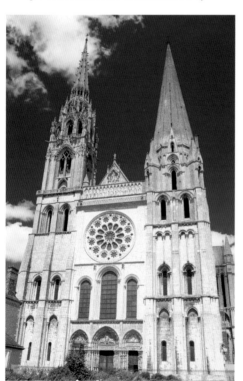

←ARCHITECTURE OR BUILDING→
The application of aesthetic considerations distinguishes architecture from building. This definition recognizes that there is a distinction between a shed and a cathedral.

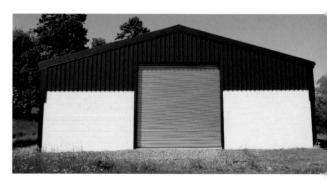

ALVAR AALTO

Alvar Aalto's (Finnish, b. 1898, d. 1976) early works were influenced by both the Nordic Classicism of his Scandinavian predecessors, such as Gunnar Asplund, and by the ever-growing Modern Movement. His library in Viipuri (1929–32) clearly reflects both of these influences, as well as his humanist manner. The interior, designed with warm wood details, is a thoughtful manipulation of natural light and section.

Aalto believed in *gesamtkunstwerk*, a synthesis of the arts. That is to say, he carefully orchestrated the design not only of the building, but also of the many furnishings, such as light fixtures, door handles, furniture, and glassware, within it. He has a number of chairs and household goods credited to him. Aalto was a prodigious builder, completing well over 100 projects throughout Europe and North America.

↑ **MANIPULATION OF NATURAL LIGHT**
The asymmetric concrete structure of Riola Parish Church in Italy demonstrates Aalto's trademark manipulation of natural light to articulate a space.

THE STUDIO COURSE

In architecture school, the studio is typically the place where students learn and implement a process of design. Most schools provide a dedicated space for the studio, given the requirements of drawing and making in this type of class.

The structure of a studio course is different from that of the typical lecture course. In studio, students draw, make, and build through an iterative process that includes detailed discussions with the professor and other students in the studio. Professors provide direct feedback in these open settings, including suggestions for how to proceed or precedents to study.

Typically, design projects developed in the studio course are evaluated during a "review." During reviews, the student leads the conversation, using the graphic material as visual support. Reviewers critique the work based on the clarity of the idea and its relationship to the representations. Students are also encouraged to comment and participate. Reviews provide a moment for students to step back and realign the design intentions with the design executions.

↑ **THE STUDIO ENVIRONMENT**
Students work best in a studio environment, at individual desks in dedicated spaces. In many studios, drawing boards sit adjacent to computers to allow for the transition between analog and digital media.

Define architecture for yourself—now and then after reading this book. The book is intended to provoke you into new ways of seeing and defining the built environment around you.

The design of the built environment takes on many forms and scales. Over many centuries, architects have designed buildings, landscapes, cities, campuses, streets, exhibitions, wayfinding and graphic material, lighting, furniture, and other products. Frank Lloyd Wright, for example, designed every element, including the furniture and cutlery, in many of his houses. He was even known to return to his clients' homes and move the furniture back to its original placements.

Regardless of the scale of the design, from micro to macro, the context, or surroundings, is an important consideration both physically and intellectually.

UNIT 2

REPRESENTATION AND DRAWING

In reality, architects produce representations of buildings, not actual buildings. In many instances, drawings and models are the closest an architect comes to constructing a building. These methods of representation require careful thought and articulation. This unit focuses on the art of drawing.

READ THIS!

Brian Ambroziak
Michael Graves: Images of a Grand Tour
Princeton Architectural Press, 2005

Jacob Brillhart
Voyage Le Corbusier Drawing on the Road
W. W. Norton & Company, 2016

Ian Fraser and Rod Henmi
Envisioning Architecture: An Analysis of Drawing
John Wiley & Sons, 1994

Drawing, as an artifact, is a two-dimensional representation used by architects. It is a form of visual communication based on a common, agreed-upon visual language that conveys ideas, depicts existing conditions, and creates as-of-yet unbuilt environments. Drawing transposes three-dimensional images, both real and imagined, onto two-dimensional surfaces.

Technical or architectural drawing operates under an established set of conventions and rules. It serves to provide visual representations for the discussion and understanding of design ideas and intentions. Just as a common set of codes and symbols allows us to communicate verbally with one another, a common language in architecture makes it possible to communicate ideas.

Drawing improves with practice. It is also a skill that can be learned. Everyone can be taught the skills to create informative, competent, and beautiful drawings. However, repeated construction of drawings will not necessarily result in becoming a good architect. Therefore, it is also necessary to motivate and exercise the creative mind while learning the skills to craft drawings.

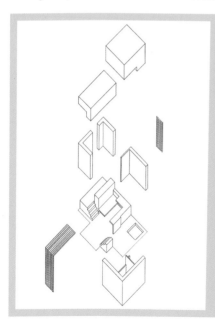

← **EXPLODED AXONS**
Exploded axons help distinguish the individual pieces of architecture—in this case, highlighting what is mass, plane, or stick.

REPRESENTATION →
Use all forms of representation when generating ideas for a project. These include axon, plan, section, elevation, and perspective.

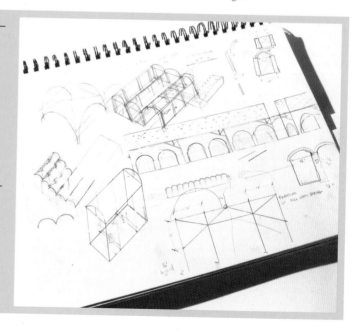

LE CORBUSIER

Le Corbusier (Swiss/French b. 1887 d. 1965) was undoubtedly one of the most influential architects of the 20th century. His Five Points of Architecture challenged previous methodologies of designing, namely the Beaux Arts tradition, and reshaped the built environment. These five points included the piloti, ribbon window, free plan, free façade, and roof garden. This approach to architecture was formalized in many of his residential designs. He is credited with not only designing some of the most important buildings of the 20th century, but also influencing the instruction and curriculum of countless architecture schools around the world. His paintings and sculptures were equally renowned and respected.

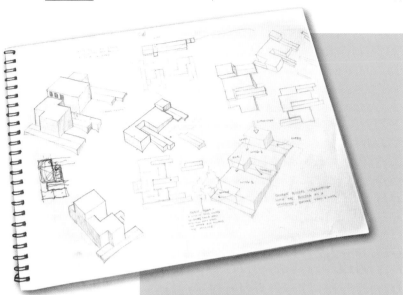

SKETCHBOOKS

- One of the tools that you will want to keep handy at all times is your sketchbook. Having multiple sketchbooks can be useful—a small one about 3½ x 5½ in. (8.9 x 14 cm) is convenient to carry in your back pocket, and a mid-sized one about 8½ x 11 in. (21.6 x 27.9 cm) allows you to work in a larger format.
- The smaller sketchbook should travel with you everywhere. It is the place to record ideas, sites that interest you, and architecture that excites you. The midsized sketchbook is ideal for working out ideas regarding your own projects and collecting images for your image folder.

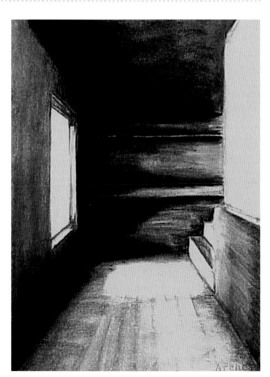

↖ **DESIGN INTENTIONS**
Different drawing methods are used to represent different design intentions. Charcoal drawings (such as the one shown on the left) can capture the mood of a space, whereas line drawings (such as this sectional perspective, above) provide a more precise technical depiction of a space.

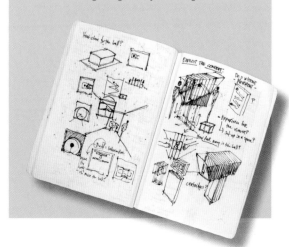

UNIT 3

REPRESENTATIONAL INTENTION

Architects envision, design, and think through drawing and modeling. They record ideas, test scenarios, and produce lines that capture thoughts. Drawings and models can reinforce a designer's idea through representational intention.

Representational intention—the methodology and choices behind the representation—has the potential to create a more meaningful connection between project depictions and the architectural idea, making a stronger argument for the project possible. Ask yourself the following questions: "What will the drawing convey? What is the design idea that needs to be narrated through the representations? What types of drawings best convey those architectural ideas?" The answers will help you establish the criteria required to reinforce the architectural idea.

For example, in perspective drawing, the vantage point of the viewer can be used to strengthen design ideas. Placing the vantage point lower on the page can reinforce a dramatic effect. This lowered viewpoint, together with proximity to the object, emphasizes the object's monumentality.

Intentions that support architectural ideas can also be conveyed through an editing process. When making considerations about a drawing, what you exclude is just as important as what you include. Every line you construct is part of the decision-making process.

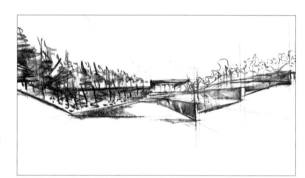

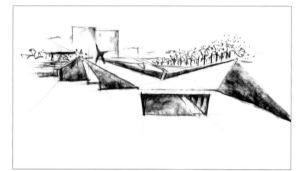

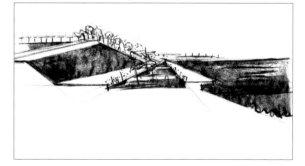

MARION WEISS

Marion Weiss (American) is a founding principal of the highly acclaimed architecture firm Weiss/Manfredi. The firm's award-winning body of work challenges conventional notions of the disciplinary interaction between architecture, art, ecology, landscape architecture, engineering, and urban planning. Weiss's provocative designs strive to clarify how movement, light, and materiality heighten the overall experience. In addition to employing sophisticated computer programs, charcoal sketching allows this architectural practice to explore the formal and atmospheric qualities of its designs. This is evident in the spatial richness that is paramount in all of its projects, regardless of scale.

←CHARCOAL SKETCH
Weiss's sectional perspective charcoal sketches show various views of her design for the Seattle Art Museum's Olympic Sculpture Park.

ASSIGNMENT 1 | FOLD AND CRUMPLE: INTENTIONS THROUGH EDITING

In this assignment, you will take a limited set of common materials and use them to express a place that is familiar to you: your home. You must interpret "your home," not as a literal place but as a translation of the place. Begin by defining the term "home." What is it about your home that is most distinguishable? How can you model that idea—not the home itself, but an abstracted version of those ideas? Translation is about taking a literal idea and modifying it through abstraction. The model you create will be a representation of this interpretation.

ASSIGNMENT RULES

- Be creative—don't be literal. Try to capture the essence of the space.
- The pieces must be physically connected (not just lying on top of each other).
- Think about the intention of your representation.
- You cannot tear any pieces once you have them sized to the given dimensions.
- Give yourself 15–20 minutes to create your abstract representation.
- Understand that there is no wrong answer or wrong model to make. This is solely about your interpretation of home.

WHAT YOU NEED

- Three sheets 8½ x 11 in. (22 x 28 cm) of regular opaque copy paper, each cut into six strips 1.5 x 11 in. (4 x 28 cm)
- Two sheets 12 x 12 in. (30 x 30 cm) of tracing paper
- Hand-torn piece of newspaper—approximately 8 x 10 in. (20 x 25 cm)

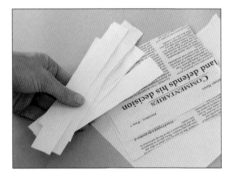

1 Take the materials listed and lay them out on a flat surface.

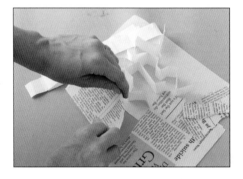

2 Without the use of tools or glue, start to create a representation of your home from memory. Try to give form to your visualization.

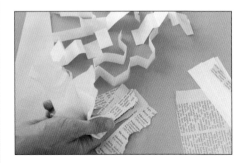

3 Fold and crumple the materials to integrate. Think about the spatial relationships between walls, objects, or planes.

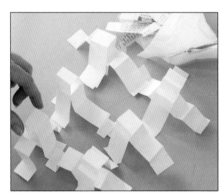

↑ FINISHED MODEL
The finished model above represents a house on water.

ASSIGNMENT 2 | STUDY THE SKETCH

A successful drawing is one that clearly conveys intentions and ideas. It does not have to be rendered in an artistic, beautiful manner for it to be "good."

One method to help you understand the successful nature of drawing is to study sketches by master artists and architects. This provides you with insight into the mind, abilities, style, technique, and subject matter selected by the artists and architects.

Drawing techniques have different associated intentions; therefore, not all sketches appear to be beautiful artistic renderings. Very clearly conceived sketches by some of the most famous architects are not always the most beautiful. During the drawing process, each artist edits or omits information that does not support the intention of the sketch.

This editing process allows the artist to emphasize a particular aspect of the view or design, clarifying the idea.

Find two sketches, one from each category listed below. Reproduce the renderings by hand in your sketchbook by copying the method of sketching. The purpose is to replicate the sketching technique used by the artist. Do not trace the sketch. Attach a copy of the original sketch into your sketchbook, adjacent to your own sketch.

Examine the technique of sketching while you copy the work. Notice the medium of sketching, the sketch surface, and the size of the lines.

SKETCHES TO STUDY

Architects
- Alvar Aalto
- Jeanne Gang
- Le Corbusier
- Louis I. Kahn
- Marion Weiss
- Michael Graves
- Ray Eames
- Sou Fujimoto
- Zaha Hadid

Artists
- Fra Angelico
- Frida Kahlo
- Georgia O'Keeffe
- Leonardo da Vinci
- Michelangelo
- Raphael
- Rembrandt

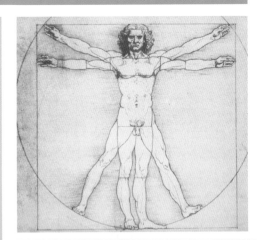

Grand Buildings Trafalgar Square 1985© Zaha Hadid Foundation

↑ GEOMETRY
Da Vinci's *Vitruvian Man* (top) explores ideas about geometry in human proportions. Hadid's proposal for Trafalgar Square, London (bottom), conveys many urban geometries.

← LINE AND RENDERING
This Frank Lloyd Wright drawing uses landscape elements to emphasize mass and form.

↓ SKETCHING WITH LINES →

Lines vary greatly among sketches. In this drawing by Michelangelo (below), hatching and contours provide objects with form and shape, while the Ray Eames sketch (right) employs lines (both thick and thin) as edge, plane, and volume.

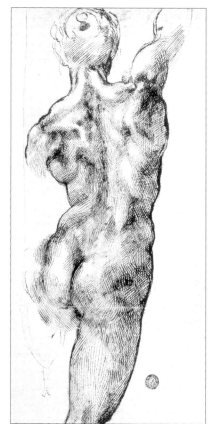

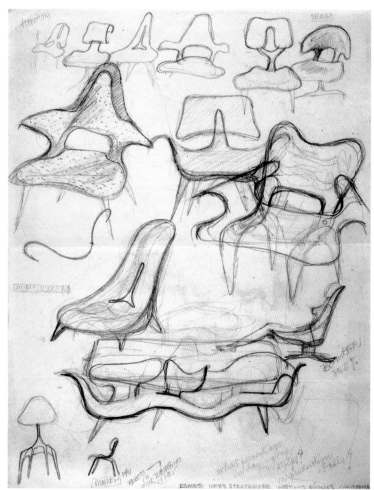

© 2017 Eames Office, LLC (eamesoffice.com)

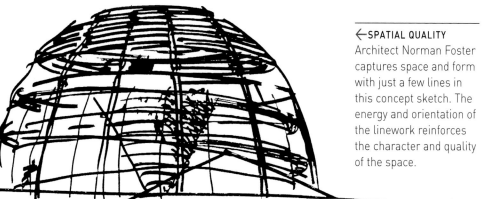

← SPATIAL QUALITY

Architect Norman Foster captures space and form with just a few lines in this concept sketch. The energy and orientation of the linework reinforces the character and quality of the space.

TYPES OF DRAWING

Architects use drawings to give their ideas physicality. They employ a variety of different drawing types, typically selected based on the criteria of design intention and the audience.

Two-dimensional drawings, referred to as orthographic projections, include plans, sections, and elevations. Perspective and axonometric are examples of three-dimensional drawing types. Drawings that overlap or combine linework with photographs, color, or some other graphic material are referred to as collage. Any of these drawing types can be constructed as hardline drawings or as freehand drawings (by hand or on the computer).

← MULTIPLE SECTIONS
Multiple sections depict the changing conditions of the light in the space. Each section captures a wall elevation showing the changing nature of the poché (or thickened service) zone. The darkest areas depict the deepest parts of the poché.

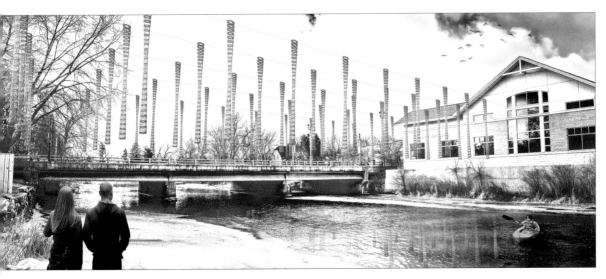

← SITE COLLAGE
Perspective drawings can be combined with existing images through collage techniques. The lights, created using Grasshopper, and the people (entourage) are Photoshopped onto an existing photograph of the site.

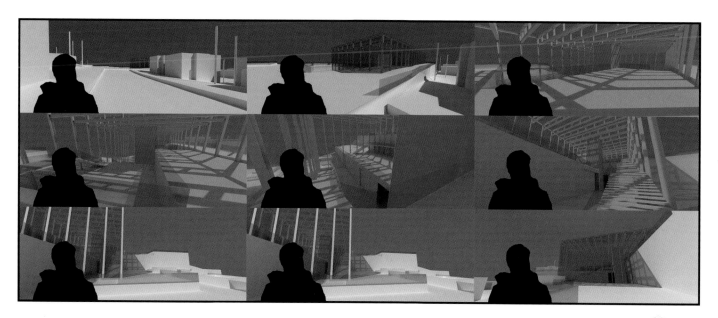

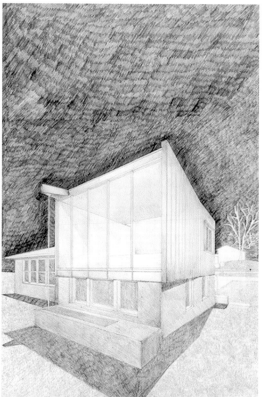

↑ **FINDING SCALE**

Interior and exterior perspectives can be linked through colors indicating the same spaces viewed from different vantage points. This series of perspectives depicts movement through a gallery space using the red box as the consistent element.

← **PERSPECTIVE RENDERING**

The graphite-rendered drawing showcases material transparencies and light qualities in spaces. In the perspective, the depth of the interior space is discernable, even from an exterior view of the building.

EXPLODED AXON →

Details of construction and material patterns are exposed in this exploded axon. Repetitive material patterns are grouped and pulled apart to demonstrate the parts relative to the working of the whole.

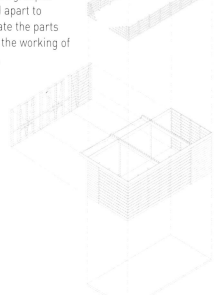

USING AN ARCHITECTURAL SCALE | (Metric)

The triangular scale rule, usually having six measurement gradations, is commonly used for drawing and modeling constructions. Most use increments of one millimeter to create a wide range of scales. The appropriate scale is used to take measurements from the drawing in meters or parts thereof.

Other scale rules are a more conventional flat format. They generally have two scales on each edge, one being 10 times the size of the other, i.e., 1:20 and 1:200. Specialist rulers are available to read measurements in meters from old imperial scales, i.e., 1:96 (⅛ in. to a foot) or 1:48 (¼ in. to a foot) (reading from left to right).

Along this line of measurements, every 2 cm is equal to 1 meter. The scaled numbers are already indicated on the measurement line. Note that the numbers on each scale correspond to a complementary set of scales.

Each scale is indicated as a ratio at the far edges of the measurement increments. For instance, the 1:50 marked on the far left indicates the scale of 1 cm being equivalent to 50 cm on a drawing scaled at 1:50.

On some scale rulers, smaller increments are marked outside the "0" mark. Therefore, it is necessary to measure the meters and add on fractions of a meter outside the mark.

↑ SCALE AND LEVEL OF INFORMATION

The type and amount of information conveyed by a drawing depends on its scale. A drawing at 1:100 scale requires less detailed information than one at 1:50 or 1:20. For example, the delineation of brick at 1:100 may be abstracted as horizontal lines, while at 1:50 or 1:20, the details of the individual bricks are drawn more appropriately.

ASSIGNMENT 3 | "THINGS I LIKE" IMAGE FOLDER

This assignment provides you with an opportunity to collect images of things that you like, find interesting, or are curious about. Document images of spaces, materials, and construction techniques to influence and inspire your design work. In developing your image folder, ask yourself not only what you like, but why you like it. Try to boil it down to a single idea. Use the following representation categories as a guide to help you maintain a variety of drawing examples:

• plans
• sections
• elevations
• axonometrics
• one-point, two-point, and three-point perspectives
• freehand sketches
• ink drawings
• graphite drawings
• computer drawings
• renderings
• physical models

In each, collect any image related to drawing and representation that is aesthetically appealing to you. These images will be a resource and inspiration for your designs.

The focus of the assignment is on representation, so do not use photographs of existing buildings. Include source material when finding images, including the building's name, the name of the architect, and where you found the image.

It is important that you expand your knowledge of representational methods. By seeing what others have done, you can learn to develop your own style.

ANALOG VERSUS DIGITAL: HOW TO COLLECT YOUR IMAGES

Pinterest, Instagram, and Flickr are digital versions of an image folder. Pinterest is a web service that allows you to tag and collect images across the web. Instagram and Flickr are both photo-sharing websites that allow you to post images and follow other members. Whichever method you choose, whether it's a sketchbook of paper copies of images or Pinterest-like websites, the intended outcome is to collect images that will become your own sources of inspiration.

RESEARCH TIP

Look online, as well as in the library, for images to inspire you. The search for one image can inspire you to find others you weren't thinking about.

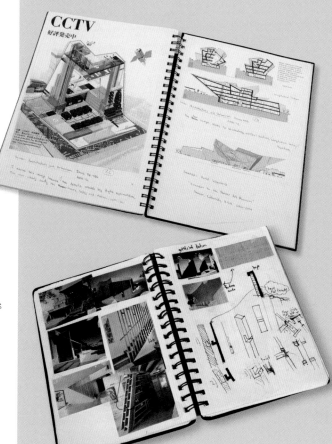

←CAPTURED IMAGES
It is important to become familiar with precedents in architecture; look at designs and drawings from contemporary and historically significant architects. Images of interest might range from conceptual to finished drawings, and from plans to perspectives. Being familiar with contemporary and historic representations allows you to learn from past examples and develop a visual library of precedents.

UNIT 5

MODELS AS REPRESENTATIONS

Drawings and models are both abstract representations: they provide methods for expressing architectural ideas and concepts. Drawings are typically constructed on two-dimensional surfaces, whereas models provide a three-dimensional abstraction of space and form.

Like in drawing, both the process and the presentation of ideas are recorded in models. Models typically provide a more holistic representation of space, operating in three dimensions. Architectural models are abstractions; therefore, they are not intended to represent real materials. For instance, models made out of basswood are not meant to indicate that the building is made out of wood. They are used as representations of space and form, with less emphasis on real materials.

Models can reinforce architectural intentions, be they spatial, formal, or tectonic. For example, the base of a model can be exaggerated to reinforce a connection between the building and the ground. By enlarging the depth of the model base, a greater emphasis is placed on the rooted quality of the project with the earth. Architects can also edit information, which enables them to control the model's intention.

MODEL PRACTICALITIES

Questions to ask yourself:
- What material should I use?
- How can I successfully abstract real building materials?
- At what scale are the materials to be depicted?
- Is the whole model made out of the same material?
- What are the limits of the site versus the limits of the model? Is it the property line or the strong edge in the neighborhood?
- At what scale should I make the model?
- What do I want to show? Remember, entourage can be included to demonstrate scale in a model.

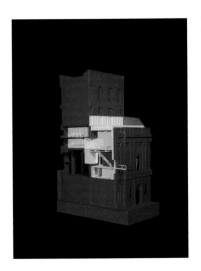

←PARASITIC DESIGN
Material distinction establishes clarity between existing and new elements. This design intervention is constructed of basswood and inserted into a model of chipboard and corrugated cardboard to represent the existing building.

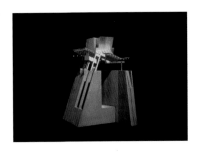

↑ SITE CONNECTION
The exaggerated base of this Newton Library model by Patkau Architects emphasizes the connection between building and site. The angle of the columnar system is carried through in its depth, form, and articulation.

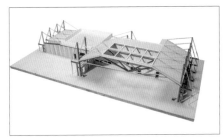

↑ DETAIL MODEL
This large-scale model depicts a truss structural system. Abstract models of this nature depict detailed construction techniques as they relate to the geometry, proportion, and scale of the design.

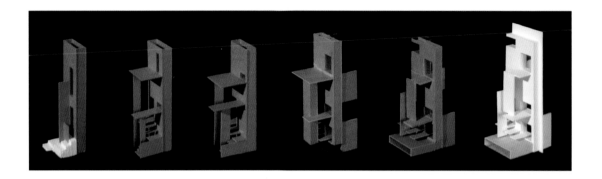

STUDY MODELS ↗

Helping you to assess ideas, study models can be manipulated and remade quickly. They provide opportunities for discovery, inspiration, and investigation. You should consider these types of models as developmental and not final renditions of the idea; they are part of the iterative design process. This series of models depicts the sequence of study models made for a window design.

MASSING MODEL ↓

A massing model depicts the volumetric qualities of a building without much detail. Massing models are used to assess and compare the relative form and scale of a building within the adjacent building context. Contextual information, such as curbs, roads, and waterways, is often included in these models to show how new buildings and spaces will interact with the existing conditions.

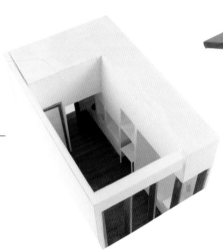

↑ TOPOGRAPHIC MODEL

This topographic model is made from chipboard. Topographic models depict the changing landscape of the site. The scale of the model determines the thickness of each contour.

↑ PRESENTATION MODELS→

Presentation models are used to show the final design. In the profession, they are used for client and community meetings. These models are not about process but product; they are usually the most well-crafted models produced for the project. The model on the right shows an architectural installation at the Haggerty Museum of Art in Wisconsin, while the model above shows a room for repose using Hydrocal and wood.

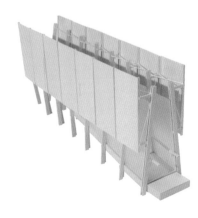

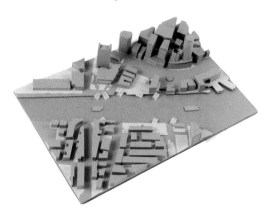

PHYSICAL VERSUS DIGITAL MODELS

During the design process, there are several benefits to making a physical model over a digital model. Physical models let you experience the building as a three-dimensional material object, allowing the design to be understood simultaneously through all of its parts and as a whole. Composition is realized dynamically through physical movement and rotation. This process compels the designer to be empathetic to the force of gravity and encourages him or her to think of the material connections and their tectonic implications for the architectural idea. In essence, the designer makes a physical connection with a physical model.

While the digital model also allows a type of visual immediacy through the rapid selection of views, these views are ultimately limited by the screen size and the limitations of the software interface. However, digital models can also provide opportunities to simulate travel through and into spaces, providing views that a physical model might not allow.

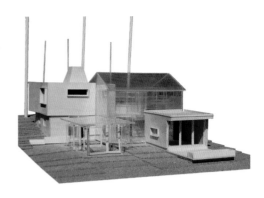

MATERIAL CONSTRUCTION→

These two images depict transparency studies of the same project through the use of a digital and physical model. The digital model (bottom) is more diagrammatic, emphasizing the continuity of spaces, while the physical model (top) allows the viewer to understand the massing of the addition (in basswood) with greater clarity.

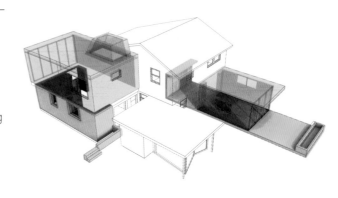

TYPICAL MODELING MATERIALS

Models do not have to be made from a single material. Using two materials can distinguish between existing and new or between materials.

Chipboard
Pros: No grain, easy to cut, cheap, consistent color and material throughout, comes in different thicknesses, comes in large sheets
Cons: Doesn't look as refined, slight variations in color

Basswood
Pros: Grain can emphasize directionality of materials; more refined look; easy to cut, comes in sticks, sheets, and blocks
Cons: Has grain, sheet size is limited, costs more than chipboard

Modeling clay
Pros: Good for carving and landscape models
Cons: Dries out quickly, messy, imprecise

Museum board
Pros: Easy to cut, no grain, comes in big sheets
Cons: Hard to keep clean, not always consistent material throughout, more expensive than chipboard

Foamcore
Pros: For making large-scale models, comes in a variety of thicknesses
Cons: Not consistent material throughout, need to adjust edges when joining

Chipboard Basswood Modeling clay Museum board Foamcore

CASE STUDY 1 | ARCHITECTURAL MOCK-UPS

DESIGNERS
bauenstudio, Mo Zell and Marc Roehrle

Two- and three-dimensional representations can be limiting when trying to understand the full impacts of a design project. Working at full scale, mock-ups are constructed to consider how a particular form or material will perform.

Full-scale mock-ups test impacts on site, constructability, and the material effects. Some mock-ups can be made using nontraditional materials to replicate the design impacts, while others require real materials to be tested. The following image depicts a full-scale mock-up of the Northeastern University Veterans Memorial. The scale of the Memorial Wall was tested using plastic and wood. The project was constructed with stone.

Other mock-ups include the wall mock-up. Typically constructed on site at full scale, this mock-up tests for construction techniques, clarity of instruction, color, and pattern choices, as well as material performance.

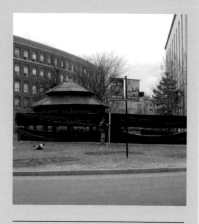

DEFINING WALL ↑
The relationship of the wall to the surrounding context and size of the space being created were verified with a full-scale mock-up. The wall height was altered when tested on site, while location and length were found to be appropriate.

COMBINING MATERIALS ↓
The structural model for an elementary school included a vacuum-formed, clear plastic shell, which enclosed the interior volume of the school. The shell was first modeled as an inverse form, carved from wood in a CNC mill. A plastic sheet was vacuum-formed around the block, then cut to size, generating a conceptual skin for the model.

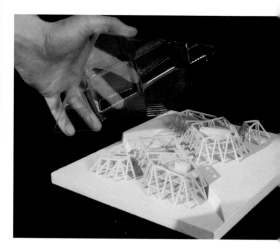

Plexiglass
Pros: Provides a transparent material, allowing interior views, can model curtain wall easily
Cons: Difficult to cut, especially holes in the middle; transparency is often misunderstood

Styrene
Pros: Highly polished smooth surface ideal as a mold for casting plaster, comes in a variety of sheet sizes
Cons: More expensive than basswood

Cork
Pros: Comes in rolls and sheets, looks finished, easy to cut, used as contours or landscape
Cons: Expensive

Corrugated cardboard
Pros: Affordable and accessible material, can use boxes and other packing material
Cons: Quality of material is rarely sufficient for final presentation models, must consider exposed edges in model

Casting (Rockite, Hydrocal, or plaster)
Pros: Can be formed into any shape, replicates requirements of concrete construction, can hold other casting materials
Cons: Requires form work, matching the consistency

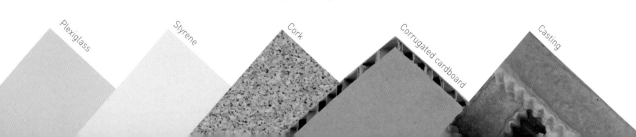

Plexiglass Styrene Cork Corrugated cardboard Casting

UNIT 6

FABRICATION

<u>Laser cutters, 3-D printers, and CNC mills are common tools for making models and full-scale constructions.</u>

Many schools now boast equipment—in some form of prototyping lab—that includes three-axis CAD-CAM mills, laser cutters, powder-based 3-D printers, plastic-based MakerBots, vacuum formers, and fabric cutters, to name but a few. Other equipment for fabrication and prototyping includes waterjet cutters; five-axis, robotic-arm CNC mills with a 6-ft (1.8-m) reach; and digitally controlled foam cutters. These tools provide direct access to new forms of making and fabrication.

1. CONCEPTUAL SKETCHES ↓

A lighting installation in downtown Waterford, Wisconsin, began with several conceptual sketches and ended with a series of iterative digital and wood models that explored the visual effects of perforations along a tube.

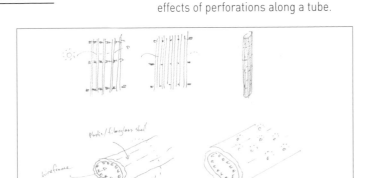

VACUUM FORMING

This is a process of transforming plastic sheet material over a mold to create a new form. The sheets are heated, then the vacuum sucks the material onto the mold. A vacuum-formed surface is singular and retains continuity of surface, as the material modulates over different forms.

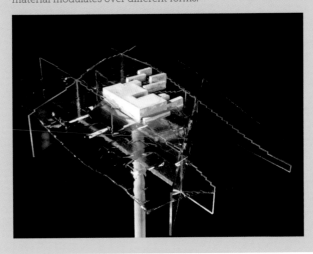

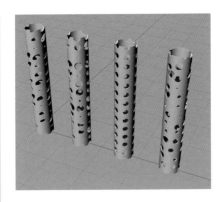

←3-D SITE MODEL

This site model for a gallery was CNC-milled from a block of plastic foam using 3-D topographic data. The block representing the site provided the form for a vacuum press, which molded a hot sheet of plastic over the model. The resulting plastic piece was cut to size and assembled as a site model.

2. VARIABLES ↑

Through the use of Grasshopper for Rhino, a number of variables are programmed into the models, including perforation size, perforation arrangement, tube cross-section rotation, and tube cross-section shape. By simply manipulating these variables in real time, a vast array of forms and types emerges.

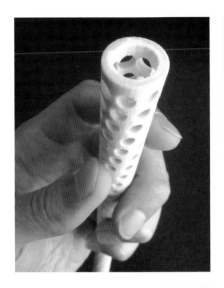

↑ 3. 3-D PRINTING
3-D printing the digital models adds a tactile and physical interpretation of the forms.

4. CONSTRUCTION →
Because the 3-D printed models dealt almost exclusively with form, the next stage of the project introduced materiality and constructability—crucial to the completion of a full-scale prototype. Having decided on a wireframe construction methodology, the parametric 3-D model was updated to include both structural rods and plates.

← 5. LED LIGHTS
To observe the visual effects of varying diameters, arrangements, and densities of perforation, an LED strip was installed down the center of the tube. Photographs capture the cast light in complete darkness.

6. STRUCTURE ↓
Structural plates were laser-cut to scale out of basswood or acrylic and strung together using thin metal or wooden rods. The resulting structure became expressive of its own construction, yet maintained the torsion and porosity from the original designs.

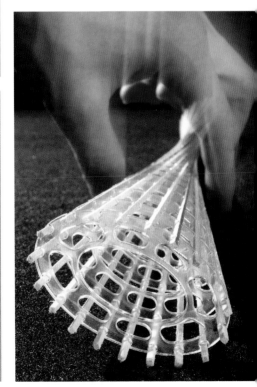

UNIT 7

WHO IS THE AUDIENCE?

Through representations, architects try to convey their ideas and intentions to various audiences. There are three main types of audience: academic, professional (including architects and contractors), and nonprofessional (namely clients and the public). Each audience requires a different set of representation types.

PRESENTING TO ARCHITECTS AND STUDENTS

Architects understand the abstract nature of representation; therefore, the presentation of ideas can be made using the full spectrum of representation techniques—freehand and hardline, conceptual and realistic—and using all of the drawing techniques. In addition, these representations can reveal the process of design thinking. The design process is often stressed as a presentation component in academia. It is not only the design that gets evaluated; it is also the process of arriving at that design that is critiqued and assessed in school. Be creative, adventurous, and inventive.

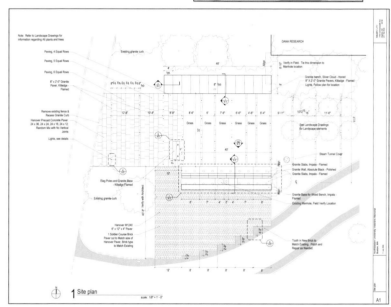

PLANNING BOARD/COMMUNITY GROUP

In an age of greater community involvement in the design of many public and private buildings, an architect's ability to communicate clearly and effectively with this group is key to the success of a project. A variety of representations, including perspectives, plans, and models, are used to convey the architectural vision to clients and the public.

In this role as a community liaison, it is important that architects listen to their audience. The public generally wants to understand how the project might fit into the existing context, as well as how it might benefit their community through improved landscaping, reduced traffic congestion, increased accessibility, and facade treatment.

↑ CONVEYING IDEAS

These two plans for a veterans' memorial were created for two different audiences. The rendered plan (top) was presented to a design review committee as a way of expressing the material qualities of the project. The monochrome plan (bottom) is a construction document (CD). It delineates a set of instructions on how to construct the project, including the exact number, type, and location of all the building elements.

CASE STUDY 2 | DESIGN PHASES

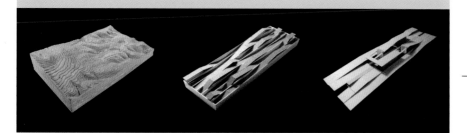

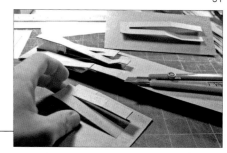

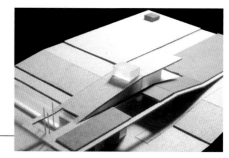

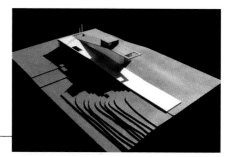

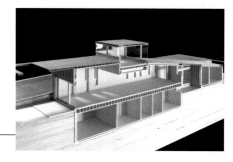

DESIGNER
Johnsen Schmaling Architects

Architects work through an iterative design process that includes constant revision and reflection. During different phases of design, architects create many representations for a specific audience.

1. PRE-DESIGN
In this phase, the architect can assist the client in establishing the program and site through interviews with user groups. Zoning issues explored include the maximum building allowed on a site, as well as possible setbacks.

The program is the project statement that often includes specific room types and associated square footage areas.

2. SCHEMATIC DESIGN (SD)
(Sketches, study models, perspectives)
Architects generate many ideas through drawing and model building. Some work simultaneously on a large scale, exploring the form of the building relative to the neighborhood, and on small details, such as material selection.

LANDSCAPE TO ARCHITECTURE ↑
In their project Topo House, Johnsen Schmaling Architects use models to translate the existing landscape into the architectural form.

3. DESIGN DEVELOPMENT (DD)
(Drawings, models, perspectives, mock-ups)
Architects describe the project in more detail. Often drawings increase in scale from $\frac{1}{16}$ in. or $\frac{1}{8}$ in. to $\frac{1}{2}$ in. so that more information can be included.

4. CONSTRUCTION DOCUMENTS
(CD) (Full-scale mock-up, details developed at larger scales)
These drawings provide instructions for the contractor. They constitute legal documents for the design project, thus requiring clarity and legibility in visual representation. The scale and number of drawings increase during this phase.

5. CONSTRUCTION ADMINISTRATION (CA)
During the construction process, site conditions, the availability of building materials, and cost issues may require changes to be made to the original construction drawing set.

↑ ARCHITECTURAL PHASES
These models of the Topo House are made during each of the different phases of architectural design. The complexity and detail increase as the project moves toward construction.

UNIT 8

CONCEPT

Purely functional solutions to problems often lead to the design of buildings, not architecture. When generating ideas about possible architectural solutions to a given problem, function should be contemplated in addition to culture, tectonics, aesthetics, and social concerns.

A concept is a generating tool; it is an open-ended, flexible foundation for establishing a way forward in making architectural designs. It is a way to organize the component parts of the project under a single idea.

There are many ways to arrive at a concept, including formal, tectonic, intuitive, analytical, narrative, metaphorical, and site ideas, to name but a few. You can derive architectural concepts from just about anything: a folded piece of paper (Rem Koolhaas) or a jumble of pixie sticks (Coop Himmelblau), for example. Even within a single approach, there are many methodologies for generating ideas.

Analysis provides one method of research that can become a platform for generating conceptual ideas. Analysis is the study of existing conditions, which may include site, context, history, and program. Analysis begins with questions. What was on the site previously? How did people use the site? After a thorough investigation, topics can then be prioritized.

PRECEDENTS

Design does not occur in a vacuum. Ideas can be generated from other projects. Understand that ideas are not sacred; they can be copied from other architects and buildings and then translated into your own

design. The key to borrowing ideas in architecture is to translate them and make them your own. Learn from precedents and apply your own design sensibilities to the knowledge you have gained.

When trying to arrive at a conceptual idea, it can be helpful to think physically about the idea. For example, you could sketch the idea or model or draw it. It's important to remember that the idea is not the architecture—it simply provides a way to arrive at architecture.

Research is a vital component of the design process. It provides you with a pool of knowledge from which to draw as you come up with project ideas. Research can involve a number of possible investigation approaches, including an examination of the building type and the history of the site, or even of similar-scale buildings with a different program.

DOCUMENTING THOUGHTS→
Recording ideas is a vital part of the iterative design process. Sketch while you are thinking. Once images are recorded, they can be reevaluated and modified. Sketches can also be coupled with written thoughts.

READ THIS!
Rudolph Arnheim
Visual Thinking
University of California Press, 2004

Andrea Simitch and Val Warke
The Language of Architecture
Rockport Publishers, 2014

CONCEPTUALIZING AN IDEA

Imagine being asked to design a pencil holder without any further design parameters. Here's a possible method of conceptualizing the idea:

- Research pencil (history, shape, size, standardization)
- Consider how many pencils will be held.
- Analyze precedents—what form do other pencil holders take? What questions do they answer?
- Study the hand—this is the one element that will be interacting with the pencil.

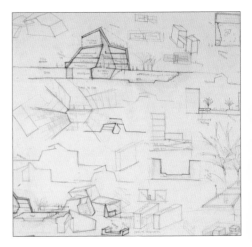

ITERATIVE PROCESS

Conceptual ideas are translated into architectural forms and spaces, details and materials, and circulation and experience. The process of design is one of iteration—that is, a repetitive process of development that changes over time. Each successive iteration builds on lessons from the previous one. The iterative process emphasizes an exploration of several options before settling on one single manifestation of a project. Through an iterative process of problem solving, ideas are tested graphically and theoretically. In every phase of the process, ask yourself "Why?"—"Why that form?", "Why that space?", "Why that location?"

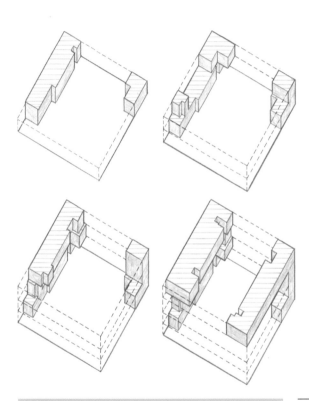

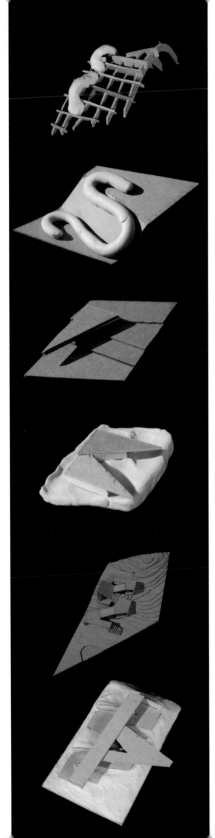

←SIMPLIFYING IDEAS

Conceptual ideas can be described through any type of representation technique. These axon diagrams reinforce the concept of a centralized space with thickened edges for a school design.

REALIZING INTENTIONS

- Make lots of things.
- Evaluate and critique your own work.
- Make bold modifications as well as minor ones.
- Be reductive (i.e., remove excess).

DIAGRAMMING FORM→

Four concepts are modeled before deciding on a particular direction. The two bottom models show the evolution of the project.

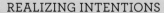

CONCEPT: THESIS

A thesis is a statement put forward about the premise of the project, how it fits within the disciplinary context, and what speculations are to be made through the project itself. The position can reflect the program, site, politics, culture, etc. Consider how the design work fits into the context of previous precedents. How does it advance technology, material, or space? How does it embody the values of architecture? A thesis involves research using historical precedents and theoretical positions to situate a new architectural design.

Every project in architecture can be framed around a thesis. The designer can take a position about what kind of design will be produced and what relevant questions should be answered through the project. Much like a concept, a thesis helps frame the path forward in design.

FORM, SPACE, AND CIRCULATION ↓

This series of plan and section diagrams depicts the iterative study of form, space, and circulation in the design of a dormitory space on an urban campus.

← LETTING NATURE IN →

The exterior skin of the Topo House is a translation of the billowing grasses covering the surrounding prairie. A series of black anodized aluminum fins wraps around the residence.

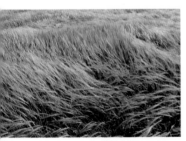

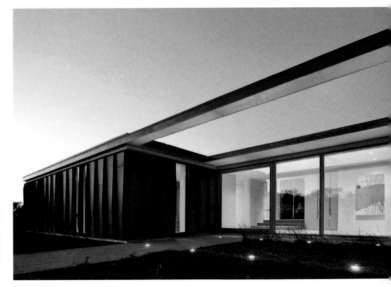

← BUILDING BECOMES LAND
In this concept model of the Topo House, the building is derived directly from the landscape. There is no distinction between building and land.

JOHNSEN SCHMALING ARCHITECTS

Johnsen Schmaling (Brian Johnsen, American; Sebastian Schmaling, German) is an internationally recognized architecture firm whose sophisticated projects are predicated by a rigorous design process. Research and an iterative exploration of ideas are hallmarks of their work. Johnsen Schmaling employs an array of tools to design its buildings—hand drawing, computer rendering, and extensive physical modeling. The scale and size of each model correspond to key issues—be this a handrail detail or the tectonic logic of the building's skin. This skillful use of modeling allows them to delve into issues of connectivity, layering, and the interplay of planar components, resulting in spatially complex buildings with a rich, exquisitely executed palette.

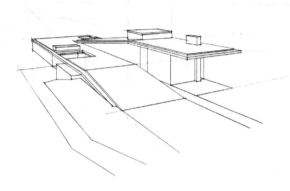

↑ REINFORCING THE IDEA
Additional representations like this framework for a perspective rendering reinforce the conceptual idea of the Topo House and land being connected.

← CHANGING LANDSCAPE →
In the Topo House, the shifts in landscape can be seen in the form as well as the plan.

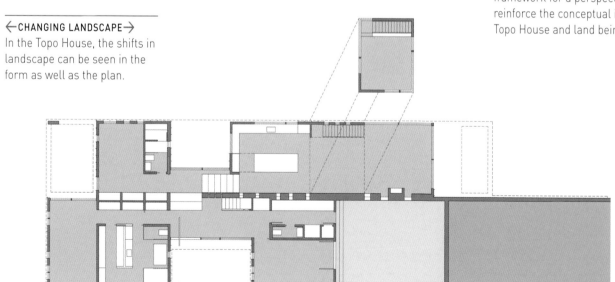

UNIT 9

TOOLS FOR SUCCESS

Some basic tools and techniques are essential for well-crafted drawings and models. As with any skill, technical ability comes with practice. The challenges met with the first drawing and first model will disappear with experience.

PAPERS AND PADS

Sketchbooks: One spiral-bound hardcover sketchbook 8½ x 11 in. (22 x 28 cm) and one 5 x 8 in. (13 x 20 cm). Keep a sketchbook with you at all times. Think of the sketchbook as a "diary" of your observations and architectural thoughts.

Large perforated recycled pad: 9 x 12 in. (23 x 30 cm). A drawing pad is ideal for sketching assignments where pages need to be removed for presentation.

Newsprint pad: 18 x 24 in. (46 x 60 cm). A newsprint pad is ideal for quick sketches. The quality of the paper is not suitable for the preservation of drawings. This type of pad is not ideal for use with charcoal.

Large-format drawing pad: 18 x 24 in. (46 x 60 cm), 100# paper. A large-format drawing sheet is ideal for figure drawing and still-life drawing. Backed by a clipboard, this pad can be taken into the field for on-site sketches. The paper quality is much more durable than in the newsprint pad. This pad is ideal for use with charcoal and pencil.

Vellum roll or sheets: 24 in. (60 cm) roll, 20 lb. Vellum is a semi-transparent material. It is relatively easy to erase and is a durable material with which to construct presentation drawings.

Roll of cream, yellow, or white tracing paper: 12–18 in. (30 x 46 cm) wide. Tracing paper is ideal for sketching and working in overlays. Overlay trace on top of other drawings to make modifications and change ideas.

Sketchbooks

Tracing paper

White charcoal pencil

Kneaded eraser

White eraser

Swing-arm lamp

Colored pencils

TOOLS FOR FREEHAND WORK

Large box: For carrying and storing tools.

Pencil sharpener: With shavings receptacle

Charcoal sticks

White charcoal pencil

Spray fix: Use this to seal your charcoal drawings.

Kneaded eraser: Use a kneaded eraser to dab lines when you want to dilute their strength or weight.

White eraser

Pencils: Hard: 2H, H; Mid: HB

Soft: B, 2B, 4B, 6B
The ideal pencils for sketching include the range from HB to 6B; softer leads give you a variety of line weights and types. You will need to develop a rapport with the pencils to establish your own line weights.

Colored pencils: Start with primary colors, then experiment with others.

TOOLS FOR HARDLINE WORK

Swing-arm lamp: Lighting is key to creating beautiful drawings and models. Use task lighting to highlight your desk surface.

Drafting board: 32 x 48 in. (80 x 122 cm) minimum; a hollow-core door or other smooth, portable surface.
Your drafting board must be sturdy and smooth without nicks or dents. A large surface is ideal for flexibility of drawing sizes. A lightweight board is ideal for carrying.

Drafting surface and board cover: A self-healing vinyl membrane covers and protects your drafting board and is ideal for drawing on. It is not a good idea to draw directly on wood or other hard surfaces.

Double-sided tape: Use this to attach the drafting surface to your board.

TOOLS FOR HARDLINE WORK (CONTINUED)

1 box of each of the following leads: 4H, 2H, H, F, HB, and B: The leads for drawing are in the H range, with a few darker leads of HB and B. The harder leads offer more precision and sharpness of line.

Lead holders: Having multiple lead holders lets you use a variety of thicknesses simultaneously without exchanging leads.

Lead pointer: Use a lead pointer for sharpening your lead. To sharpen, pull slightly outward, using centrifugal force when rotating the lead around in the pointer.

Erasing shield (with small slots): Use a shield to erase short lines or specific lines in areas where there are lots of other lines you want to keep.

Draft dots or tape: Use dots or drafting tape to attach drawings to the board. These adhesive materials won't leave residue on your paper.

Drafting brush: A drafting brush prevents smudging. Use this tool rather than your hand or sleeve. Oils from your hands must be minimized on the drawing surface.

Parallel motion: 42 in. (107 cm) long with rollers on underside. Use the parallel motion to construct hardline drawings. Never use it as a guide for making cuts—preserve and protect it at all times. Every time you come to your board, make sure that it is aligned properly. You can test this by bringing the edge down to the bottom of the board.

Permanent marker: Label your tools with a marker.

18-in. (46-cm) 30/60/90°, 14-in. (36-cm) 45°, and 10-in. (25-cm) adjustable set square: Use this to construct axonometric and perspective drawings.

Triangular scale: Use the scale for measuring and dimensioning your drawings.

Aluminum or plastic tacks: Hold your work up for display or reference by using tacks.

Set square

Permanent marker

Compass

TOOLS FOR MODELING

Utlilty knife

Metal ruler

Cutting mat

Blade holder: Use a blade holder to cut most model-making materials. Thicker materials require either more cuts or the use of a utility knife.

Blades (×100): Buy blades in bulk, since you will be replacing them often.

Utility knife: Make long cuts with a larger knife. Cutting into thick surfaces like foam is easier with a long blade that is adjustable up to 4 in. (10 cm) in length. When cutting with large knives, score the material first with a light stroke. In general, aim to use less pressure and more strokes. Change blades often.

White glue: White glue dries clear and is very strong. Use in small amounts to maintain a clean appearance.

Acrylic glue: Use this for gluing acrylic materials.

Cutting mats: 18 x 24 in. (45 x 60 cm) and 8 x 10 in. (20 x 25 cm). Cutting mats are designed to "heal" after being cut. They protect your tabletop and drawing board and prolong blade usage. It is useful to have more than one size.

36-in. (90-cm) long metal edge with cork backing: A cork-backed metal edge provides a slip-resistant tool for cutting.

6-in. (15-cm) metal-edge ruler: A metal ruler is good for measuring and cutting smaller model pieces. You can also use any straight-edged metal object like a metal triangle. Plastic triangles and parallel bar edges are susceptible to nicking and should never be used to cut along.

Tweezers: In model building, use tweezers to help you connect small pieces together.

Sandpaper (medium): Use sandpaper to clean the edges of any wood surface. A sanding block is helpful to maintain 90-degree corners on wood. You can make a sanding block by wrapping the sandpaper around a scrap piece of square-edged wood. Light sanding can remove pencil marks and minimize joints between two pieces of wood. Too much sanding, however, can round the edges of the model. You can also sand acrylic to change the transparency. Reduce the amount of scratches apparent in the acrylic by sanding on both sides.

OPTIONAL TOOLS

- Portfolio and/or a drawing tube
- French curve
- Triangles, 4–6 in. (10–15 cm) long and 16–20 in. (40–50 cm) long: 30/60/90° and 45° triangle
- Triangular engineer's scale
- Calculator
- Scissors
- Electric eraser
- Circle template
- Oval template
- Measuring tape (25 ft [7.6 m] or longer)
- Graphite sticks (6B or softer)
- Clamps and fasteners: binder clips, small clamps, rubber bands
- Miter box and saw
- Wax paper
- Chopper
- Hot glue gun
- Pushpins
- Digital camera

CARING FOR EQUIPMENT

To maintain your equipment, carefully store and clean your tools after each use. Store tools flat on horizontal surfaces.

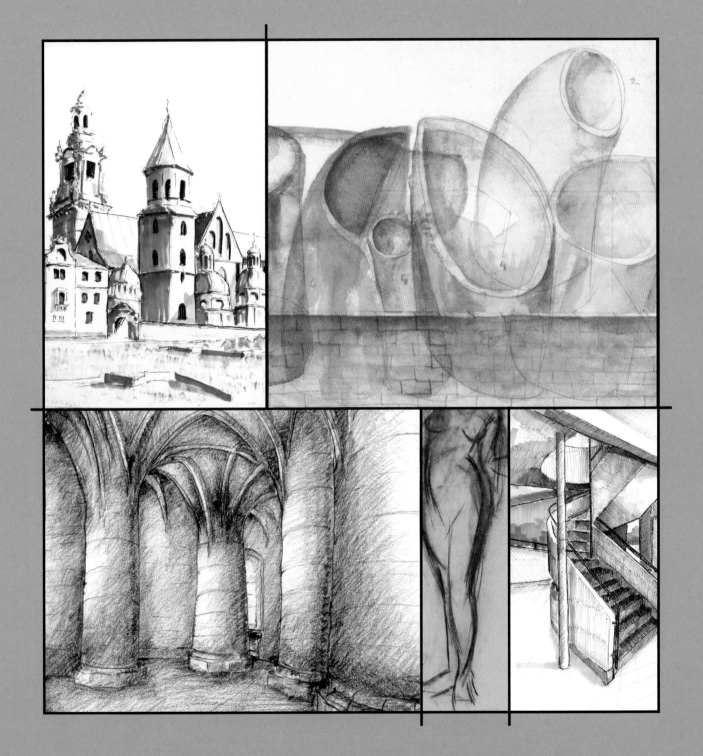

CHAPTER 2

LEARNING TO SEE: SKETCHING

Sketching is a technique for documenting ideas in a quick, uninhibited fashion. Learning to sketch is like learning to see in a new way for the first time. It is a method of thinking visually on paper, and it can be observational or invented. The quick fashion or loose methodology does not imply that the sketch is sloppy or uninformative. Quite the contrary . . . architects use sketches as a method of representation to isolate, recall, and document ideas. Sketches are often the first method of representation used to document a design idea.

Like drawing, sketches can reinforce design intentions. With the fluidity of a single line or the movement found in a group of thoughtfully composed lines, sketches can reinforce the architectural narrative. As with architectural skills, sketching can be learned, developed, and mastered with patience and time.

This chapter will demonstrate different ways to observe and record ideas and visual data in the world around you. With practice, you can increase your ability to capture ideas quickly, efficiently, and accurately.

UNIT 10

SKETCHING TYPES

Sketching involves the translation of existing visual information or an idea onto a two-dimensional surface. The types of sketches used by artists and architects vary depending on intent. Technique and medium influence both what and how a sketch is made.

OBSERVATIONAL SKETCHING

Observational sketching is one of the most common ways to record the environment. The first rule is to draw what you see and not what you know or think you see. Sketching involves seeing, not just looking. By not letting your knowledge of an environment or familiar object muddle your observational skills, you will be able to transfer existing information to the page more easily.

The second rule of observational drawing is to make the drawing your own—that is, observational drawing can be about exploration, not mere documentation. As the artist, make decisions about what to edit or emphasize.

In general, drawing from life is complex. You provide clarity and your own self-expression through your sketches of the built environment. Start each sketch with a purpose. Think about which aspect of the view you want to capture. Ask yourself what you want the narrative of the drawing to be—that is, what story you want it to convey.

CONTOUR SKETCHING

The contour sketch is a single-line drawing that focuses on the outline of the form or figure. When drawing, you should be attentive to the edge of the form and the quality of the line creating that edge. There is no tonal value expressed in this sketch type, but by varying the thickness of the line, it can express the mass of the object. In graphite, lines can accentuate, accelerate, become thin, and then become thick. With each change, they indicate a subtlety in the form of the object representing roundness, a crisp edge, depth (see Eames' sketches, page 19), and thickness—all with a single line.

BLIND SKETCHING

Blind sketching, a type of observational drawing, captures an object or space without the artist being distracted by accuracy. In this type of drawing, the hand and eye communicate an image onto the paper without the eye watching the hand construct the image. The hand is not inhibited by the observations of the eyes trying to override the brain into drawing the image "correctly." This method of sketching allows for a focus on what you are seeing and helps to develop and strengthen the control of your hand. Sometimes blind sketches capture the essence of the view better than a longer observational sketch. It also improves intuitive spatial coordination when practiced often.

ASSIGNMENT 4 | PLEXIGLASS SKETCH

Part 1: Take a piece of clear acrylic, roughly 10 x 14 in. (25 x 36 cm), and hold it 16–24 in. (40–60 cm) away from your face in a comfortable position. Direct the acrylic toward a complex scene. Do not face something straight on. Close one eye. Literally trace over what you see using a washable marker pen.

This assignment reinforces your accuracy in drawing perspective through tracing, as well as your ability to draw what you see rather than what you know. It provides the structuring elements that will aid your confidence in sketching.

Part 2: Stand in the same location and draw the same view in your sketchbook without the acrylic.

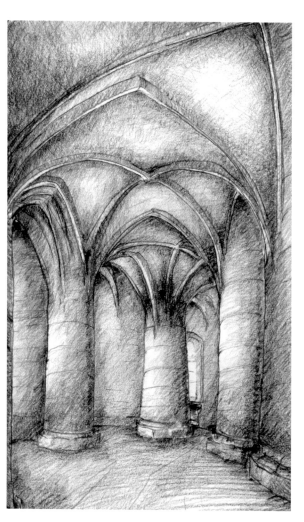

DESIGN SKETCHING

Design sketches allow you to think on paper and draw what does not exist. They can take on any physical manifestation. Design sketches can be intermixed with text, photography, and other graphic images. What you design does not exist until you construct it on paper; therefore, it is important to learn how to record your ideas in sketches. Frequent sketching of existing objects hones your invented drawing skills.

←LIGHT AND SHADOW

This interior sketch of the Crypts of the Abbey of Mont St. Michel, in France, uses the density of marks with a black colored pencil to distinguish between light and shadow.

↑ANALYTICAL SKETCHING

Analytical sketches are less pictorial; they don't necessarily depict spaces or objects as you would see them but are more abstract and reductive in nature. These types of drawings help reorient a project or an existing condition to understand it better. Analytical sketches assess the essential component parts and relationships of an object or idea and record them in a visual manner.

GESTURE SKETCHING

The gesture sketch is a quick sketch that captures the essential weight and movement of a scene. It is an initial reaction to a view. It is made with a series of gestural lines, usually in about 30 seconds. It conveys the essence of the object, the "bones," without being distracted by the details. (See Siza's sketch, page 45.)

UNIT 11

SKETCHING TECHNIQUES

The line is the basic building block of any sketch. The quantity and quality of the lines determine the type of sketch and the technique employed. Line variations occur with different media types, and a series of lines graphically conveyed in similar fashion can create tonal value.

Tonal value emphasizes the creation of a surface rather than the contour or edge of an object. Tonal sketches map the lights and darks of objects and spaces. When blocking out for value sketching, concentrate on the major organizing elements in the initial layout, then work the detail into the drawing. You can use a number of sketching techniques to create tonal values, including hatching, scribbling, stippling, or shading.

READ THIS!
Louis I. Kahn
The Value and Aim of Sketching
Writings, lectures, and interviews, 1931

Paul Laseau
*Freehand Sketching:
An Introduction*
W. W. Norton and Company
New York, 2004

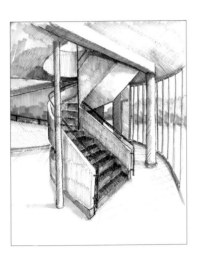

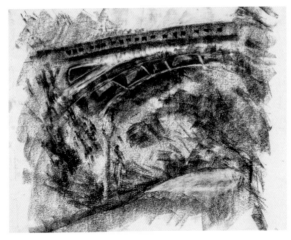

HATCHING ↑
Hatching is created by a series of diagonal lines in one direction. Cross-hatching tones are created by a series of diagonal lines in two directions.

SCRIBBLING ↑
Scribbling uses random rounded lines that numerously overlap to create a tonal value. The emphasis is not on the individual squiggle or line, but on the uniformity of all the lines to create a tone.

SHADING
As in this example by Hugh Ferriss, shading emphasizes areas of tonal space over the production of a single line. Depth is achieved by changing the values of tone. This technique is typically associated with drawing media that quickly create large surface areas, such as charcoal, pastel, and loose graphite.

ASSIGNMENT 5 | ACHIEVING TONAL VARIATION

On a sheet of paper, create three rectangular boxes 2 x 8 in. (5 x 20 cm) divided into 1 in. (2.5 cm) increments. Practice a different method of sketching in each box. Start at the left and label the boxes as follows: "stippling," "shading," and "scribbling."

To achieve tonal consistency, build up a series of layers rather than using hand pressure to vary tone. For example, start with the stippling method. In the top eighth of the vertical box, begin to put a few dots on the paper. Put the same density of dots in the whole box from top to bottom. Repeat this exercise from the top, but this time skip the first eighth. Repeat the exercise again, this time skipping the first two eighths. Continue until you have repeated this eight times. Within the eight divisions of the vertical box, you will see the variety of tonal variation is possible to achieve with the layering technique. The goal is to achieve a smooth gradation from one tonal range to another.

Stippling, shading, and scribbling provide tonal variations for sketching and rendering.

COMPOSITION

- The foreground and background can provide a transition between the viewer and the object.
- The white of the page is just as important as the black of the line being created. Don't be afraid to leave lots of white on the page.
- Understand the relationship between form and space. Consider the effects of light, volume, weight, shadow, edge, and space.
- Consider the size of the image relative to the size of the paper—the size determines the amount of information necessary and feasible.
- Consider the location of the sketch on the page. The size of the image to be drawn determines where it is possible to locate the sketch and the page orientation. The page orientation can reinforce the intentions of the sketch.

LOUIS I. KAHN

Louis I. Kahn (Estonian/American b.1901 d. 1974) is one of the best-known architects and teachers of the 20th century. For Kahn, architecture was the resolution of the interaction of materials and light—without light, architecture would not exist. Kahn's travel sketches depicted not only the architecture he observed but more importantly the way buildings interacted with light. A keen observer, he was known for his inspirational quotes.

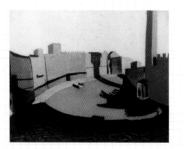

↑ **MASS AND LIGHT**
Louis I. Kahn's travel sketches document ancient Italian architecture like the Campo in Siena. The appreciation of mass, geometry, and light in his travel sketches would later inspire his own architecture.

"The capacity to see comes from persistently analyzing our reactions to what we look at, and their significance as far as we are concerned. The more one looks, the more one will come to see."
Louis I. Kahn

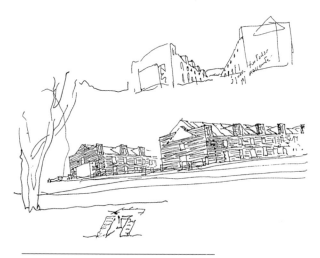

↑ **CAPTURING SPACE**
With a focus on the line, Alvaro Siza's travel sketches clearly convey the mass of buildings and the space in between.

UNIT 12

SKETCHING MEDIA

Media refers to both the sketching instrument (i.e., charcoal, pencil, ink), as well as the material upon which the sketch is drawn. Both can reinforce the intentions of the sketch and should be considered before starting.

Media choices include graphite, ink, wash, charcoal crayon, Conté crayon, and pastel or colored pencil. Time, location, intention, and audience determine which media choice to use, as well as which technique would be most appropriate. Each media can provide a variety of effects.

INK ↓

Ink is a permanent, non-erasable material with a consistent line weight and thickness. Tonal variation is achieved through pen thickness, overlapping lines, and the pattern and density of line, rather than variations in hand pressure.

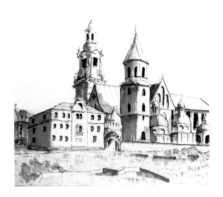

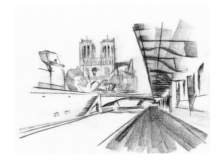

WATER-BASED WASHES ↓

Water-based washes include watercolor, gouache, and ink wash. Watercolor is a water-based paint that is applied like a wash. It is useful for indicating transparency, giving tonal variation, and adding color, but it is difficult to correct. It can also be hard to control the location of the wash. Watercolors are created from the lightest to darkest value. Gouache is a water-based opaque wash that can be overpainted. Ink wash is made by diluting ink. Bamboo or brushes create both line and value.

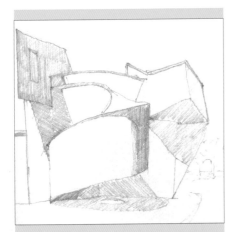

↑ GRAPHITE

Graphite makes readily controlled marks and is easy to erase. Soft pencils are typically used for sketching (from HB to 6B), as they have the flexibility to create a number of different marks on the page based on hand pressure and the angle of the lead. With a soft pencil, it is easy to create depth on a two-dimensional surface using shading, cross-hatching, lines, and tones.

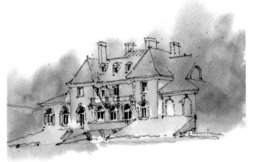

↑ CONTÉ CRAYON

Conté crayon is a square-profiled drawing stick made of compressed chalk. It is similar to charcoal—often harder—but generates a soft line. Conté crayons are ideal for creating drawings on rough paper. They offer a variety of line types, from thin to thick, as well as the tone achieved by using the flat of the stick. Unlike charcoal, the Conté crayon cannot be smudged.

MAKING MARKS

- Map out a few light lines that indicate the general structure of the object or space; start with the general and proceed to the specific.
- Think about the location of the first marks. Where you set your first marks will determine size and scale, so design the sketch on the page.
- Pay close attention to the proportion and scale of elements.
- Use a pencil to create alignments of objects in the view (setting up vertical or horizontal relationships). Use construction lines to help define relationships between parts of the object.
- Develop hierarchy in the sketch.
- Build up detail.

- While sketching, never apologize for any line that you make. Redraw over any part of a sketch that seems incorrect; this is part of the learning process. Start light and build up.
- There is an editing process that occurs when transferring what you see or invent onto paper. This allows you to process a specific intention for the drawing while making decisions about what to include and leave out.
- Sketching is not only about developing your style but also developing the understanding of when and which media and papers to use to convey your ideas best. Your drawing media and type should reflect the nature of your design and the architectural intentions.

↑ **TRANSFERRING DATA**
To establish accurate proportions, scale, and distance, use a pencil to transfer approximate dimensions and angles onto the paper.

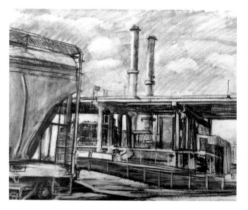

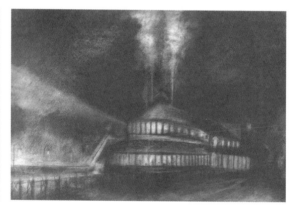

↑ → **CHARCOAL**

Charcoal is a workable, flexible material that allows for various marks and tonal values. It is ideal for depicting the dramatic effects of light on a surface and for providing textural qualities of space and materials. The "messy" quality liberates the artist from any fear of drawing incorrectly.

As in the drawing by Turner Brooks of the Eugene O'Neill Theatre in Waterford, Connecticut (above, right), the high contrasts in light escaping the building are depicted as if they have been carved out of the sky. These charcoals (above left and middle) document existing sites, whereas the Turner Brooks charcoal is a speculative design that expresses movement.

Newsprint

Tracing paper

Vellum

All-purpose acid-free paper

PAPERS AND PADS

Newsprint: Thin, inexpensive paper with a natural gray tone, ideal for practice sketches. It tears easily, and it is therefore harder to develop or work a drawing on this type of paper. It has no tooth.

Tracing paper: Trace is a transparent material used for overlay sketches.

Vellum: A translucent material that is ideal for working with graphite. The paper comes in a variety of weights. Linework, rendering, and shade/shadow tonal work can be created on vellum. It is ideal for layering drawings on top of one another due to its translucent quality.

100# all-purpose acid-free paper: Acid-free paper such as Strathmore is a thicker white paper ideal for sketching with charcoal, ink, and pencil. It is more durable than newsprint.

Arches: A French watercolor paper better for line and tonal drawings. It comes in a variety of weights ranging from 90 lb to 140 lb. "Hot press" is a smooth paper with less tooth, while "cold press" is rougher and more textural. The paper is archival quality and very sturdy. The rougher tooth holds the marks of Conté crayon, charcoal, and pastel very well, while the smooth tooth is ideal for graphite.

Mylar: A clear film that takes ink well. It is relatively easy to erase ink on mylar using an electric eraser and a little bit of moisture.

Craft paper: Smooth brown paper. It works well with pastels and charcoal, and it provides an excellent nonwhite surface on which to draw. White and colored pencils can be used on this surface.

ASSIGNMENT 6 | STILL-LIFE SKETCHING

Create a still life using a combination of chairs, stools, and other small-scale objects. Place them in a manner that is atypical to their normal orientation; this helps to relieve familiarity or preconceived ideas about the objects. Look at the objects in different ways: as solids, as space definers, as surfaces, and as voids. You are reexamining what is familiar. Use the sketch as a way to tell the story of the objects.

Experiment with different media and techniques to find those that are most expressive for you. Consider issues of layout and composition (how you fill the page with the object).

BRIEF

Construct a series of eight timed sketches using a variety of the techniques and media described in this chapter.

- Two rounds of 30-second blind drawing
- 30-second sketch
- 1-minute sketch
- 5-minute sketch
- 10-minute sketch
- 30-minute line sketch (use hatching, scribbling, or stippling)
- 1-hour tone sketch (use charcoal, Conté, or pastel)

Redraw the same composition using another medium.

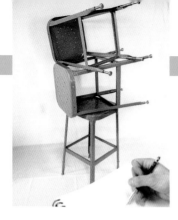

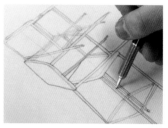

1 Start with a 30-second blind drawing to attune your hand and eye control. Work to get the whole object on the page within that time frame. Detail is not important. Concentrate on proportion and the relative scales of each object to itself and to the other objects.

2 Begin a new drawing by sketching the spaces between objects as opposed to objects themselves. This will enable you to work on proportion and scale without being distracted by foreshortened elements.

3 Use guidelines to verify the location of elements in the sketch. For each timed drawing, your goal is to get a complete image on the page. Your drawing techniques will change slightly as the time increases.

4 Return to areas of the drawing to provide additional details, tone, or corrections to the alignment, proportion, or scale of the elements. Build up the drawing. Do not develop one area too much prematurely.

STEVEN HOLL

Steven Holl (American b. 1947) founded a critical journal in 1978 entitled "Pamphlet Architecture." These small booklets became avenues for architects to disseminate theoretical architectural treaties. Holl balances theoretical work with built work, exploring and testing ideas pertaining to the links between science, technology, and art. He has designed important cultural buildings throughout Europe and North America. Steven Holl's work can be characterized with his insightful investigations of how light enters and interacts with a building. He studies these relationships through watercolor sketches.

INVESTIGATIVE WATERCOLOR SKETCH →
This Steven Holl sketch of the Chapel of St. Ignatius in Seattle captures his concept of the seven vessels of light entering and energizing the building. The characteristics of watercolors, transparency, overlapping, and color perfectly allow him to study the interplay of light and form.

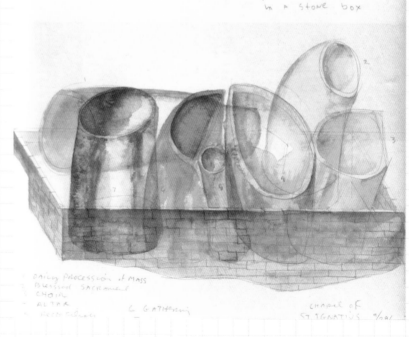

UNIT 13

SKETCHING THE LINE

Lines are man-made creations that indicate form, depth, material, or brightness.

A line is a continuous mark on a surface that is defined by its length relative to its width or thickness. The thickness of the line can vary with different media. Mastering the straight line helps with all sketching media. The line, if properly drawn, can delineate sharp edges or soft contours.

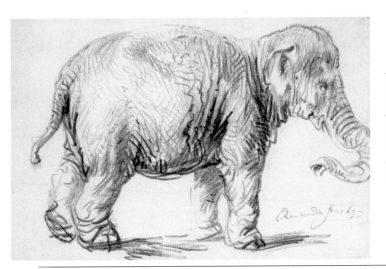

←CHANGING LINES
Lines can vary greatly within a sketch. A change in line thickness can indicate a change in form, as is seen in this Rembrandt sketch.

"Line does not exist in nature. Line is an invention of man; so, in fact, is all of drawing . . . There must have been a reason for the invention of the line. Yes, it is a guide for those who would venture into the formlessness that surrounds us on every side; a guide that leads us to the recognition of form and dimension and inner meaning."

George Grosz, painter, 1893–1959

↓INK LINE WEIGHTS
Ink offers a more consistent drawing line than graphite. Variation of line type is achieved through pen thicknesses rather than hand pressure. Pens have a consistent stainless-steel tip and ink flow. Therefore, they maintain their line consistency and type throughout the length of the line.

The ink weight range includes: 0.13 mm, 0.18 mm, 0.25 mm, 0.30 mm, 0.35 mm, 0.50 mm, 0.70 mm, 1.0 mm, 1.4 mm, and 2.0 mm. The lines created with ink are similar to those that are available in digital programs as well. As with graphite, keep a range of light, medium, and dark instruments for drawing on hand.

GRAPHITE LINE WEIGHTS
Through the pressure, thickness, and angle of a graphite tool, the line can describe different textures, shapes, and forms. Individual hand pressure affects a graphite line and thus determines the selection of lead grade to use. Leads are graded from H to B (hard to soft), with the full range extending from 9H to 9B. The harder the lead, the lighter, crisper, and thinner the line will be.

ASSIGNMENT 7 | LINE DRAWING EXERCISES

Line drawing exercises allow you to gauge your own hand pressure and to achieve straight-line accuracy. It is important to develop the proper hand-eye coordination to draw. You will need to move your entire arm when making long, straight lines. This provides you with stability as you move the lead holder across the page. Twist the lead holder between your fingers as you move it across the page to maintain a consistent point on the lead.

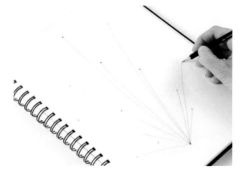

1a Using a large sketchbook or sketch pad, distribute 10 dots randomly across the entire page. Do not align more than three. Draw a freehand line to connect two of the dots. Look ahead to where the line will end. Try to make the line straight and of a consistent weight.

1b Connect every dot to every other dot. Use an HB sketching pencil. Do not lift the pencil up or pause in the middle of a line. Use your entire arm to draw—from your shoulder to your fingers.

2a On another sheet, draw a series of horizontal lines, keeping the lines parallel and around ½ in. (1.25 cm) apart. Draw each line continuously from one side of the paper to the other. Vary your hand pressure after every five lines.

2b Cross vertical lines over the horizontal ones to create a grid. Try a variety of lead hardnesses, and both a lead holder and sketch pencils. In addition, use an HB lead in the lead holder for five lines, then press harder for five lines, then lighter for another five lines. Next, try the HB pencil using the same methodology of five lines regular, five lines harder, and five lines lighter.

3a Carefully draw horizontal lines across the width of another page. Maintain a 1-in. (2.5-cm) distance between the lines at the top quarter of the page. For the next quarter, keep a consistent ½-in. (1.25-cm) spacing between the lines, followed by a ¼-in. (6-mm) spacing for the next quarter. Finally, the bottom quarter of the page should be filled with lines ⅛ in. (3 mm) apart.

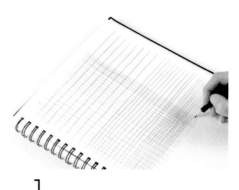

3b Repeat the same exercise, drawing vertical lines.

UNIT 14

SELECTING AN OBJECT

By taking a sketchbook with you everywhere, sketching can be practiced at every opportunity. For good practice, make sketches of different objects using various techniques.

Sketching every day can improve your drawing and observation skills. There are so many things to draw that you need not look far to find inspiration. A building, a room, a piece of furniture, and even people can provide a wide range of sketching opportunities. Operable tools also provide easily accessible objects that can be used for sketching practice. Even simple household tools, such as scissors or staplers, are good to draw. In choosing an object or space to draw, select one that has some form of physical or visual variation. For the tools, this may be the fact that the object can change shape through its mechanics. For rooms or buildings, this might mean making sure that there is enough information to draw.

Practice sketching the same object or space over and over again using different media and sketching techniques. Vary the lighting and the viewpoints to provide further areas of study. Additional qualities to look for in choosing an object include:
• Multisidedness
• Complex lines
• Geometric variations
• Reflectivity
• Transparency
• Irregular surfaces
• Shadows created by shape

BUILDING

Select a building that has a regular geometry, repetitive elements, and noncurvilinear forms.

OBJECT

Pick an object that can sustain your interest for a long period of time. The object you choose should be portable and operable.

SPACE

Find a space to sketch that is open and well defined—that is, the buildings that surround the space clearly define the shape of the space. This could be a large room, a plaza or courtyard, or an alleyway between two buildings.

READ THIS!

Bernard Chaet
The Art of Drawing
Wadsworth Publishing, 1983

Douglas Cooper and Raymond Mall
Drawing and Perceiving
Van Nostrand Reinhold, 2007

Norman Crowe and Paul Laseau
*Visual Notes for Architects
and Designers*
John Wiley & Sons, 2011

Betty Edwards
*Drawing on the Right Side
of the Brain*
TarcherPerigee, 2012

Rendow Yee
Architectural Drawing (Chapter 3)
John Wiley & Sons, 2012

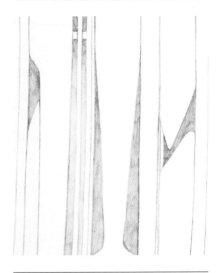

↑ **CLOSE UP**
A close-up view of a penknife (see Assignment, right).

ASSIGNMENT 8 | SKETCHING SMALL OBJECTS

SHADOW AND FORM →

Complete a series of sketches focused on the shape and form of an object (here, a penknife). Changing the density of the stipples reveals form and shadows. In another sketch, use shadows to ground the tool to a surface. Transparency sketches show the interior form and structure.

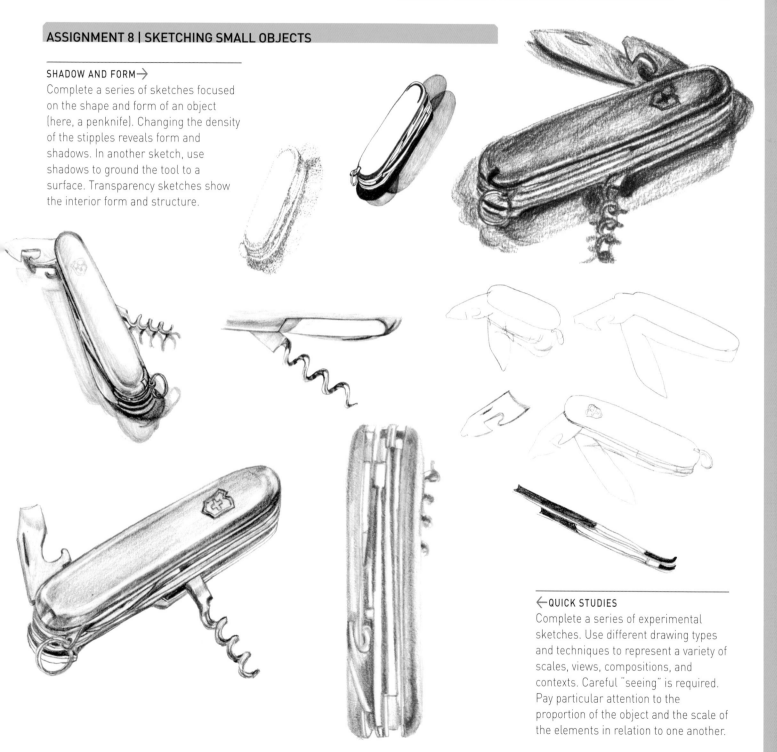

← QUICK STUDIES

Complete a series of experimental sketches. Use different drawing types and techniques to represent a variety of scales, views, compositions, and contexts. Careful "seeing" is required. Pay particular attention to the proportion of the object and the scale of the elements in relation to one another.

UNIT 15

FIGURE DRAWING

Drawing the nude figure is an important way to practice recording proportion and scale, while establishing the relationship of individual parts to the overall whole. Gravity, structure, balance, and form are all discovered when figure drawing.

DRAWING FIGURES

Where and how
- Art museums, schools of art or architecture, and community colleges often host figure drawing sessions.
- Figure drawing does not have to be nude. Ask friends to pose for you, or go to a public place.
- Draw statues in public spaces.

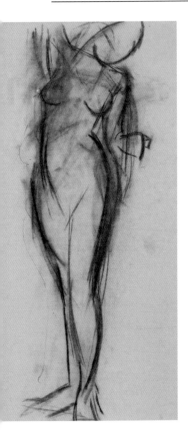

↑ FIGURE AS CONTOUR
This representation of the figure by artist Mary Hughes uses the changing thickness of the line to capture curvatures in the form of the body.

The body does not have sharp edges, yet the contour is delineated with a line.

One technique for drawing the nude figure is to imagine a vertical line—a plumb line—that establishes relationships between distant elements. Imagine a vertical line running from the center of the figure's nose to a point at the base of the body. Where does the line end? Does it align with the heel, toe, or a void space? Use a pencil to mimic the plumb line to establish these vertical and horizontal relationships. Close one eye to limit the three-dimensional clutter. Establish direct relationships between various parts of the figure and the pencil in an effort to minimize the effects of foreshortening or depth. Translate these relationships onto paper. Find the weight of the figure. Let stronger lines emphasize this weight.

As in all observation sketching, draw what you see rather than what you think you see. The figure is very familiar; however, look for the spaces between the parts, as opposed to the parts themselves. See the contour of the form, as opposed to the body part that makes the form. Concentrate on drawing the positive space, the shape that the figure makes, or even the negative space—the spaces in between. When mistakes of proportion or form are made, it is immediately noticeable.

Draw the whole figure on the page. Draw to fill the paper—that is, don't draw too small on the paper. Consider these as working drawings that can be fixed by redrawing over existing lines.

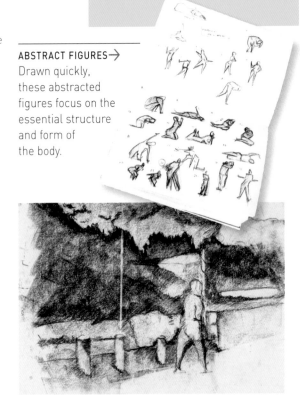

ABSTRACT FIGURES→
Drawn quickly, these abstracted figures focus on the essential structure and form of the body.

↑ IN MOTION
Figures in perspective help to set the scale. In this charcoal drawing, the figure depicts motion and activity.

ASSIGNMENT 9 | IMAGE FOLDER EXERCISE

Find examples of sketches executed by a 19th-century architect (consider Henry Hobson Richardson, Karl Friedrich Schinkel, Louis Sullivan, Frank Furness, Henri Labrouste, Sir John Soane, and Charles Rennie Mackintosh) and a 20th/21st century architect that uses a similar drawing technique. This could be similar drawing media, a similar drawing type, or even a similar viewpoint. Note the relationship between the time period and the representation and techniques. What changes have occurred between 19th-century and contemporary sketches? For each drawing, examine the technique of the drawing, the medium of the drawing, and the size of the drawing (if this is listed). Store the sketches inside your image folder.

←PERSPECTIVE
A low vantage point in both of these perspectives by Studio Gang of the Aqua Tower in Chicago enhances the verticality of the building.

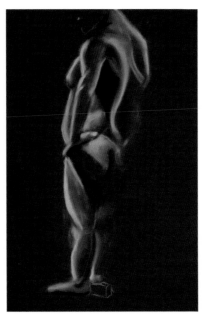

←PAPER OPTIONS
Drawing on colored papers allows you to try a variety of different sketching techniques. White pencil can be used on dark paper. The color of the paper is incorporated into the figure sketch.

In general, the feet and the head are the most difficult elements of the figure to appropriately scale. Practice drawing them so that your future drawings capture the appropriate scale and proportion.

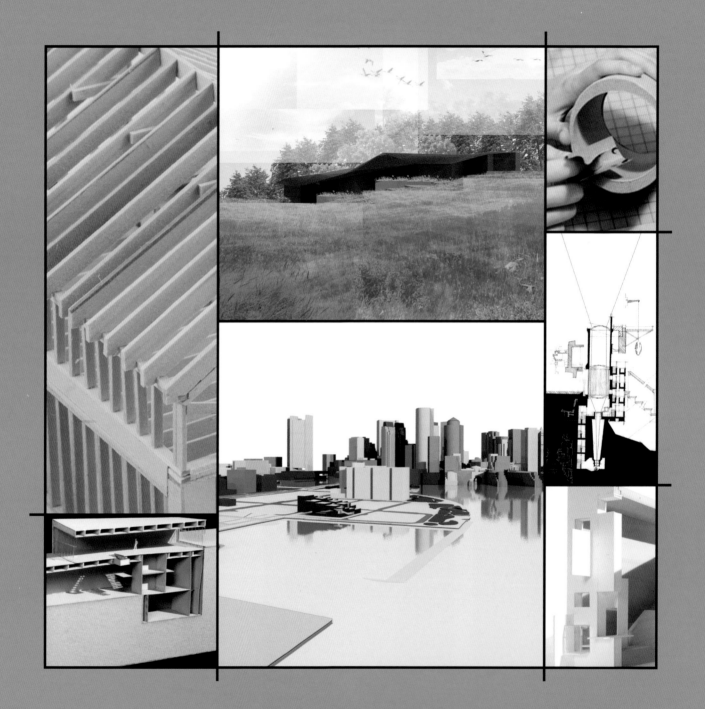

CHAPTER 3

ORTHOGRAPHIC PROJECTION

Plans, sections, and elevations, which are known as orthographic projections, are the fundamental representations used in architecture. They are parallel projections onto a plane and, when grouped together, convey a three-dimensional object as a series of single views on a two-dimensional surface.

Orthographic projections are abstract drawings that do not represent objects as we see them. Because orthographic projections lack the three-dimensional qualities of perception, they have none of the foreshortening or distortion that we see in real life.

The method and construction of orthographic projections can reinforce design ideas. Therefore, it is important to understand the basic structuring devices for creating these types of drawings. Using a variety of orthographic representations for a single object or building allows for the further development of design ideas. For instance, program and circulation can be studied in plan, while stairs, double-height spaces, and windows can be investigated in section.

Learning orthographic projection enables a designer to communicate with a variety of audiences, whether this is a builder, a client, a community, or other architects.

Since it is difficult to convey a project in a single drawing, multiple drawings or orthographic sets are used to present a more complete picture.

This chapter introduces fundamental skills of orthographic projection through the work of Albrecht Dürer. Drawing techniques and line weights are discussed.

PLAN, SECTION, AND ELEVATION

<u>A compilation of two-dimensional
orthographic drawings can describe the
space of a three-dimensional object.
There are three drawing types that make
up the collection of orthographic (90°)
projections: plan, section, and elevation.</u>

To create a plan, section, or elevation, an object's information
is flattened or projected onto a corresponding picture plane.
 Orthographic drawings are cuts through space, whether
horizontal or vertical, and either directly through or just outside
an object. They are not perspectival; it is best to imagine that
you are able to look directly at each component part of the
object, thus eliminating the perspectival aspects of the object.
Anything that is cut is rendered using the darkest line type in
the drawing (the only exception being transparent materials).

PLAN
A plan is a horizontal cut through an object, building, or space,
typically looking down. Imagine the cut as a plane, parallel to
the ground plane, intersecting a building or object.

↓ FLOOR PLAN
The floor plan is a means of conveying
an architectural space. It is a horizontal
cut through a building, typically at 4 ft
(1.2 m) above floor level. The cut-height
convention is set to include doors and
windows, while elements such as
counters and half walls that are not
cut are shown from above for spatial
clarity. Scales include ⅛, ³⁄₁₆, ¼,
and ⅜ in.

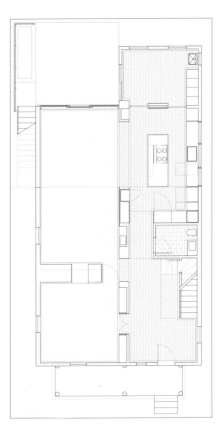

← ROOF PLAN
A roof plan is a horizontal
cut above a building
mass that looks directly
down onto the roof.
Shadows are often
included on a roof plan to
demonstrate the height
and mass of the building
relative to the space
around it. Scale: ¹⁄₁₆ in.
or smaller.

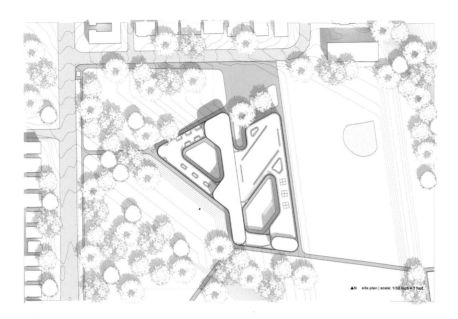

↑ SITE PLAN

A site plan typically includes a roof plan but also incorporates much of the surrounding context. Trees, landscape elements, and topographic lines are often included. Sometimes a site plan includes the first-floor plan to demonstrate the relationship between the interior and exterior spaces. The site plan is drawn at a larger scale than the architectural drawings so that more information can fit on a page. Scales can include an architectural scale of 1/64 in., or larger, or engineering scales of 1:250 or 1:500.

↑ FIGURE-GROUND PLAN

A figure-ground plan usually depicts an entire neighborhood, district, or city. Architects and urban designers use it to interrogate building patterns. It is an abstraction of building and space. Typically, buildings are rendered as black poché (the solid cut elements that are rendered in black) and nonbuildings or spaces are white. These maps are useful for analytic and pattern studies.

← REFLECTED CEILING PLAN

A reflected ceiling plan (RCP) is a horizontal cut that depicts the ceiling plane in a space as if it could be seen from above. This is typically used to indicate ceiling grids and lighting locations, or the orientation of material on the ceiling surface. This drawing depicts the RCP for the floor plan to the left.

READ THIS!

Paul Lewis, Marc Tsurumaki, David J. Lewis
Manual of Section
Princeton Architectural Press, 2016

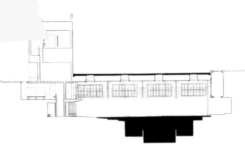

BUILDING SECTION ←→

A building section depicts interior spaces but can also extend outside the building to include the contextual outlines of adjacent buildings. Scales: ⅛, ³⁄₁₆, ½, ⅜ in. Showing people (or entourage) in the section can clarify the scale of the space.

↑ SECTION

A section is a vertical cut through an object, building, or space. Sections describe vertical relationships and help define the spatial characteristic of a building. A scaled figure shown in a section clarifies the height relationships within the spaces. Imagine the cut as a plane, perpendicular to the ground plane, intersecting a building or object.

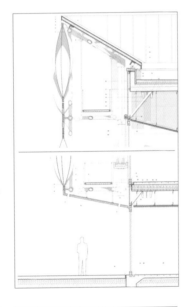

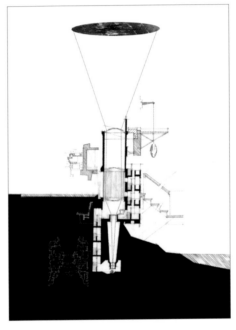

← POCHÉ

This section depicts elements that are carved into the mass of the earth. Poché (cut elements that are rendered in black) reinforces the heaviness of the cut.

STREET SECTION ↓

A street section depicts the spatial relationship between the building being cut and the space of the street and neighboring buildings. Scale: ¹⁄₁₆ in. or larger.

WALL SECTION ↑

A wall section of a building depicts detailed construction systems and material choices. Scales: ¼, ⅜, ¾ in., or as large as can fit on the page.

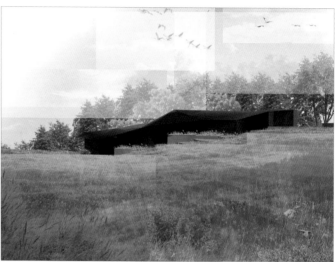

ELEVATION

An elevation is a vertical section that is cut outside of, and looking toward, an object. The cut is a plane, perpendicular to the ground, that does not intersect with the building or object. The ground is typically the only element that is rendered as a cut line. All the lines relating to the building are lighter and rendered as elevation lines. These lines vary according to their distance from the projected picture plane. Elements farther away are lighter than those that are closer. Scales: ⅟₁₆, ⅛, ¼ in.

CONTINUITY OF SECTION CUT

An architectural section does not distinguish between materials, and therefore all elements cut in section are continuous with one another, with one exception: when cutting through glass or some other transparent or translucent material. Glass is never rendered as a dark, cut element. If it were, it would appear as a solid wall—contradicting its transparent nature. Instead, it is rendered as if it were in elevation, even when it is cut through.

Construction sections differ from architectural sections in that they depict the building systems employed to construct the wall, ceiling, and floor, along with material information for the contractor.

PHOTOGRAPHIC AID ↑

This collage combines site photographs with a building elevation to reinforce how the building parallels the sloping site.

↓ BUILDING ELEVATION

A building elevation gives an impression of how one facade of the building will look from the exterior. This elevation explores the relationship between a new building and existing city skyline.

There are a number of techniques for constructing orthographic projections and for distinguishing cut elements in plans and sections from noncut elements. They include line weights, poché, and rendering techniques. Line weights are used to distinguish between lines that are cut and those that are not.

Poché comes from the French word *pocher*, meaning "to make a rough sketch." It is typically understood to be the cut elements in a building rendered as a solid black mass. This method, when constructing orthographic drawings by hand, is much more time-consuming than using proper line weights.

Rendering of interior spaces is another way to distinguish between the white space of the cut area.

←COLUMN CUTS

Cutting a section through a column (middle image) deceptively depicts two separate spaces with a wall between. Always cut a section in front of the column (never through it), and render the column using elevation line weights.

CREATING A SECTION

Choosing the method for depicting a section can reiterate design intentions and design legibility. Section lines should always be drawn using the darkest line weights.

GROUND AS PART OF THE SECTION

Extend the ground line to the edges of the paper to bring the white of the page into the section.

SECTION BASE

The white of the page is separated from the white of the section cut by creating a section box. The dimensions of the white box should reinforce the design intent—should it be deep or shallow? The box completes the section graphically so that it has an object-like gestalt.

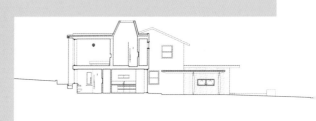

POCHÉ SECTION

The section cut is "filled" with black. Use proper line weights for the other noncut elements (objects in elevation) in the drawing to convey depth.

SKY SECTION

This section inverts the poché drawing by rendering the sky as a tone or color. The sky recesses and "punches" the drawing forward. Consider this as a method for filling the section cut with white poché.

LINE TYPES

Employing different line types makes a drawing clearer. Lines that represent cut objects are the darkest, while lines for objects that are farther away from the cut plane are lighter. In plans, elements that are above the cut plane and not seen in the projected drawing should be drawn with dashed elevation lines.

Cut lines: Section lines in plan and section—use a B or softer lead; these are the darkest elements in an orthographic drawing.

Profile lines: Define the edges between an object or plane and open space—use HB leads.

Elevation lines: Define edges that are farther away from the cut line in both plan and section—use H or 2H leads. These lines can also vary in weight, depending on their distance from the cut plane.

Construction lines: Help you organize and construct the drawing—use 4H or 6H. These lines should be visible from 12 in. (30 cm) away but disappear when standing 3 ft (0.9 m) or farther from the drawing.

Hidden lines: Dashed lines that depict objects or planes that are not technically visible in the drawing—use H or 2H. The spacing and the length of the dashes should be consistent. In plans, hidden lines are used to show objects above the cut line. This is extremely helpful when roof canopies, ceiling changes, or open spaces to upper floors must be understood relative to the plan below them.

Start each drawing with three line weights: HB for cuts, H for elevation, and 4H for construction lines. As your drawing skills improve, increase the number of line weights, including distinguishing between different elevation lines based on distance.

Scale considerations: The scale of the drawing changes the choice of lead weights.

Each drawing requires a decision about how best to convey the information at different scales.

LINE CLARITY

- Try to achieve sharp, dark lines, NOT thick, dark lines. Softer leads are harder to keep consistent across the page.
- Architectural space takes priority when making decisions about line weight and type.

TYPICAL SCALES

When representing buildings, architects use scales to reduce the size of the building so that it fits conveniently on paper.

Typical architectural scales include: ¹⁄₁₆ in. = 1 ft, ⅛ in. = 1 ft, and ¼ in. = 1 ft.

When sections are drawn larger than the plans, they might be drawn in the scale range of: ¼ in. = 1 ft to ¾ in. = 1 ft.

The larger increments found on the architectural scale are used for detail drawings: 1½ in. = 1 ft and 3 in. = 1 ft.

The engineering scale is used for site plans, roof plans, and overall building massing. Typical scales used are: 1 in. = 50 ft, 1 in. = 100 ft, and 1 in. = 200 ft.

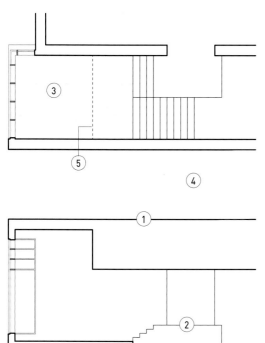

← LINE TYPES
1. Cut lines
2. Profile lines
3. Elevation lines
4. Construction lines
5. Hidden lines

ASSIGNMENT 10 | CHAIR SECTION

BRIEF

Find an interesting chair. Create a series of orthographic drawings that include two to three plans (cut at different heights), two sections (cut in the middle and then off-center), and at least one elevation. Compose these drawings onto a single sheet of paper.

TO BEGIN

- Draft plan—freehand. Do not use a straight edge.
- Draft section—use construction lines to align the proportions of the plan to those of the section.
- Draft elevation—use construction lines to align the proportions of the section to those of the elevation.

IN GENERAL

- Cut several plans of the chair at varying heights. Make horizontal "slices" at different heights: at 1 ft, 2 ft, and 3 ft (0.3, 0.6, and 0.9 m).
- Align the plans vertically with the section or elevation using construction lines to maintain similar proportions across the page. Use light construction lines (4H) to draw similar elements in each plan. Construction lines help maintain consistency between drawings. Plans, sections, and elevations have proportional relationships to one another, and information can be transferred between the drawings without the need to remeasure.
- Construct drawings on a large sheet of paper, measuring 18 x 24 in. (46 x 60 cm), and use the entire page.

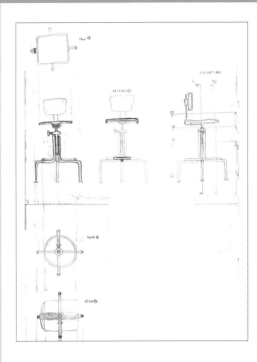

LINE LEGIBILITY

- When creating orthographic drawings, review them during the process to verify the legibility of the lines.
- If the orthographic drawings are for a studio review or public meeting, then make sure the lines are visible from 3–4 ft (0.9–1.2 m) away.

←COMPOSITIONAL ALIGNMENTS

By aligning plans, sections, and elevations on a single sheet of paper, dimensional information can be transferred without the need for remeasuring.

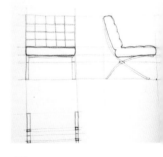

1 Use a 4H lead to create a series of construction lines to establish the boundaries of the chair. Determine the chair's width proportion to its overall height. Continue to establish these proportions for all of the required orthographic projections. Complete this step before adding detail and line weights.

2 Use an H lead to begin to darken the elements that are seen in elevation. The construction lines remain the lightest line weight on the page and should, at this point, begin to fade naturally as other, darker lines appear to become more dominant.

3 Use an HB lead to begin to darken in the elements that are cut in section. Section cuts are continuous and shall not be left open-ended. Make crisp, dark lines with a sharp lead. The light construction lines should remain on the drawing.

INFLUENCE OF COMPUTERS ON ORTHOGRAPHIC DRAWINGS

Orthographic representations can be achieved in both manual and digital formats using the same method of construction. However, it is more typical for manual drawings to be constructed in an additive format—that is, one where the drawing is assembled from the parts and pieces of the design ideas—whereas in digital formats, the orthographic projections are deconstructed from a single three-dimensional digital model. Clarity of line weight and line types are built into the decision-making process in the additive methodology, while the clarity of line weights is often an additional process that needs to be enacted upon the drawings after they are sliced from the three-dimensional model.

No matter which methodology you prefer, both skills are essential in crafting architectural spaces.

Hand drawing provides an immediate cognitive and physical connection between your thinking and the drawing implement. There is an immediate result between a line being drawn on paper to the scale of the human hand.

In digital formats, information is translated through a mouse, keypad, or other implement to the flat image on the screen. There is a second interface between the brain and the graphic (in this case, the screen). The limitation of using a screen is that it requires constant zooming in and out of an image without this having a resulting impact on the object itself. Although the construction of objects on a computer is considered one to one, the screen is the modulating factor that limits the size of the view of the object.

← ↓ DIGITAL CAPABILITIES
Sophisticated drawings can be constructed using a number of digital programs. Which program to learn is often a product of your work or academic environment. The graphic rules that apply to manual drafting also apply to digital drafting.

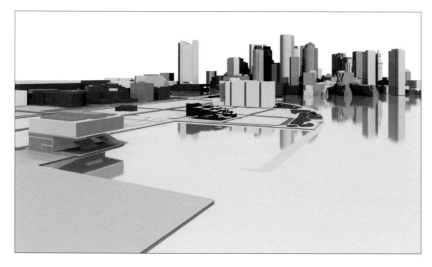

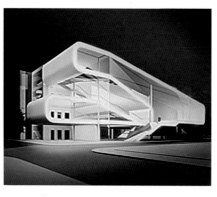

UNIT 17

COMPOSITE REPRESENTATION

Since dimensional information can be translated between drawings that are constructed at the same scale, how drawings are arranged on a page can impact the legible hierarchy of the project (as seen through the drawings).

CONSTRUCTION

Sections and elevations drawn adjacent to one another allow for the sharing of height information. If stacked vertically, the location information (along the x-axis) can be shared. Plan information can translate to sections using construction lines.

PAGE COMPOSITION→

The arrangement of similarly scaled drawings on a page can reinforce design intentions. The composition, or layout, of the drawings helps with spatial understanding. By placing sections below plans, three-dimensional information can be extracted more easily—that is, the height, width, and depth of spaces can be understood more clearly when orthographic drawings align. In general, every time drawings are placed on a page, the composition of those drawings should be a highly considered exercise. White space on a page is just as important as the drawings.

CONSIDERATIONS

Decisions that need to be considered before construction of a composite drawing:
- Size of the page
- Page orientation
- Drawing size—is there a hierarchy of images that you want to present? Is one type of drawing better to present at a larger scale than others?

→ORTHOGRAPHIC ALIGNMENTS

This room for repose section aligned below the plan reveals a massive ceiling thickness that is not apparent in the plan, as well as the connection to the ground. The left section cuts through the central bay, revealing the thinness of the roof material in comparison to the thickness of the ceiling mass seen beyond.

↓ALIGNED SECTIONS

Four sections align with the central plan. Note the variations in thick and thin materials described in both plan and section.

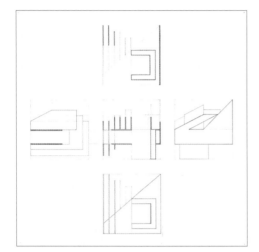

SHEET LAYOUT

When constructing a page layout with multiple drawings, consider the amount of white space on the page. Using different-scaled images allows for a hierarchy of content. Repeated elements, such as similarly sized boxes, provide organization and flexibility in a layout.

COMPETITION BOARD→

When using hierarchy to arrange the images on the board, the perspective located near the center of the layout is the most important. Supporting orthographic drawings, diagrams, perspective images, and text wrap around this central image. Text provides a scale variant on the page layout and should be considered in the same way as all the other images.

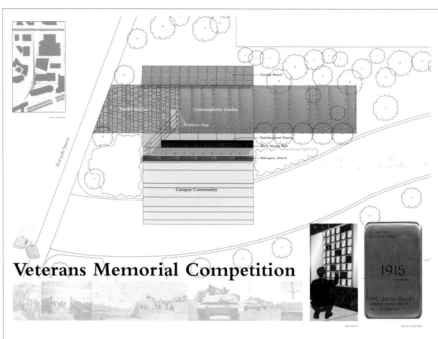

Veterans Memorial Competition

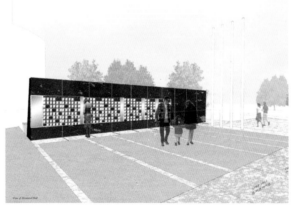

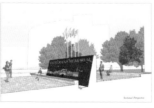

UNIT 18

MODELING TECHNIQUES

Models are abstract representations of ideas. They are used in the iterative process of design to define and refine ideas. Models are used to depict form, space, structure, context, and ideas.

Models can be either generative—used during the design process to explore ideas—or final representations that are regarded as the final product. Generative models can be made quickly with low-quality materials, whereas final models are typically highly crafted using high-quality materials. Presentation models are considered for public audiences; generative models are used for internal discussions about the process of design. Process models include study and massing models as a means to understand, explore, and refine the realization of design ideas.

PROCESS MODELS

A study model is a representational tool that is used to study architectural ideas and concepts. These models are constantly altered, modified, or reconfigured throughout the design process. Study models provide opportunities to review optional solutions and test ideas before making final decisions. Keep process models as a way to visually review the evolution of a design over time.

MODELING SAFETY
- When using sharp instruments, always cut away from yourself.
- When cutting materials with any knife, score the material along a guideline first, then make several passes with the knife.
- Replace blades often.
- Never use nonmetal materials as a cutting guide.

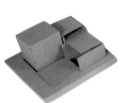 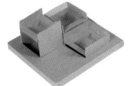 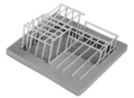

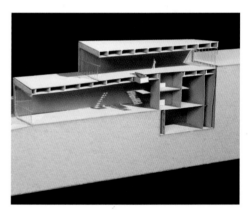

↑ **MODEL SERIES**
Diagrammatic study models in series (multiple models at the same scale) convey a variety of ideas about a project. These models are easy to construct and help you to visualize ideas in a three-dimensional way. This series of small-scale studies emphasizes volume, skin, overlapping continuous planes, and structure.

↑ **SCALE**
Models are scaled so that the most information can be conveyed in the smallest model—that is, the scale of the model should reflect the amount of information that needs to be included. For instance, massing models are typically made on a large scale (the buildings are very small), as they are generally used to study form and neighborhood patterns.

↑ **INTERIOR SPACE**
For study models on a larger scale, show both the interior and exterior components of the design. If the model is intended to show only exterior elements, then the model can be small. This final presentation section model for a gallery depicts both the interior and exterior design components.

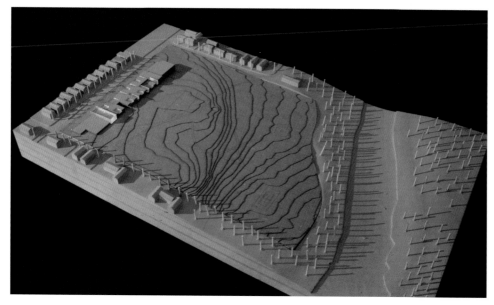

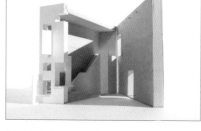

↑ MODEL CONSTRUCTION
Note the construction techniques used in this model for a new window design, including the peg connectors and overlapping joint between the ceiling and exterior wall.

↑ SITE MODELS
Made of high-quality materials, this site model depicts the relationship between a new K-8 school and the adjacent public park.

MATERIAL THICKNESS
Every material has a thickness, which needs to be considered in the process of model building. Carefully consider how to join two materials together, whether these are similar materials or not. For example, consider the edge joint between two planar materials. From which direction will the joint be revealed? Is it from the front or the side?

Material dimensions affect the assembly and should be considered when cutting complementary elements of the model. Heed the carpenter's motto: measure twice and cut once. Different materials may require different joint conditions. Foam board can be mitered to meet at the corner; each piece is full length. Chipboard and basswood are typically butt-joined and require an understanding of the joint location for the accurate measuring of materials.

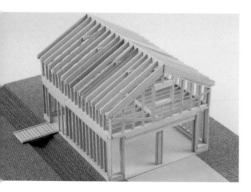

↑ GARAGE FRAMING MODEL
The tectonic logic of the garage is apparent with this basswood model that accurately depicts the framing members.

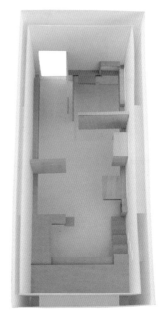

↑ MATERIAL DIFFERENCES
Wood contrasts with white walls.

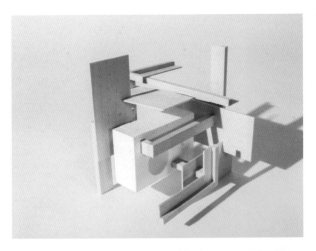

←ASPECTS OF STUDY
This model explores the weight of differing materials in a dynamic spatial interpretation of an El Lissitzky painting.

GLUING

White glue, such as wood or craft glue (PVA), is a common joining material. Use a minimal amount of glue so that cleanup at the glue joint and drying times are reduced. Use a small wooden dowel to apply glue to an edge surface. Drag the applicator across the edge of the material in a steady manner. Do not apply too much glue along the edge. Hold the glued materials together to allow the joint to dry. Use pressure to seal the joint. Temporary fasteners or drafting tape can be used to hold the elements in place, especially when gluing complicated structures.

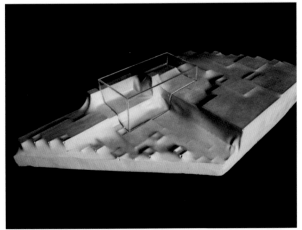

←UNIFYING
This vacuum-formed gallery unites the man-made and natural landscape.

SANDING

When working with wood, it is critical to use a sanding block to clean up joints and material surfaces. A sanding block is a rectangular piece of wood wrapped in sandpaper. It keeps edges from being rounded. Sand the wood in the direction of the grain. By doing so, the joints are made seamless. Do not sand to shorten a piece of material that is too long. This only rounds the edges, reducing the crisp edge of the cut. If a piece of material is too short, then recut the piece and sand only to clean the joint.

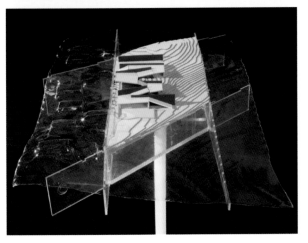

←ELEVATION
The vacuum-formed, transparent topographic base is integrated with a stand to elevate it 3 ft (0.9 m) off the ground.

DIGITAL MODELING MACHINES

- Laser cutter
- 3-D printer (plastic, starch)
- 3-D laser scanning station
- CNC mills
- 7-axis robot
- Waterjet
- Foam cutter

MODEL BASES

The base of a model establishes the site and has the potential to reinforce design ideas. Think about whether the base should be minimized, accentuated, or exaggerated. It is often easier to construct the base first, but it may also be built in conjunction with the entire model.

MODEL ENTOURAGE

Entourage includes trees, bushes, people, and cars. It can be a challenging component of a model, since it oscillates between reality and representation. Trees can be represented abstractly in a number of different ways: with wooden dowels, twisted wire, dried gypsophila (baby's breath), or wildflowers. Determine ahead of time whether or not the landscape is central to the design idea or peripheral. The level of realism in the overall model determines the level of realism for landscape entourage.

Entourage provides supporting information and should therefore maintain the model's color palette, scale, and intensity. If a model is made completely out of basswood and then complemented with green trees, those green trees tend to dominate the model.

MODELING TIPS

- Basswood can be curved by wetting and bending it around a rounded object. Use rubber bands to hold the wood in place while it dries. Basswood can be bent both with and against the grain. The dry wood should be longer than needed. If possible, cut it to size after bending.
- Wax paper can be used as a gluing surface for complex structural members. The transparency of the paper allows a drawing to be placed underneath as a guide. Glue does not adhere to the paper, making it easy to work on.

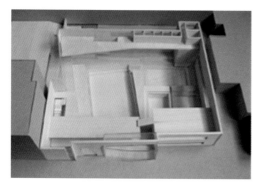

←DESIGN ACCESS
Models need to be visually accessible. This swimming pool interior is visible when the roof is removed.

↑IDENTIFYING THE SITE
Chris Cornelius of studio:indigenous identifies the site in this model, Bending Out of Course, as planar separated from a mass below.

UNIT 19

CONSTRUCTION: DÜRER'S ALPHABET

Albrecht Dürer was born in Nuremberg, Germany, in 1471 and apprenticed with his father, a goldsmith. At 15, he also apprenticed as a painter, becoming an enthusiastic observer of the landscape. Dürer developed an interest in man-made things and the natural environment, cultivating both in his art. He was a highly respected painter, engraver, and woodcut designer during the Renaissance.

↑ DÜRER LETTER
Dürer's alphabet uses a simple geometric proportioning system for all letter constructions, eliminating the need to measure. All construction lines can be determined through geometric means.

Dürer saw art as the combination of talent, intellect, and mathematics under a humanistic approach. He understood the need for disseminating his work using the printing press to aid him. To this end, he wrote and published a treatise on mathematics titled *Underweysung der Messung* (Treatise on Measurement). This was only the second work on any type of mathematics to be published in German.

The treatise gives instructions to the reader on how to "construct" (i.e., draw with mathematical precision) lines, curves, polygons, and solids. In addition to abstract geometry lessons, Dürer also provides practical examples of the uses of the theorems, such as drawing in perspective and shading solids. He shows how the design of typefaces should be mathematically rigorous and based on "scientific" rules of proportion and geometric construction.

The Roman letter was based on geometric principles and rules. It is this clarity and rationale that defined it as an elegant type. Dürer used geometric principles to construct the capitals of a Roman alphabet, providing detailed instructions for each letter and including images of both the geometric processes and finished examples.

In addition, Dürer constructed a second alphabet, the Fraktur alphabet, using geometric shapes. The Fraktur alphabet was a typeface used in German-language publishing. The letters are not in alphabetical order because Dürer built his alphabet incrementally. Essentially, all the letters are variations of the letter "I" and so he began with this letter, adding tails or other features as necessary to create the rest of the alphabet.

Upon his death in 1528, Dürer left a legacy of more than 70 paintings; 100 engravings; 250 woodcuts; 1,000 drawings; and three printed books on geometry, fortification, and the theory of human proportions.

ARTIST AT WORK →
Dürer understood the relationship between perspective construction and space. He conveyed that understanding in many of his drawings and etchings.

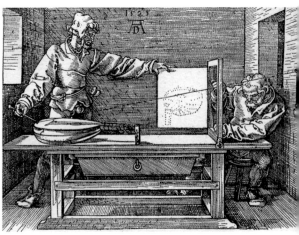

ASSIGNMENT 11 | MAKING ORTHOGRAPHIC DRAWINGS

BRIEF

Construct a full set of orthographic drawings of one of the letters from Albrecht Dürer's geometric Roman alphabet. Each Dürer letter is based on a specific geometry and proportion. It is imperative to communicate that precision and proportion in the construction of the letter. Read the instructions carefully, rereading them as many times as necessary, because the language Dürer used is antiquated. Reconstruct the letter following his instructions; measuring is not required. Use the proportioning system to construct the drawings. Construct the orthographic drawing set using a parallel motion, triangles, compasses, and a lead holder. Construct the elevation, following Dürer's instructions, inside a 4-in. (10-cm) square. Then use this drawing to construct a full set of orthographic drawings (plans, sections, and elevations). Imagine the letter as a 4-in. (10-cm) extruded volume, perpendicular to the surface of the elevation drawing. In other words, if the original elevation is considered in the x and y direction, the extrusion should be considered in the z direction.

COMPOSITION

Compose the set of drawings onto a sheet of paper, measuring 24 x 24 in. (61 x 61 cm). Relate the plans, sections, and elevations in this composition using construction lines. These lines should be clear and legible on the final drawing within 12 in. (30.5 cm) of the surface and from a distance of 3 ft (1 m) they should disappear altogether. Use a 4H lead for the construction lines and an HB lead for cut lines. Compositionally, think of the elevations as an unfolded box. Use tracing paper to construct a first draft of the orthographic drawings. Construct the final set of drawings on vellum.

1 To divide a space evenly without math, first draw two lines that align with the space to be divided. Take any scale measurement that is divisible by nine. Lay the zero on the left line and the nine on the right. The ruler will not be perpendicular to those lines. Mark off the corresponding increments of nine to set up evenly spaced increments.

2 Lift your triangle after making vertical lines to avoid smudges.

3 Match the line weights in one elevation to the line weights for all the elevations on the same page. Keep a consistent line quality between drawings.

← COMPOSITIONAL STRATEGIES
The full set of orthographic drawings should include one front elevation (the original letter), two sections, and four elevation views, including two side elevations, one top, and one bottom view. Place each drawing in a 4-in. (10-cm) square.

ASSIGNMENT 12 | MAKING A MODEL

BRIEF
Construct a three-dimensional model of the Dürer letter using chipboard material. Make a study model first for practice and then a final finished model. The practice model allows for the testing of construction techniques and will reveal problem areas. Evaluate the final model on its overall craft and accuracy.

SCALE
Full scale—the model of each letter is to be considered as if it were inside a 4-in. (10-cm) cube.

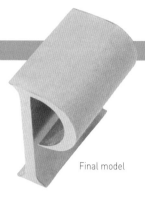
Final model

1 Use your straight edge to cut material. Score first, then make a series of cuts.

2 Curved elements are more difficult to cut. Take it slowly, but try to maintain a continuous cut.

3 Construction sequence is important. Recognize which pieces of material will be exposed (those facing front). This will affect the length of each piece of material.

4 Use a piece of chipboard to apply glue. Do not use a lot of glue to secure two pieces of chipboard. Too much glue can introduce moisture to the material and cause it to warp.

5 Be conscious of the natural joints in your material. Make them meaningful to the project. Some materials come in limited sizes, so thinking about joint connections can be an important aspect to building the model.

6 Lightly sand edges that may have extra glue or were roughly cut. Sand with the grain of the material if it is visible.

WHAT YOU NEED

- $\frac{1}{32}$ in. (0.5 mm) and/or $\frac{1}{16}$ in. (1 mm) chipboard for model
- Cutting mat
- Knife and blades
- Metal straight edge
- Orthographic drawings of letter

TIP
Use internal blocking for additional support. Small triangles also help to make planes perpendicular to one another.

ASSIGNMENT 13 | CONCEPTUALIZING AN IDEA

BRIEF

Use the proportioning system established by the Dürer letter elevations to design a device to hold eight sketching pencils. Consider whether to store them individually or as a group. Work within the 4-in. (10-cm) volume, and only use straight lines. Reconstruct the lines of the letter onto a 4-in. (10-cm) volume. The pencils do not have to be wholly contained within the volume. Consider the design from all six sides.

Function: Store eight pencils
Intention: How do I contain the pencils?
Architecture: Aesthetics and compositions

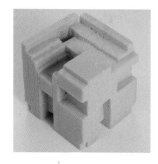

1 Establish the parameters of the "site." For this assignment, it is the 4-in. (10-cm) cube. Use it as a way to think spatially about a concept. Consider the weight of the pencils and how that will affect what you cut.

2 Apply the Dürer proportioning system to all sides of the cube. This provides the parameters in which you can work. Think about carving into the volume as part of the design process. Consider the length of the pencil and how that will affect what you cut.

3 Begin subtracting portions of the foam. The depth of the cut is based on your notion of how the pencils will be held up. The cuts, if deep enough, will begin to affect the other faces of the volume. Consider the interface with the hand in the design.

4 Consider all six sides of the model. Any surface could be on top. This aspect of the assignment creates the challenge. Your site is complex, even though as a volume it appears simple.

CONCEPT MODELS FOR A RECYCLING CENTER

This series of nine study models is part of a 180-strong photographic sequence that explores innovative and whimsical forms for a recycling center. The thickness and purposefully arbitrary nature of the forms emulate a crumpled piece of paper about to begin the recycling journey.

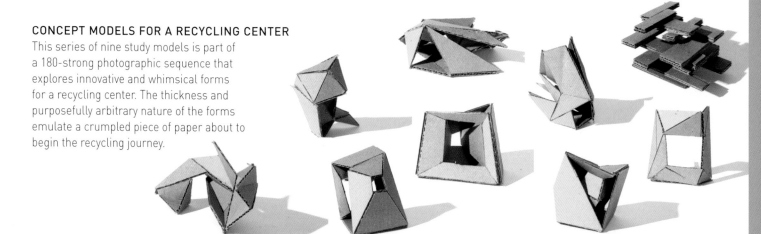

CHAPTER 4

OBJECTIVE ABSTRACTION: AXONOMETRIC

This chapter introduces you to axonometric drawings and the work of 20th-century architect El Lissitzky. If you have ever doodled a cube, then you have most likely done an axonometric drawing. They are representations of objects that are commonly found in our daily lives—for example, furniture-assembly directions.

Axonometric drawing is an objective three-dimensional representation that combines plan and elevation information in one abstract drawing. It is objective in that it cannot ever be perceived in real space. The axon is measured along three axes in three directions, and its ease of construction is due to the fact that parallel elements remain parallel in the representation. This differs greatly from the construction of a perspective drawing, where receding lines converge in space.

The three-dimensional axonometric can be derived from a two-dimensional plan or elevation. The construction retains true scale measurements throughout the drawing. The axonometric provides a relationship between multiple surfaces simultaneously. It can be used to study form and space, as well as the interplay between vertical and horizontal elements. The axonometric is used to study spatial strategies through additive and subtractive space.

This tradition was pioneered by early-20th-century artists such as El Lissitzky and Theo van Doesburg, as well as other artists and writers. Peter Eisenman, a member of the New York Five who were practicing in the 1970s, crafted much of his early residential work using axonometric drawings. Design firms such as Selgas Cano and is-office continue to draw in this abstract manner as a reflection of their design intentions.

UNIT 20

INTRODUCTION TO AXONOMETRIC

Axonometric projections can be categorized as isometric, diametric, trimetric, or oblique projections (including elevation and plan oblique).

The most straightforward axonometric to construct is the plan oblique (which is referred to as axonometric). Its construction is derived directly from a two-dimensional drawing, such as the plan, and can be measured and scaled at any point in the drawing. The plan oblique is derived from a rotated plan. The plan can be rotated along any angle, although 30-, 60-, and 45-degree angles are often used. Each angle provides a slightly different emphasis on the object and thus should be selected with care. A 30/60 rotation emphasizes the left surface, the 60/30 emphasizes the right surface, and the 45/45 provides equal emphasis on both surfaces.

To enhance the reading of depth in an axonometric, distinguish between spatial edges using line weight adjustments. A spatial edge is the edge where an object meets open space beyond. This profile line weight is darker than the elevation line.

The basic construction of the axonometric box can be thought of as an extrusion from the plan. The extruded form provides a framework for you to draw within. From the plan, true measurements along the vertical axis can be made. All lines parallel in the plan can be established with parallel lines in axonometric. Elevation and section information can be transferred onto the axonometric through measuring. Any circle that is drawn in plan remains a circle. However, circles in the elevation plane become ellipses in axonometric.

AXON ADVANTAGES

- Easily measure along any axis
- Scalable
- Understanding volumetric relationships
- Nonparallel lines can be located by plotting the endpoints of the line and then connecting.

TYPES OF AXONOMETRIC →
Various axonometric drawings can be constructed from the same drawing with emphasis on different parts.

Isometric

Plan oblique

READ THIS!
Jeffery Balmer & Michael T. Swisher
Diagramming the Big Idea
Routledge (reprinted 2012)

Peter Eisenman
*Giuseppe Terragni:
Transformations,
Decompositions, Critiques*
Monacelli Press, Inc.,
New York, 2003

Edward Ford
The Details of Modern Architecture
Volumes 1 and 2
MIT, Cambridge, MA, 1996

CONSTRUCTING A PLAN OBLIQUE

1 Rotate your plan to an angle that highlights components of the design. Begin construction by extruding the corners of the box using a 4H lead. Measure heights using the same scale as the plan.

2 Continue using construction lines, but start to add detail like doors and windows. Take vertical measurements to determine the height of the window off the ground.

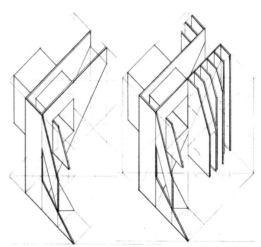

3 Add more details, from front to back or left to right.

4 Using HB lead, darken those components of the construction lines that are visible as elevation lines. You can leave the lightly drawn construction lines on the drawing.

IS-OFFICE

is-office (founded by Kyle Reynolds and Jeff Mikolajewski) is a collaborative design and research firm whose interests lie not only in the resultant artifact but perhaps, more importantly, in the nature of that inquiry and the process by which it is explored. Their work, both speculative and built, is grounded in a methodology that prioritizes a rigorous graphic process with an intellectual context. Building upon a rich history of drawing and making, is-office utilizes the axonometric drawing type to explore and to reveal.

VANTAGE POINT

Crowns, a project that interrogates Chicago's towers, uses axonometric drawing because of its objective vantage point (as opposed to perspective) and its ability to show the fifth facade of the building: the top.

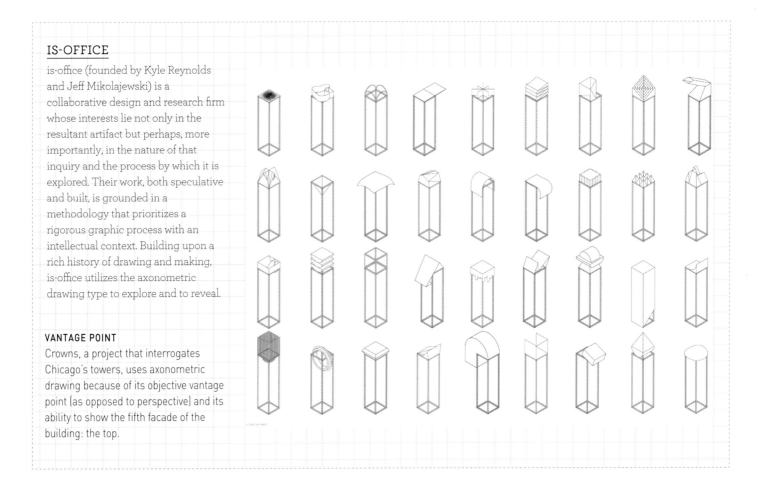

AXON VARIATIONS

The isometric is a type of axonometric that provides a lower angle view than a plan oblique. Equal emphasis is given to the three major planes. The isometric does not allow for construction to be extruded directly from the existing plan but requires the reconstruction of the plan, with its front corner being drawn at 120 degrees instead of 90 degrees. The isometric is typically drawn with vertical information true to scale. The measurements are transferred along the receding 30-degree lines.

The diametric, another axonometric projection, has two axes that are equally foreshortened, while the third appears longer or shorter than the others.

Variations on any of the axonometric types include the Choisy axon, exploded axon, cutaway axon, transparent-view axon, and sequence axon. The Choisy axonometric (also known as the worm's-eye view) emphasizes a view from below, typically of a building's ceiling and its adjacent spaces. The exploded axon pulls the object apart into smaller elements while maintaining a sense of the whole. The location of the exploded elements is typically maintained relative to the original mass with dashed lines.

QUICK DIGITAL MODELING

A three-dimensional modeling program such as SketchUp, which is commonplace in architecture studios and offices, provides quick and easy ways to model buildings and spaces and can provide base drawings for hand-drawn overlays. The software is able to rotate a model so that it can be seen from any viewpoint. SketchUp is a good tool for transforming two-dimensional work into three-dimensional study models. The program can easily extrude objects and cast simple shadows.

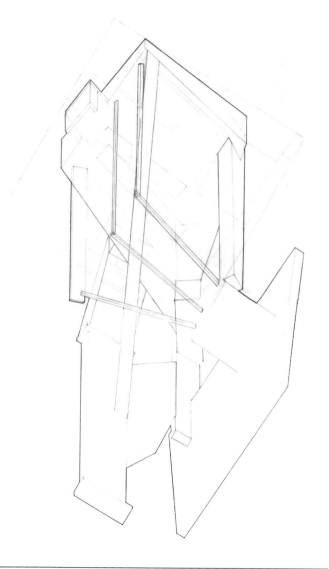

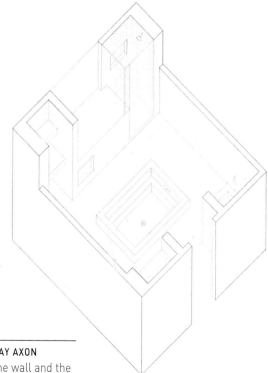

↑ CUTAWAY AXON
Parts of the wall and the entire ceiling in this cutaway axon are removed to reveal the interior spaces.

↑ TRANSPARENT AXON
The transparent axon depicts overlapping spaces as see-through to allow the interior to be revealed. It is similar to the cutaway axonometric but shows the removed part as a transparent element. The darkest line, a profile line, indicates the edge between the object and open space.

UNIT 21

SPATIAL OVERLAP AND COMPLEX SPACES

Axonometrics provide a drawing tool to help develop and understand clear, well-defined, and yet complex three-dimensional spaces in architectural design.

By simultaneously representing plan and section information, the multiplicity of volumes of form and volumes of space in a design are understood in a three-dimensional manner. Axons can depict form or space. The reciprocal relationship between container and space can be made apparent with this type of drawing.

SPATIAL OVERLAP

In this series of spatial study models, a small library and reading room are abstracted into volumes. Excavation (top): the volume of the sunken reading room is carved underground to minimize distractions and control light. Reflective space (center): public spaces and book storage are contained in a volume on the second floor, distinct and discrete from the reading room and other portions of the library. Circulation elements (bottom): elements such as stair towers are housed in this volume, which completes the upper courtyard and provides access in its stair tower on the ground level.

↓ SPATIAL DIAGRAMS

Axonometric diagrams show the way in which water interacts with this chapel. The play of form, line weights, and image opacity describes the movement of water through each state.

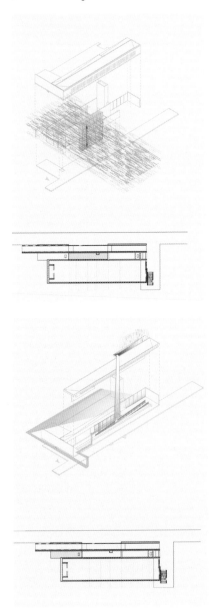

CASE STUDY 3 | EXPLORATION OF PROPERTIES AND PROCESSES

DESIGNER: Martha Foss

Each of these small-scale designs is an exploration of material properties and fabrication processes. They are translations of flat materials into three-dimensional forms that hold space. Added fasteners, such as glue or screws, are limited, forcing the nature of the material itself to make any connections and satisfy the function of the piece. Each design is created through a sculpting of space with a two-dimensional material.

The design process simultaneously involves drawing, experiments with the material itself to discover its limitations and advantages, and full-scale models to test and further the drawn forms. Process drawings are presented alongside the final product as a way to demonstrate the entire process of thinking and making, from idea, to form, to product.

←↑ CANDLE HOLDER
This wall-mounted candle holder is laser-cut from one 9 x 4 in. (23 x 10 cm) sheet of stainless steel, minimizing waste and exploiting the nature of the production process. The two planar pieces, one extracted from the other, can be packaged and sold flat. These two pieces are then separated and locked back together in a new way, creating the three-dimensional candle holder.

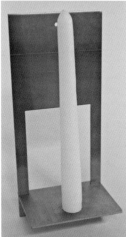

PENCIL/LETTER HOLDER→ ↗
This pencil and letter holder is made from bent and laminated maple. The wood is curved, looping back on itself to create a space-containing piece. The first series of curves produces voids to hold letters, and one final gesture creates a place for a pencil.

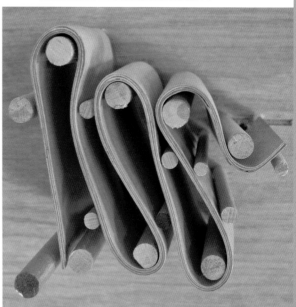

UNIT 22

INTRODUCTION TO ANALYSIS

Diagrams appear frequently in everyday life: underground maps, assembly directions, musical notes, graphs, and so on. In architecture, diagrams are the result of an analytic process of abstracting a building or object into its component parts. A single analysis can be represented by a single diagram or series of diagrams. Analyses can be constructed using both drawings and models.

READ THIS!

Roger H. Clark & Michael Pause
*Precedents in Architecture:
Analytic Diagrams, Formative
Ideas, and Partis*
John Wiley & Sons, Hoboken
Fourth Edition, 2012

Analysis is a reductive process—a simplification of one idea in isolation. Analytic models and diagrams may depict formal investigations, conceptual ideas, or ordering principles.

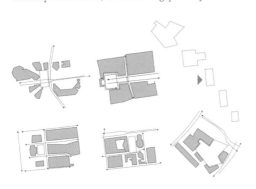

North Avenue

Martin Luther King Drive

←HISTORIC ANALYSIS
This drawing shows historic building conditions as an underlay to current building blocks (rendered in gray).

KEY CONCEPTS FOR BUILDING ANALYSIS

- Parti
- Massing
- Structure
- Circulation
- Axis
- Symmetry
- Scale and proportion
- Balance
- Regulating lines
- Light quality
- Rhythm and repetition
- View
- Part to whole
- Geometry
- Hierarchy
- Enclosure
- Space/void relationship

↑CONTEXT ANALYSIS
These diagrams compare and contrast the size and shape of various public plazas in Berlin, Germany.

↓ANALYTIC REPRESENTATION
These axon diagrams depict a process of cutting into the landscape, then building a series of retaining walls to hold back the earth.

SELGAS CANO

The Spanish architecture firm Selgas Cano, which was founded by Jose Selgas and Lucia Cano, designed the Serpentine Gallery 2015 summer pavilion and also a temporary pavilion, with Helloeverything, for the Louisiana Museum of Art in Copenhagen, Denmark. The 2015 Louisiana Hamlets Pavilion was later repurposed as a school for 600 children in a disenfranchized community in Nairobi.

The temporary nature of the installation allowed it to be easily disassembled, packed, and then reassembled.

↓ DIAGRAMMING DESIGNS

A set of diagrams reveals not only the means of assembling the structure but also its tectonic logic. The relationship of the parts and the hierarchy of assemblage is clearly connoted.

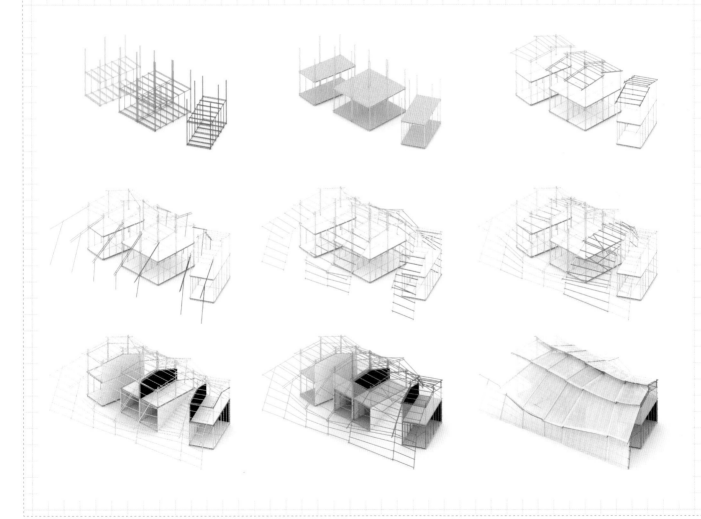

Data collection is different from analysis. Data collection is the identification of existing information. Analysis requires an interpretation of data. This means that the data are translated through the process of documenting, drawing, and modeling. Analyses are generally depicted graphically in a diagram.

Analysis provides a framework for making design decisions. At the beginning of the design process, analysis can be used to study the site, the program, and formal opportunities, and to represent a conceptual idea. In the middle phases of the design process, analysis can be used to clarify and strengthen ideas. Toward the end of the design process, analysis can be used to explain the conceptual basis for the design, especially during presentations.

Design ideas can be synthesized in analytic representations and diagrams. This allows the audience to understand the idea quickly. In complex projects, overall explanations are often made using diagrams rather than showing every facet of a project at once.

"Parti," a term used to describe the main idea/concept of a project, can be represented in a diagram. Projects can have multiple ideas but typically only one parti.

←ICONIC DRAWING

The use of icons in this diagram gives the drawing a visual clarity that is not always possible with text alone. The icons transcend language barriers and can be scaled to a smaller size whereas the font might become illegible. It also possesses a visual delight—the icons are clearly depicted.

KEY CONCEPTS FOR URBAN ANALYSIS

- Figure-ground relationships
- Street patterns
- Street section—horizontal vs. vertical
- Scale—hierarchy of form or space
- Land use
- Typologies
- Neighborhood relationships changing street grid, formal street variation, building type change
- Perspectival relationships—views
- Edge conditions, surfaces, and materials
- Natural vs. man-made
- History

- Type vs. program
- Open space
- Public green space vs. building
- Access—pedestrian, vehicular, other?
- Adjacencies
- Circulation—vehicular vs. pedestrian
- Pedestrian usage
- Movement
- Water elements
- Climate—sun angles/sun shadows

←PROGRAM ANALYSIS

Program analysis is shown in this series of diagrams for a K-8 school.

 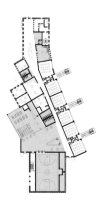 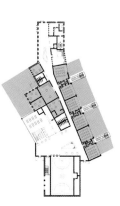 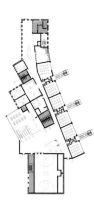

CIRCULATION COMMUNAL SPACES CLASSROOM SPACES SERVICE SPACES

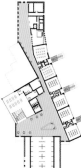 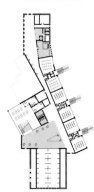 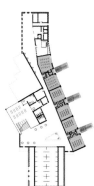 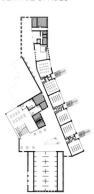

UNIT 23

INTRODUCTION TO EL LISSITZKY

Compositions possess an order: implicit or explicit.
This order can be derived from geometry.

El Lissitzky, who was well known as an experimental Russian artist, contributed to the Suprematist art movement during the early part of the 20th century with his abstract, nonrepresentational art. His works, known as "Prouns" (Project for the Affirmation of the New), were geometric abstractions, both two- and three-dimensional. He created the world through art rather than describing it.

Born in 1890 in Pochinok, Russia, Lissitzky became one of the most

influential yet controversial experimental artists of the early 20th century. His list of professions included architect; painter; designer; lecturer; theorist; photographer; and head of the graphic arts, printing, and architecture workshops at the People's Art School in Vitebsk.

Russian artist Kazimir Malevich had a major influence on Lissitzky's work. At the time, Malevich developed a two-dimensional system of abstract art composed with straight lines and colored forms dispersed over a white, neutral canvas. This mode of dynamically arranged forms of squares and rectangles, floating freely on the page, was referred to as Suprematism. Suprematist artists challenged conventional representations of the world.

As Lissitzky embraced the Suprematist movement, his works eschewed the traditional role of gravity in a painting. He used the axonometric as a graphic tool to demonstrate his interest in nonhierarchical, infinite space.

In addition to being a prolific painter, Lissitzky generated visionary architecture in the form of skyscrapers and temporary structures, including his speaker's podium known as the Lenin Tribune.

> *"Every form is only the frozen snapshot of a process."*
> Raoul Heinrich France

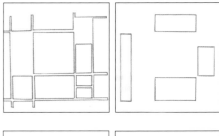

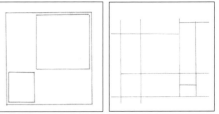

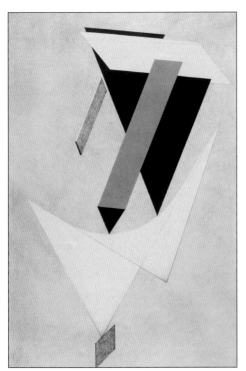

←TWO-DIMENSIONAL GEOMETRIC FORM
Lissitzky created tensions on the canvas by contrasting the shape, scale, and texture of elements, as well as by allowing for simultaneous multiple points of view.

↑COMPOSITION
Compositional analysis of a Piet Mondrian painting examining structure, color, pattern, and shapes.

ASSIGNMENT 14 | ANALYZE A PROUN

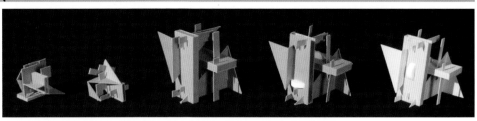

Grounded in the traditions of the Bauhaus movement of the early 20th century, this assignment uses analysis to create a new three-dimensional object generated from a two-dimensional El Lissitzky Proun. To start, imagine what exists beyond the Proun's canvas. Is it purely an extrusion of the canvas, or are there opportunities to translate the Proun into something else?

BRIEF
Find a Lissitzky Proun and translate it into three dimensions. Analyze and model three-dimensionally, and then create a series of orthographic projections of the finalized transformation of the Proun.

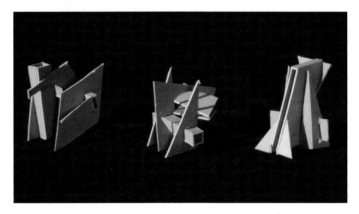

↑ **MODEL SERIES**
A complete series of models, from study to the final presentation model.

← **PROUN STUDIES**
Three form studies generated from the Proun analysis.

ASSIGNMENT RULES
Translations are interpretations and not literally a re-creation of the painting. It is an iterative process, like writing, that requires multiple edits and adjustments in support of a conceptual idea—in this case, about composition.

FINAL REQUIREMENTS
Compose orthographic elevation drawings and an axonometric drawing. Pencil on vellum for final drawings:
- plans
- sections
- axonometric

PROCESS

1 Find a Proun to analyze. Place tracing paper over it and scale the Proun image so it is as large as possible on a sheet of paper, measuring 8½ x 11 in. (22 x 28 cm). Isolate and analyze elements of the image by examining geometry, scale, proportion, transparency, hierarchy, depth, layers, and color.

2 Sketch these analytic drawings on a continuous piece of tracing paper. Select three drawings to make into three-dimensional models.

3 Create a physical model of each analytic drawing using chipboard; the model should fit inside a 3-in. (7.5-cm) cube. Study ideas at a smaller scale, especially when testing out new concepts before a direction of inquiry is settled upon. Finally, create a new model from your analytic models; this model should be at full scale—the 6-in. (15-cm) cube.

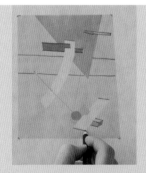

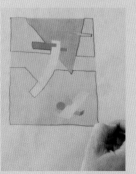

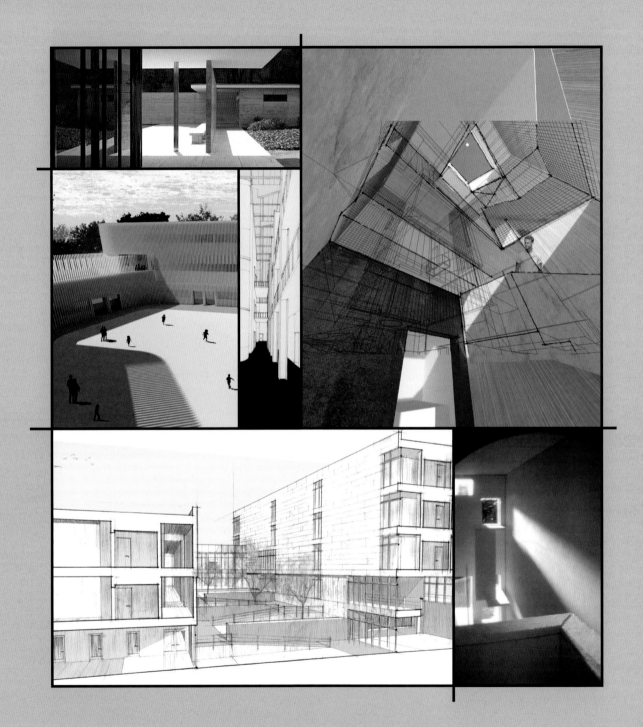

CHAPTER 5

SUBJECTIVE REPRESENTATION: PERSPECTIVE

This chapter details the techniques of perspective construction, its historical importance, and its use over time.

In the 15th century, Filippo Brunelleschi demonstrated perspective construction through the implementation of a mirror and painting at the Duomo in Florence. Though the exact representations used by Brunelleschi are unknown, it is speculated that he was one of the first to apply linear perspective construction to depict three-dimensional space. Leon Battista Alberti, one of the greatest scholars of the Renaissance, later wrote and distributed a treatise, *Della Pittura*, on linear perspective construction.

Perspective construction translates three-dimensional space onto a two-dimensional surface. It is a subjective representation that mimics, through a two-dimensional drawing, the experience of a space, building, or object. Its construction follows a series of set rules that is applicable to the various types, including 1-point, 2-point, or 3-point perspectives.

Taken from the point of view of a person, the perspective depicts visual experience and perception of space. Although perspective drawings, as well as photographs, cannot mimic the complexity of the human eye, which includes peripheral and binocular vision, they are an accepted representational tool that closely approximates human vision.

UNIT 24

PERSPECTIVE CONCEPTS

Perspective construction is the translation of the three-dimensional world onto a two-dimensional surface.

Perspective drawings differ from other three-dimensional drawings, such as the axonometric, in that they are subjective. A perspective is constructed from the eye level of a viewer looking in a particular direction from a single stationary point. As described in Unit 20, the axonometric is an objective, abstract, three-dimensional image that is not representative of real-world views. Its lines remain parallel to one another, thus maintaining objective neutrality in the drawing. In contrast, parallel lines in perspective converge toward a single point, mimicking a particular view of the world. In perspective construction, elements of the same height that are farther away from the observer appear to be smaller than elements that are closer. In addition, the lines of an object that are not parallel to the observer are compressed to convey depth.

Perspective construction requires a consideration of the relationship between the viewer and the object being viewed, as well as the angle of view from the observer toward the object.

↓ **KEY CONCEPTS**

In this woodcut, Albrecht Dürer demonstrates some of the key concepts needed to construct perspective drawings. A gridded picture plan marks where the sight lines cross, and information about the figure is then translated onto the gridded paper.

DESIGN APPLICATION

Perspective drawings can be used to develop design ideas. Use trace overlays on top of constructed perspectives, photographs, or digital images to manipulate elements and spaces in relation to the experience of the viewer. Understanding the relationship between the plan and perspective, or orthographic drawings and three-dimensional representations, is key to making architectural designs that are grounded in the reality of the occupants.

Picture plane (PP) Sight line (SL)

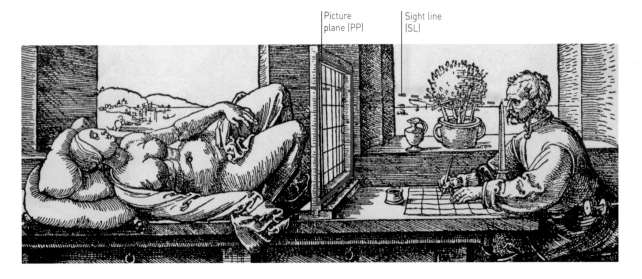

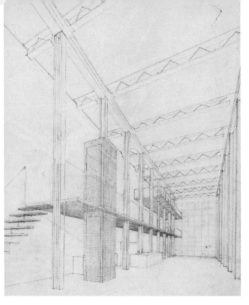

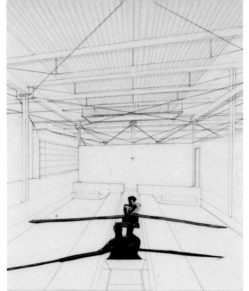

↑ PAIRED IMAGES
The 1-point perspective on the left and the 2-point perspective on the right highlight a passage along a ramp. By pairing up the images, movement through a space is seen through key vistas and orchestrated visual sequences.

↑ VISIBLE CONSTRUCTION LINES
The construction lines of this pencil-on-vellum perspective reinforce its hand-drawn character.

↑ SCALE FIGURES
Thomas Eakins' rowers are collaged into this pencil perspective to provide scale and context.

PERSPECTIVE TERMINOLOGY

Station point (SP)
Location of the observer in space.

Picture plane (PP)
A transparent plane, intersecting the cone of vision, that receives the projected perspective image and is perpendicular to the viewer. The PP is translated onto the 2-D drawing as a horizontal line that intersects the plan. Its location on the plan in relation to the SP impacts the size of the drawing.

Sight line (SL)
A line that extends from the SP at eye level, through the PP, to the object. (See Dürer image, opposite.) The perspectival image occurs where the sight lines cross the PP.

Horizon line (HL)
This line depicts the eye level of an average-height viewer. Conventionally, this is established 5 ft (1.5 m) above the ground plane.

It can be exaggerated to emphasize the eye level of a child's perspective, at HL 2 ft (61 cm); someone sitting in a chair, at HL 3 ft (91 cm); or someone on a second-floor balcony, at HL 15 ft (4.5 m). [Calculation: 10 ft (3 m) for the first floor + 5 ft (1.5 m) from the second floor to eye].

Cone of vision (CV)
The conical volume that depicts the viewable area from the SP. This visual field is typically considered to be a 60-degree cone from the eye. Replicating vision is difficult due to the fact that humans have binocular vision, while the perspective image reflects monocular vision. Therefore, the CV is only a guide to constructing the perspective image. Lines or elements of the drawing constructed outside the 60-degree CV will be distorted.

Measuring line (ML)
This is the only line that can be measured as a true dimension. Any vertical measurement can be accessed from this line. It is typically marked as a vertical line at the intersection of the picture plane and the plan.

Vanishing point (VP)
A point on the horizon line where parallel horizontal lines converge. Each set of orthogonal lines can have one, two, or three vanishing points. (In 3-point perspective construction, the third vanishing point related to vertical line construction is not located on the horizon line but remains on the picture plane.) In a 2-point perspective, each set of orthogonal lines, positioned nonparallel to the horizon line, has two vanishing points. Any lines that are parallel to the orthogonal lines recede to the same vanishing points. Any lines that are not parallel will have a different set of vanishing points. Locate nonparallel elements using new vanishing points or by translating points on the plan, locating each corner, and connecting the points.

UNIT 25

TWO-POINT PERSPECTIVE

There are a number of different methods for constructing perspectives that vary in difficulty. The method described here uses the plan as a basis for construction. The same principles can also be applied to freehand sketch perspectives.

SETTING UP A 2-POINT PERSPECTIVE

Consider the intention of the drawing, or the focus. What needs to be conveyed? This will help you establish where to stand, at what height to look from, and which aspect of the design to emphasize.

One-point perspectives are typically used to emphasize a strong space along a single axis, while 2-point perspectives provide ways to see spaces and objects more dynamically. Three-point perspectives are typically used to represent tall buildings. Choose the right type of perspective to represent the architectural intention.

READ THIS!

Frank Ching
Design Drawing
John Wiley & Sons, 2010

Rendow Yee
Architectural Drawing: A Visual Compendium of Types and Methods
John Wiley & Sons, 2012

Lewis.Tsurumaki.Lewis
Opportunistic Architecture
Princeton Architectural Press, 2007

1 Use two 30/60/90-degree set squares to establish the cone of vision. The point of the two set squares indicates the location of the station point (SP). Tape down the plan and lay a large piece of tracing paper or vellum on top. Place the sheet of paper so that it covers the entire plan and leaves room at the bottom for the image.

2 Next, establish the location of the picture plane (PP). For ease of construction, this horizontal line should intersect a point on the plan, preferably a corner of the plan and one that will be seen in the perspective image.

3 Draw a vertical line from the intersection of the PP and the plan to establish the measuring line (ML). This line should extend into the white space left open for the image construction.

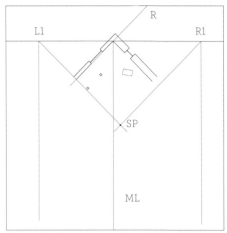

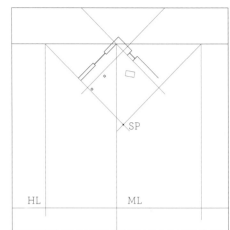

4 Location of the vanishing points: From the SP, using your adjustable set square, draw a construction line parallel to line L of the plan that intersects the SP and crosses through the PP. Repeat on the other side for R.

5 Label the intersections with the PP L1 and R1. At R1, the intersection of the construction line and the PP, draw a vertical construction line, perpendicular to the PP, into the open space of the page. Repeat at L1.

6 Establish the horizon line (HL). Locate the HL between the plan and the bottom of the page. This should allow enough room to construct the perspective image. The horizon line is a horizontal line parallel to the PP.

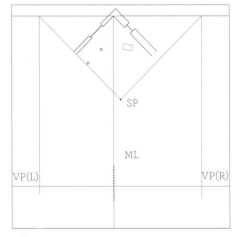

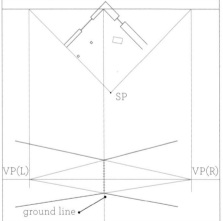

7 Where the vertical lines from the L1 and R1 cross the horizon line, establish the vanishing points (VPs). Call them VP(R) and VP(L). The ML should also cross the horizon line. This intersection establishes the location of eye level for the person standing at the SP. If the person is standing on the ground, the horizon line would be 5 ft (1.5 m).

8 Mark a series of 1-in. (2.5-cm) intervals above and below the horizon line. Indicate the ground line at 0 ft/m and the tallest dimension along the ML. Construct the walls to establish the framework of your space. Lines in plan parallel to line R recede to VP(L). Extend a line from 0 ft/m and the height of the wall (in this case, 10 ft/3 m) on the ML to each VP to create the wall.

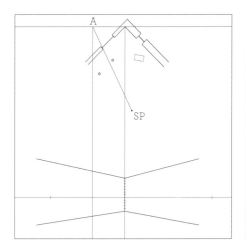

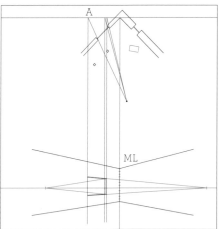

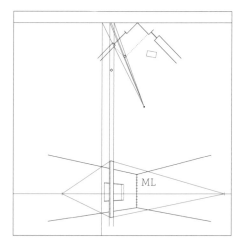

9 To obtain vertical information, follow a two-step process. Draw a construction line that intersects the SP and any point on the plan, and continue it through the PP (label A at the PP).

10 Draw a second construction line, starting at A (the intersection of the first construction line and the PP), perpendicular to the PP into the perspective image area. Repeat for all lines in a given element. Cross the vertical lines with height lines obtained from the ML.

11 Go back and forth between getting vertical information from the plan, measurements from the ML, and surfaces that vanish to one of the VPs. Heights can only be taken along assisting planes for elements not along the ML. See "Assisting Planes," page 100.

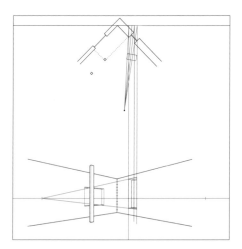

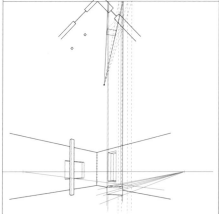

13 All vertical measurements must be translated along surfaces if they do not connect directly to the ML (such as the chest in this drawing). That is, an object detached from a wall touching the ML must have its vertical measurements transferred across a series of perpendicular planes (even if those planes do not exist as actual surfaces in the design).

12 Repeat for each element.

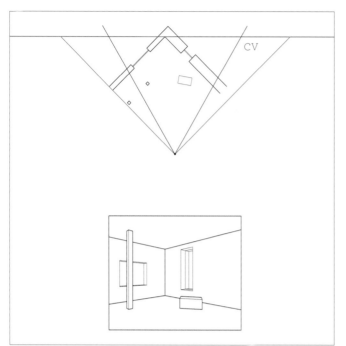

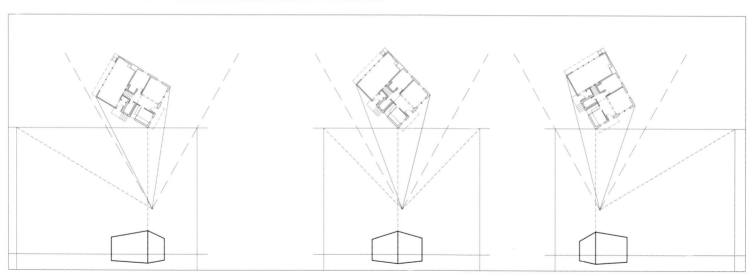

14 Finished perspective. The CV (shown here in blue) establishes the box around the perspective.

↑ PLAN ALIGNMENTS
The plan rotation adjusted to the SP establishes which surfaces are emphasized in the perspective drawing.

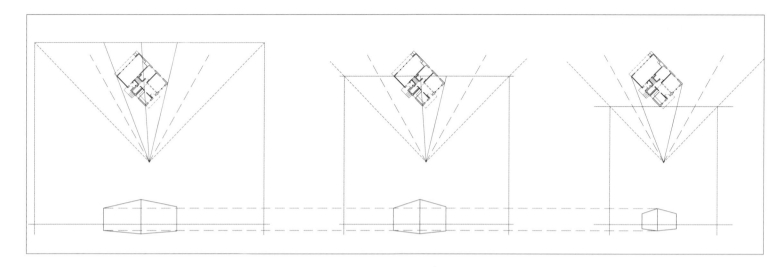

↑ MOVING PICTURE PLANE

The location of the PP determines the relative distance between the vanishing points (VPs). As the PP moves away from the SP, the VPs move apart. Where the PP crosses the plan determines the location of the ML. If the ML is constructed off the front of the plan, the image recedes to the back. If the ML is constructed off the back of the plan, the image will project forward.

↓ MOVING HORIZON LINE

As the location of the eye changes from 5 ft (1.5 m) to 20 ft (9.5 m), the projected image of the object changes from aerial view +20 ft (+9.5 m) to worm's-eye view -20 ft (-9.5 m). Note that all people in perspective, no matter how far away, if standing on the same ground plane will have their eye level located along the HL.

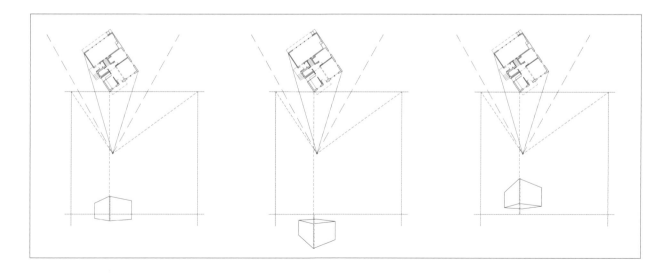

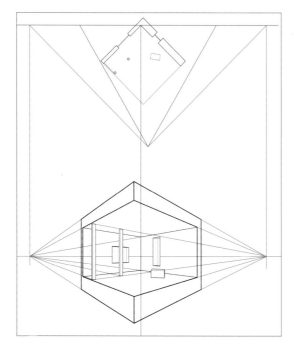

↑ SP LOCATION

If the perspective is taken from the point of view of a person standing outside the room looking inside, you will be able to see the perimeter conditions of the room. When the SP is located outside a room, the thickness of the walls and floors are depicted. Note: 45 degrees is only used for demonstration purposes. The plan can be rotated to any angle; the chosen angle should capture desired views.

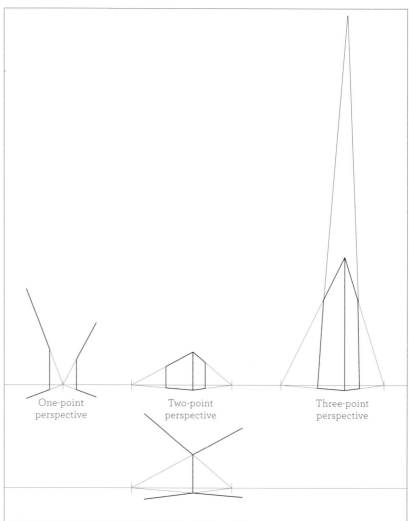

One-point
perspective

Two-point
perspective

Three-point
perspective

↑ PERSPECTIVE TYPES

Perspective construction includes the 1-point, 2-point (with both concave and convex views), and 3-point.

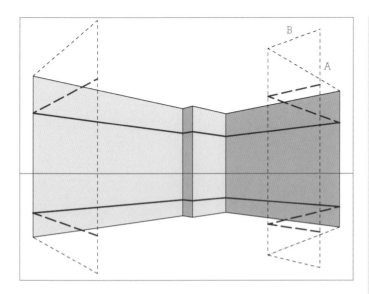

↑ ASSISTING PLANES

Assisting planes are used to translate dimensions from the ML onto other surfaces of the perspective. If wall A does not exist, but you need the height of wall B, translate the height information across the assisting plane (wall A) to wall B.

PERSPECTIVE TIPS

A series of relationships between the component parts of the constructed perspective establish the outcome of the drawing.

The relationship between the SP and PP establishes the actual size of the image being drawn. The farther the PP is from the SP, the larger the image will be. The SP and PP can be moved independently of one another.

Moving the SP farther away from the object affects the rate of foreshortening of the object. The movement of the SP causes the VP to be farther away from one another. This distance may be a physical constraint of your drawing surface.

The orientation/rotation of the plan relative to the SP and CV establishes which elements are seen in the perspective.

Eye level is established by the intersection of the ML with the HL. This is typically located at 5 ft (1.52 m) from the ground, but when an aerial, or "bird's-eye," view is desired, the HL is moved higher, or in a "worm's-eye" view, the HL is much lower.

Start the perspective construction with a sketch vignette. The sketch provides the basic structuring elements of the drawing.

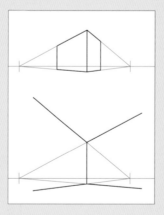

CONCAVE AND CONVEX
In 2-point perspective construction, the alignment of receding lines is either concave or convex. Concave shows a view inside a space, while convex shows the outside version of the space. Though the specific angles of the lines may vary, these concave and convex systems can be used to sketch any perspective view.

UNIT 26

ONE-POINT PERSPECTIVE

One-point perspective construction differs from 2-point perspective construction in that lines parallel to the picture plane do not converge but extend to infinity.

Because there is no convergence due to their parallel nature, lines parallel to the picture plane (PP) are constructed using a parallel rule. One-point perspectives are considered to be more static than 2-point perspectives, especially if the design is symmetrical. They have a single focus and are often used to depict a view looking down a street or long space. Typically, 1-point perspectives focus on the space between the walls, while 2-point perspectives focus on the surfaces that make up the space.

 As in any perspective construction, establish intentions before setting up the perspective drawing. What needs to be emphasized? As in the 2-point perspective, these decisions help establish where to stand, at what height to look from, and what part of the subject to view.

 In a 1-point perspective, the plan is placed parallel to the PP and only one vanishing point (VP) exists that aligns with the station point (SP). The point of view is aimed into a space perpendicular to the PP.

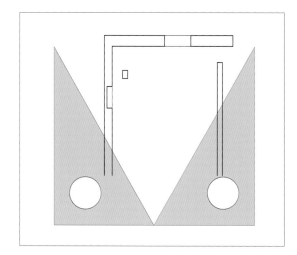

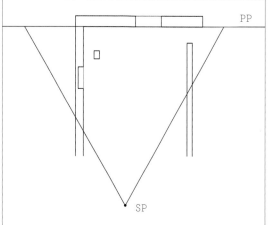

READ THIS!

Erwin Panofsky
Perspective as Symbolic Form
Zone Books, 1997

1 Rotate the plan so that the wall to view is parallel to the PP. Establish the SP and the cone of vision (CV). How far away is the SP from the wall? Lay tracing paper or vellum over the secured plan.

2 Draw the PP to coincide with the back elevation for ease of construction. That is, the horizontal line demarcating the PP should cross the front edge of the wall. Blue lines indicate the CV.

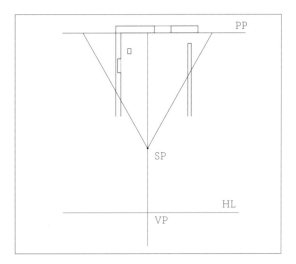

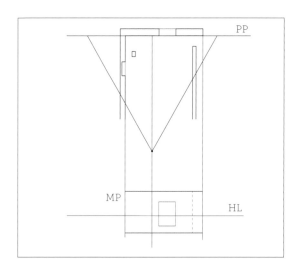

3 Locate the horizontal line (HL) and VP on the elevation. The VP should correspond to the height of a viewer's eyes looking into the space and can be located directly in line with your SP. The SP and VP vertically align since this is a single-view perspective with one focus.

4 Construct the back wall elevation that corresponds to the location of the PP at the same scale as the plan. Draw this in the open space below the plan. This serves as the measuring line (ML), or, in this case, the measuring plane (MP).

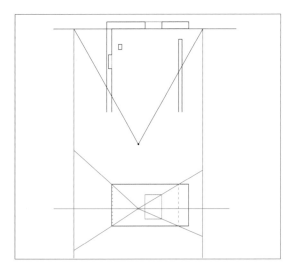

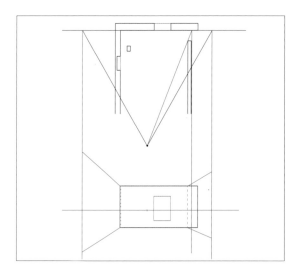

5 Connect the VP to each of the four corners of the elevation. Extend these lines beyond the limits of the elevation. This will provide the parameters of the room: walls, floor, and ceiling.

6 Vertical lines are obtained through the same method as the 2-point perspective (see page 96, step 9). Method: SP to the point on the plan; where the line crosses the PP, drop a vertical line down.

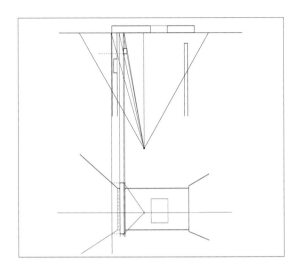

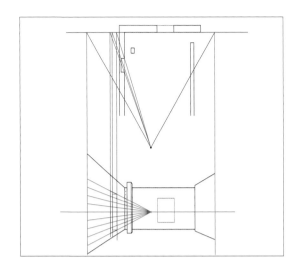

7 Continue depicting vertical data through the previously described method (see page 96, step 9). Use the assisting planes to find the heights of the elements not connected to the ML/MP.

8 Translate vertical heights from the MP to the objects not directly adjacent to it.

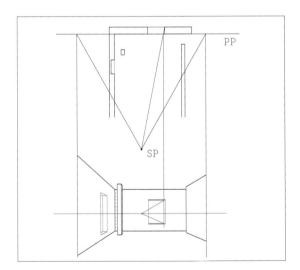

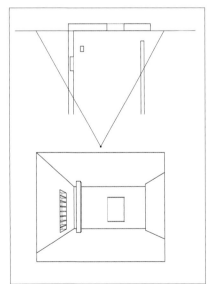

10 The finished perspective. The CV sets the parameters of the box.

9 Show the depth of the wall at the window opening. Extend a line from the SP through a point on the plan to where it crosses the PP, and drop a vertical line down. Use measurements from the MP to draw the corners receding to the VP.

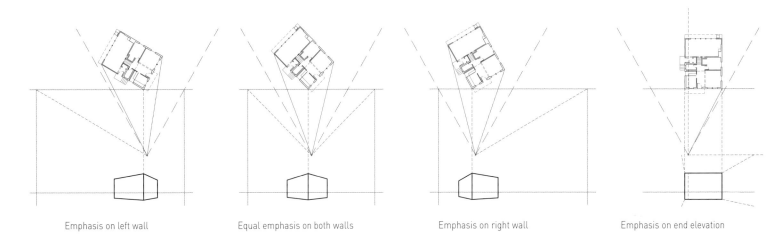

Emphasis on left wall Equal emphasis on both walls Emphasis on right wall Emphasis on end elevation

↑ REDUCING VANISHING POINTS

Understanding how the vanishing points work in
a 2-point perspective provides the foundation for
understanding why a 1-point perspective has only
one vanishing point. This image depicts the rotating
vanishing points of a 2-point perspective to a
1-point perspective.

ATELIER BOW-WOW SECTION PERSPECTIVE

Yoshiharu Tsukamoto (Japanese, b. 1965) and Momoyo
Kaijima (Japanese, b. 1969) are founders of the architecture
firm Atelier Bow-Wow. They are known for their ability to
build on small, difficult, urban sites. The use of sectional
perspectives, in both their conceptualization process and
construction documentation, allows them to simultaneously
depict the quantitative and qualitative aspects of
their projects.

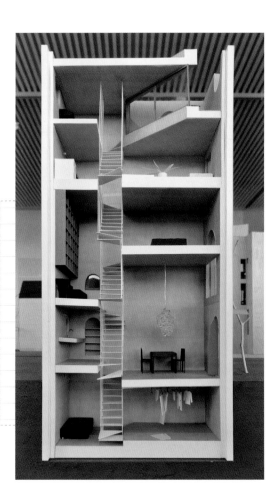

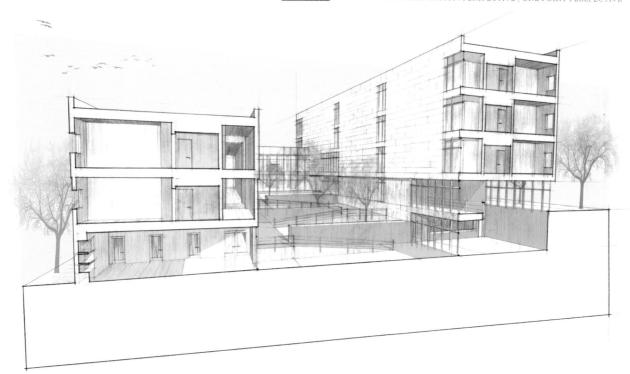

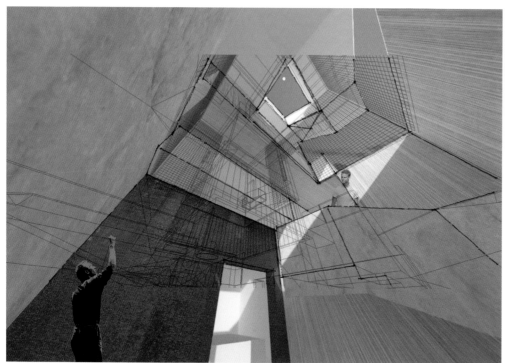

↑ SECTIONAL PERSPECTIVE
This sectional perspective depicts a residence hall with two housing masses framing an outdoor courtyard and event space.

← THREE-POINT PERSPECTIVE
Looking up through this 3-point perspective draws the viewer through the space with a focus on the sky above.

UNIT 27

CROPPING A PERSPECTIVE

The horizon line establishes where the ground stops and where the sky begins. It gives the page a bottom and a top.

When finishing a perspective drawing, consider page composition in relation to your design and representational intentions. Should the paper be cropped or cut to meet the perspective, or should a box be drawn around the perspective to contain it? Where are the limits of the cone of vision? Vertically? Horizontally? Ensure there is enough room on the paper so the perspective image is not compromised.

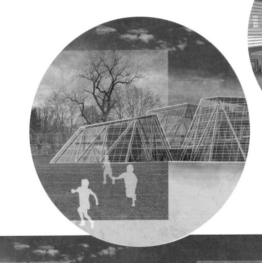

←↑ MAKING THE FRAME
These interior and exterior perspectives for an elementary school reveal transparent material, children playing, and context images that are collaged into the background. The circle frame brings focus to the elements in the center of the image. The images were modeled in Rhino, then rendered with V-Ray. The textures (for the ground and sky) and entourage (the children, trees, and birds) were added in Photoshop.

↓ INTERIOR PERSPECTIVE
This interior perspective of a K-8 kindergarten space highlights the wooden structure and wood wall surfaces.

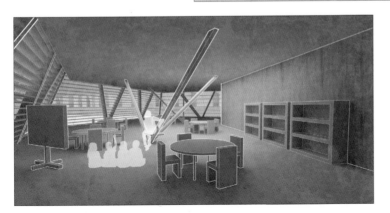

↑ EXTERIOR PERSPECTIVE Site photos and abstract figures are collaged into this exterior perspective. The above two perspectives are the same but are cropped differently to provide a different focus.

↓WEST BANK INDUSTRIAL WORKER'S CLUB

In this 2-point perspective drawn with pencil on Arches paper, the horizon line defines the boundary between the dark sky, which speaks of impending doom, and the sun-reflecting ground plane. This view from the approach ramp simultaneously emphasizes the power of the forms and the delicate quality of the floating buildings.

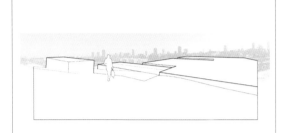

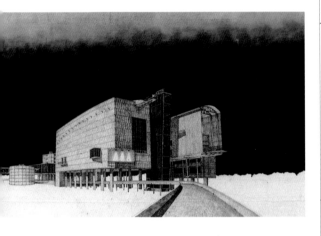

VERTICAL EXTENSION

A 3-point perspective is constructed in a similar way to a 2-point perspective, except that all the vertical lines converge to a distant vanishing point. This technique is useful when constructing views that look up at a tall building or look down into deep spaces. In each case, either the picture plane is tilted or the object is tilted relative to the picture plane. In a sense, all three axes are oblique to the picture plane.

REPLICATING EXPERIENCE

Perspective drawings are not solely used as presentation drawings for clients, planning, or academic reviewers. They are necessary throughout the design process to verify plan and section ideas against spatial and experiential ones. They are design tools that aid the development of ideas.

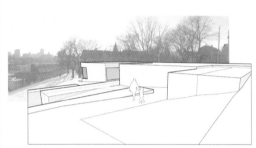

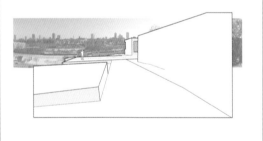

←OVERLAP OF PERSPECTIVE AND CONTEXT

These exterior perspectives collage city views in the background while depicting the connection between the building and the landscape. The collage image extends beyond the cropped edges of the perspective as a way of indicating the expansiveness of the view and context.

↓SPATIAL EXPRESSION

The enormity of the courtyard space in this elementary school is reinforced by the abstract figures. Context images of the site are collaged into the background, while birds are added as scale figures in the sky.

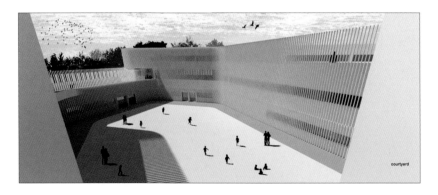

courtyard

UNIT 28

ARCHITECTURAL ELEMENT DESIGN: OPENING

By setting limits in a design problem—in this case, a single architectural element—focus is put on the variety of design decisions involved in each component part of the element and in the relationships of those component parts in creating the overall project.

GETTING STARTED

Designs are not created in a vacuum. Ideas and inspiration can be drawn from the existing conditions of the site. Various scales of the existing conditions can be investigated— that is, a site might be a room within a building, a neighborhood, a district, or a city. Each of these existing conditions can influence the design. The existing conditions, along with the rules of the program, create a framework of response for each design.

PRECEDENT RESEARCH

Investigate typological precedents— previous designs with the same program—to start a project. Historical precedents provide a way to position new work within the discipline of architecture.

RECONSIDER FAMILIAR TERMS

An opening in architecture is typically a building element such as a door or window. The *Webster's New World Dictionary* defines an opening as an open place or part, hole, gap, or aperture. From this definition, the functions of door and window are disassociated with the term and thus afford a new way of thinking about it. Reconsider the familiar double-hung bay by thinking of openings as thresholds between two sides. The spaces on either side of the window can be unique or similar. Regardless, the opening participates in both realms simultaneously and independently. An opening affects the experience of a space depending on its size, shape, material, texture, and transparency. They are not neutral elements.

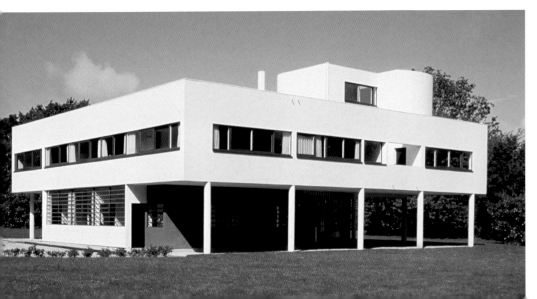

← PRECEDENTS
The Villa Savoye, designed by Le Corbusier, juxtaposes a glazed strip or ribbon window with similarly sized unglazed openings. An opening on the roof terrace acts as the focal point of the interior circulation sequence through the house, framing a view of the adjacent landscape.

↑ NEW EXPERIENCES

These orthographic drawings show the range of experiences developed in this design for a new window opening.

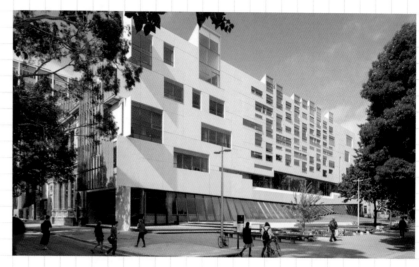

NADAAA

Led by Nader Tehrani, Katherine Faulkner, and Daniel Gallagher, NADAAA is an internationally recognized design firm whose projects are as equally rigorous in concept as they are executed. NADAAA's success is predicated by an uncompromising pursuit in exploring the tectonic expression of their designs. This attention to detail continues throughout the design process, culminating in the production of deliverables that demonstrate not only a quantitative clarity but also the richness of their intentions.

STUDY MODEL AND
EVOLUTION→

This series of models depicts the evolution of design ideas for a new opening. Note how the design gets more complex over time and is more engaged with the scale of a user.

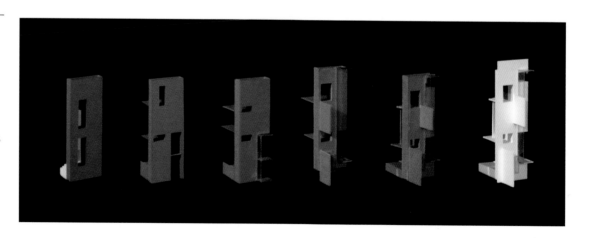

ASSIGNMENT 15 | DESIGNING AN OPENING

Examine the nature of an opening in detail by exploring issues of light, ventilation, hierarchy, size, scale, materiality, proportion, privacy, view, point of view, space, place, security, and control. The project is small but involves complex decision making.

BRIEF

Design an opening for an existing space with a stairwell that connects one floor of a museum to another. The solutions for design should be practical and poetic.

RULES

- Opening(s) can only be placed on the east wall.
- Openings can take up to a maximum of 35 percent of the total surface area of the east wall.

- Openings cannot penetrate the roof (i.e., no skylights).
- Glass may be clear, colored, or frosted; no glass block or other types of specialty glass may be used.

PROCESS: RESEARCH

Find three precedent examples. Limit any preconceptions that an opening must look like a window. Design is an iterative process; therefore, evaluate initial solutions and redesign based on the clarity of the narrative relative to the articulation of the idea. Repeat this process over and over again. The initial idea produced is a generator for the architecture and will be manipulated over time. Initial sketches may look vastly different from the final outcome of the project.

Record your ideas in a sketchbook. Do not try to use all the ideas in one project. Edit ideas—too many ideas are just as bad as too few.

HOW TO DRAW GLASS IN PLAN AND SECTION

Typically, glass is drawn using two lines as close together as possible while still maintaining two distinct lines. Due to the transparency, they are not drawn as cut lines even if cut in plan or section. At $\frac{1}{16}$ scale, glass is represented with two lines roughly $\frac{1}{4}$ in. (1.2 cm) apart to scale; at $\frac{1}{8}$ scale this might be 1 in. (2.5 cm) apart. The two lines representing the glass should never be farther apart than 1 in. (2.5 cm). Consider the location of the plane of the glass in the wall thickness. Should the glass be centered in the wall, flush to one side, or asymmetrical?

TRANSLATING IDEAS TO PAPER OR MODELS

- Create three study models at $\frac{1}{8}$ scale to investigate the conceptual thinking recorded in your sketchbook. What is the intention of the opening? How does it react to the existing conditions? Is it about light? What quality of light? If it is about view, what is the nature of the view? Is it directional?
- Create a plan and section of the existing space at $\frac{1}{4}$ scale. Use this as an underlay for freehand orthographic sketches.

Select one of the original study models. Continue to develop the details of the opening ideas using the plans and sections as underlays to make changes and modifications. As changes are made,

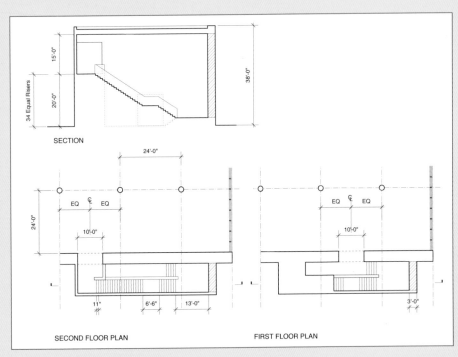

SECTION

SECOND FLOOR PLAN

FIRST FLOOR PLAN

create a new study model to explore these ideas at a larger scale. This new study model should be twice as big as the first study model, at ⅛ scale.

During the process, construct perspectives to investigate how the ideas in plan and section are executed as an experience of someone in the space. Use the perspectives as a design tool. Manipulate elements of the perspective, which can then be modified in plan. In addition, use the perspectives to represent floor, wall, and ceiling materials to begin to characterize the space.

Use charcoal drawings to experiment with the way light moves and changes. Take the models outside into the sunlight to see how light enters the space. Sunlight is scaleless, so shadows cast on the model replicate built conditions.

IMAGE FOLDER EXERCISE

Window precedents to your image folder.

Le Corbusier	La Tourette, Ronchamp, Villa Savoye, La Roche-Jeanneret
Frank Lloyd Wright	Fallingwater
Steven Holl	The Chapel of St. Ignatius
Tadao Ando	Koshino House, Church of Light, Church on the Water, Vitra Museum
Clark and Menefee	Middleton Inn
Louis I. Kahn	Salk Institute, Esherick House
Konstantin Melnikov	House in Moscow
Carlo Scarpa	Brion Cemetery, Canova Cast Museum
Alvaro Siza	Faculty of Architecture, Faculty of Journalism, Galician Center of Contemporary Art, The Serralves Foundation, Vieira de Castro House
Giuseppi Terragni	Casa del Fascio
Herzog & de Meuron	Roche Pharma Research Institute
Jean Nouvel	L'Institut du Monde Arabe
Zaha Hadid	Guangzhou Opera House
SANAA	Toledo Museum of Art
Tod Williams and Billie Tsien Architects	Cranbook Natatorium

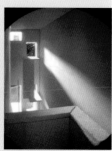

↑ DRAWING VS. PHOTOGRAPH
This charcoal drawing emphasizes contrasts between dark and light. The sharp light casting across the space is representative of the rising sunlight in the eastern sky. Compare the light quality in the charcoal drawing to the model photograph.

↑ GLASS HOUSE
The Palm House at the Royal Botanic Gardens, Kew.

UNIT 29

THE KIT OF PARTS

The "kit of parts project" dates back to the 1950s, with the introduction of the nine-square grid problem by John Hejduk at the University of Texas.

Along with fellow academics Colin Rowe, Robert Slutsky, and others, Hejduk was part of a new trajectory in architectural education that promoted design as a formal issue.

The original kit of parts problem included a reduction and simplification in the number and type of formal elements, often repeated, that led to a focus on threshold, enfilade, space, vistas, and movement. These limited parameters concentrate the development of the narrative as it relates to the composition and sequence of spaces.

Compositional design strategies make up the core of the kit of parts problem. Composition is the active arrangement of parts to create a whole in order to establish order. Even with a limited number of parts, many solutions are possible.

MIES VAN DER ROHE

Ludwig Mies van der Rohe (German-American, b. 1886, d. 1969) is considered to be one of the most influential of the early Modernists.

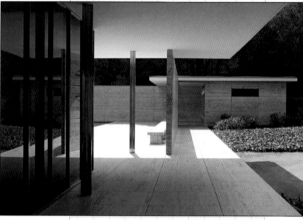

The Barcelona Pavilion

After establishing himself at IIT in Chicago, Mies went on to create a number of influential buildings in the U.S. His buildings aspired to establish a new style to embody the spirit of the times. Perhaps the first to do this was the German pavilion for the World Exhibition in Barcelona in 1928–29, the Barcelona Pavilion. It embodied the streamlined aesthetics of the era. The Barcelona Pavilion was an exercise in harmonious proportions and exquisite composition of materials. The expression "less is more" has been attributed to Mies.

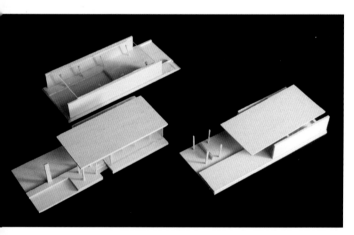

↑ **CAPTURING LIGHT**
These basswood models capture the sharp light cast into the space.

CAPTURING SPACE →
Space between the walls, roof, and columns is captured in this constructed perspective.

ASSIGNMENT 16 | USING THE KIT OF PARTS

BRIEF

Compose a series of spaces using a prescribed kit of parts to orchestrate an experience based on the following five themes:

- Ceremony
- Contemplation
- Dialogue
- Imbalance
- Tension

Record the dictionary definitions of each word along with your personal interpretations of them. Use a soft pencil (2B or 4B) or felt-tip pen to freehand trace over a hard-line plan of the gridded site. Generate at least 12 different spatial composition plans based on the themes and definitions. Explore each theme at least once.

While sketching in plan, think three-dimensionally about the design. For each plan, draw a series of four small perspective sketches that represent the sequence of movement through the design. Do the sketches reinforce the idea? If not, revise the sketch (use tracing paper), then return to the plan and modify it based on the perspective changes. Draw plans and sections at ³⁄₁₆ scale so that relationships between the two can be exploited.

Make a model to establish the three-dimensional sequencing strategy and to study the light qualities of the spaces. In addition, create a series of charcoal drawings to explore light responding to the kit parts, the materials, and the textures throughout the day.

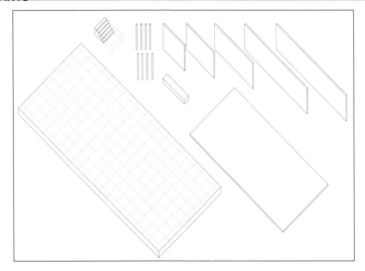

RULES

The site is a solid plinth, measuring 2 ft 6 in. (76 cm) high, by 80 ft (24.4 m) long, by 32 ft (9.75 m) wide. The plinth is delineated by a grid measuring 4 x 4 ft (1.22 x 1.22 m).

- Locate two shallow reflecting pools: one measuring 1 x 38 x 18 ft (0.3 x 11.6 x 5.50 m) and another 1 x 22 x 10 ft (0.3 x 6.7 x 3 m). Place each pool with at least two edges aligned with the grid. They must remain parallel to the grid and may not be placed on the edge of the plinth.

- Subtract a volume of 2 ft 6 in. (76 cm) high by 6 ft (1.82 m) wide by at least 10 ft (3 m) long to allow for an entry stair.

- Place columns at grid intersections, and align the center-line of walls with a grid line, except at the perimeter of the plinth where the edge of the wall must align with a grid line. Do not place columns inside the pools.

- Use walls and columns to support a canopy. The edges of the canopy must run parallel to the grid. The canopy measures 6 in. (15 cm) deep by 26 ft (7.92 m) wide by 54 ft (16.46 m) long. No wall may cantilever over the plinth edge. Five walls should measure 6 in. (15 cm) wide and 10 ft (3 m) high by five different lengths: 12 ft (3.7 m), 16 ft (4.9 m), 22 ft (6.7 m), 36 ft (11 m), and 40 ft (12.2 m).

- Place a monolith measuring 1 ft 6 in. x 2 ft 6 in. x 12 ft (45.7 cm x 76.2 cm x 3.7 m). Orient the monolith vertically, horizontally, or on its side. At least two edges must align with the grid.

FINAL REPRESENTATIONS

- Plans and sections at ³⁄₁₆ scale (1 longitudinal section and 2 cross-sections)
- 3 constructed perspectives
- 1 basswood model
- 2 charcoal drawings

CHAPTER 6

DYNAMIC RENDERING STRATEGIES

This chapter looks at a number of different rendering techniques that enhance the dynamic qualities of representations.

Architectural drawings can evoke a sense of the mood, texture, and atmosphere of a space, transcending mere two-dimensional abstract representations.

Dynamism in architectural drawing can be achieved through variations in medium, color, vantage point, and composition. Exaggerations create opportunities to further the architect's intentions.

In addition, this chapter will explore the step-by-step process of design while examining space as both an additive and subtractive design tool. Designers that use these techniques include Pierre Chareau (in Maison de Verre) and Le Corbusier (in Villa Savoye), as well as contemporary architects such as John Pawson.

RENDERING TECHNIQUE

Line drawings alone cannot convey the textural qualities of a space—how a room reacts to light or which materials enrich the space. It is sometimes necessary to embellish line drawings with indications of material, shade, and shadow.

Rendering materials and light help to convey the rhythm and scale of a space. Materials such as concrete, wood, metal, glass, and plastic can be depicted on floors, walls, and ceilings through a variety of techniques, including line, tone, and color. Metal and stone can be rendered with reflections or shadows. In some cases, a tonal value is given to one material in a drawing to distinguish it.

Two issues to consider when representing materials are scale and intention.

SCALE

Consider at what scale the representation is drawn. For example, brick can be rendered in a number of different ways depending on the scale of the drawing. Sometimes it is rendered as horizontal lines abstracting the unit quality of the material itself. In a larger-scaled drawing, the addition of vertical breaks helps identify individual bricks versus the general horizontal nature of the brick.

INTENTION

Consider the emphasis of the material: is it horizontal, vertical, or a particular wall or surface? In the example with brick, it is the horizontality of the material that is most important.

Sometimes an image has only one material rendered, while the other surfaces remain as line or black/white drawings. This technique of limiting the materials being rendered gives a hierarchy to the material and space.

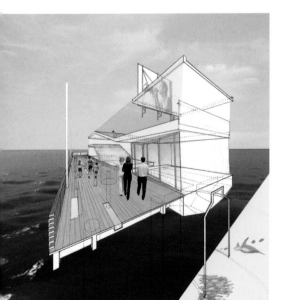

←MATERIAL INDICATIONS
This sectional perspective for a museum uses selectively rendered material to highlight the boardwalk as an important element of the design. Wall transparency allows for a peak into the interior space of the building, without overwhelming the image with too much information.

SHAPE AND TEXTURE→
This pencil rendering by Douglas Darden of his Oxygen House reveals the form and textures of the building. By rendering most of the object, the white of the page becomes compositionally important. Plan information is added in the white part without compromising the drawing.

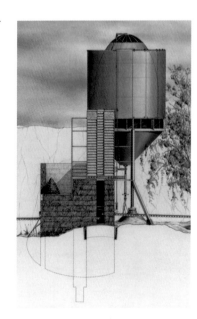

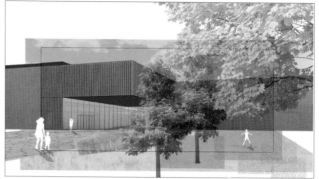

↑ MATERIAL RENDERING TECHNIQUES

Photoshop, or programs like it, allow for the easy assembly of rendering layers over a base drawing (which can be either a manual sketch or digital drawing). These two images depict the base drawing for a K-8 school, which was first created in Rhino and then rendered in Photoshop.

CONNECTION TO THE GROUND →

This design for a K-8 school complements the topographical change of the sloping site. The connection between the school and the earth is legible through the application of gray poché in the section. Abstract figures and photographs from the site add to the scale of the space.

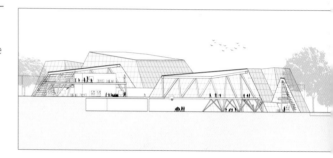

WHAT TO INCLUDE OR NOT INCLUDE

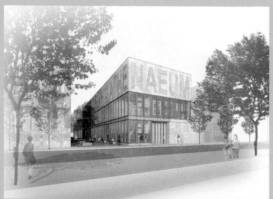

Images do not need to be completely rendered. Selectively choosing what to include or not include helps to frame the intention of each drawing. In these renderings of a new Athenaeum by bauenstudio, the exterior street view is rendered with a yellow sandstone material, while the exterior courtyard eliminates this material and focuses on rendering the artwork on display as seen through the glass.

UNIT 31

CHARCOAL DRAWING

Charcoal drawings capture the quality of light in a space. This unit details one method of construction using compressed charcoal.

READ THIS!

Turner Brooks
Turner Brooks: Works
Princeton Architectural Press
New York, 1994

Nell Johnson
*Light is the Theme: Louis I. Kahn
and the Kimbell Art Museum*
Kimbell Art Foundation
Fort Worth, 2012

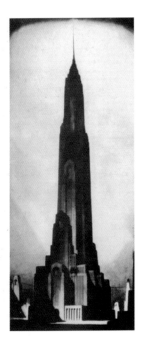

↑ MONUMENTALITY
Hugh Ferriss used charcoal to evoke a sense of monumentality in his building representations. Note the surface quality of the marks on the page.

Charcoal drawings provide a method for rendering mood, light, and textural qualities in an evocative manner that transcends the line drawing. They use contrasting lights and darks to demonstrate how light affects space, materials, and movement. In this method, tone and shade are used to create volumes or planes of solids and surfaces. This drawing type reveals the experiential nature of a space.

CHARCOAL OPTIONS:
• Vine stick
• Soft compressed (this is the preferred choice—it provides a variety of line types but is a little messy)
• Pencil

The soft, compressed charcoal stick offers a myriad of possible marks on the page, depending on the length of the charcoal stick, the pressure applied, and the positioning of the stick. Holding the charcoal stick in a variety of ways produces different line types. Smearing the marks can reduce the impact of an individual stroke on the page.

←ADDING DETAIL
Depicted in these three charcoals is a process of adding detail over time. Note when the foreground conditions are added.

PRECEDENTS
Look up charcoal drawings by Hugh Ferriss and Turner Brooks to see evocative, high-contrast images. Similar to El Lissitzky's speculative axonometric drawings, their charcoal drawings explore the possibilities of design, as opposed to the representation of known conditions.

← STUDYING LIGHT
Charcoal drawings capture the sunlight cast on these grain elevators. Study not only the light but also the repetitive elements in these and other industrial buildings.

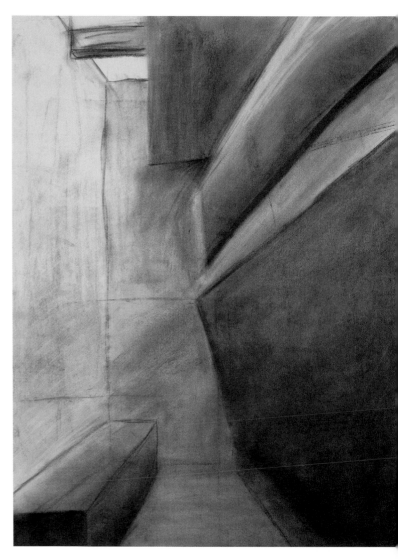

METHODOLOGY

To subdue any fears of drawing with a dark material on white paper, lightly tone the entire drawing surface with the long edge of the charcoal. By changing the page from stark white to gray, not only is the pressure of making the first mark lessened, but white marks can be made with an eraser.

To achieve tonal consistency, use the heel of your hand, your finger, or a chamois cloth. These tones are less like lines and more like planes of dark or light.

The "messy" quality of charcoal liberates the artist from achieving detailed precision. Any mistake can be easily fixed by rubbing, smearing, erasing, or adding more charcoal. Images are massaged into place rather than drawn. Begin each drawing lightly and work toward dark. It is harder to lighten or erase black than it is to add more black.

COLOR OR NOT

Similar art forms, such as black-and-white photography, rely on tonal differences in the image to enhance and reveal the depth of the space. Walker Evans, who is well known for his black-and-white, Depression-era documentary photography, suggested that you should master black-and-white photography, emphasizing tone, shade, and quality of light, before trying to work with color film.

↑ SPATIAL NARRATIVE
Charcoal is a dynamic medium that enables dark shadow areas and delicate veils of light to describe the play of light on surfaces. This charcoal perspective reveals light washing a wall surface.

UNIT 32

SHADE AND SHADOW

Capturing the interaction between architecture and light is integral to good design.

Representational forms that can be used to show the effects of light include orthographic projections, as well as axonometric and perspective drawings. The graphic depiction of shadows in these drawings provides additional depth that characterizes a moment in time when architecture responds to light. Shade and shadow in orthographic drawings expose the physical relationship between the elements in the space that are receiving the light and the elements that are creating the shadow—the wall, window cutout, and so forth.

There are two key considerations to bear in mind when including shadows:
- Shadows are cast onto surfaces (no surface = no shadow).
- A dimensional relationship exists between the element casting the shadow and the surface accepting it.

↑ INDICATION OF DEPTH IN PLAN
Shadow plans indicate the relative heights of individual elements and the relationship between solid and transparent surfaces. This site plan reveals that the tallest element is a circular tower that casts a shadow across the roof surface and onto the ground below.

↓ SHADOWS
Sun studies highlight areas of both sunlight and shade. These three diagrams indicate the shadows created by the morning, noon, and evening sun.

LIGHT AND INTENTION
Place a complex object under a desk lamp and document it under different angles of light. The light can create short and long shadows. Does the orientation of the light enhance or obscure part of the design? Take photographs. How do these compare with the object?

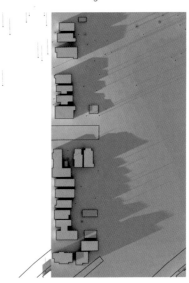

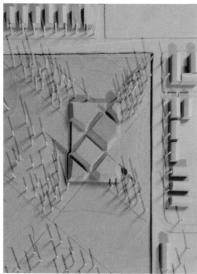

←SCALE IN CONTEXT

In a site model, shadows show the scale and form of a building relative to the topography of the site; they also provide a method of distinguishing the design from the adjacent context.

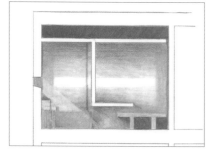

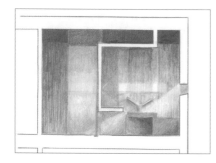

↑RELATIVE INFLUENCE OF LIGHT

In sections, shadows show the influence of light in a space. The farther away the surface is from the light, the darker it is.

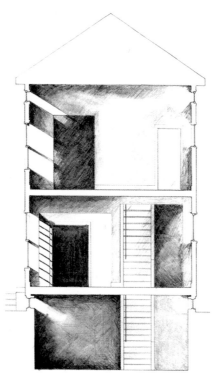

↑NORTH LIGHT

North-facing windows get diffuse natural light. Many artists' studios face north for the evenness of the light quality over the course of the entire day. On rare occasions, light from the north gets reflected off adjacent buildings, creating cast shadows into a space.

LIGHTING TERMINOLOGY

Know a site's sun orientation.
In the northern hemisphere:
- Summer Solstice: June 21 at noon
- Winter Solstice: December 22 at noon

Solar charts provide the correlating height and angle of the sun in the sky relative to a specific location. Note that the summer and winter sun move along different paths in the sky. Closest to the June 21 date, the summer sun rises north of east and sets north of west, while on dates closest to December 22, the winter sun rises south of east and sets south of west.

Sunlight can only be cast onto surfaces.

Light sources can be either the sun or artificial lighting that acts upon an object. The rays of the sun are considered parallel for constructing shadows. This is due to the distance light travels between the sun and the Earth—around 93 million miles. In reality, the sun's rays diverge as they reach the Earth's surface, but this divergence is insignificant relative to shadow casting. In contrast, artificial lights typically emit a radial light due to their proximity to the object.

Shade is the unlit surface of an object.

Shadow is the shape of one object cast onto another surface.

UNIT 33

COLOR, COLLAGE, AND COMPOSITION

Two techniques for enhancing representations include collage and color. Composition also plays a key role in emphasizing elements in a representation.

COLLAGE

In the early 20th century, the Cubist artists Braque and Picasso formally introduced the technique of collage into art. Collage is an abstract method of representation that combines existing images with contrasting materials to create a new image. Collage artist Ben Nicholson describes collage as "an aggregation of various pieces which create an irresistible spectacle in the eye of the maker."

Collage provides a starting point for generating new ideas while reevaluating existing conditions.

↓ RE-CREATING NARRATIVE

This collage from Chris Cornelius of studio:indigenous, titled "Radio Free Alcatraz: Trajectories," illustrates the 19-month American Indian Occupation of Alcatraz Island. The collage method, overlapping site data, historical images, and geometric lines onto Mylar, exploits the narrative of reimagining the place as if Native Americans never left Alcatraz.

READ THIS!

Ben Nicholson
The Appliance House
MIT Press, Cambridge, MA, 1990

Lebbeus Woods
"Lebbeus Woods: Terra Nova
1988–1991,"
Architecture and Urbanism,
extra edition, no. 8, pp, 1–171,
1991

Pamphlet Architecture 1–10
Princeton Architectural Press
NYC, 1999

↑ ABSTRACT OVERLAY

This collage shows an overlay of abstract information to highlight aspects of human scale and the usage of the space. It depicts a feeling of the space, as opposed to the reality of the space.

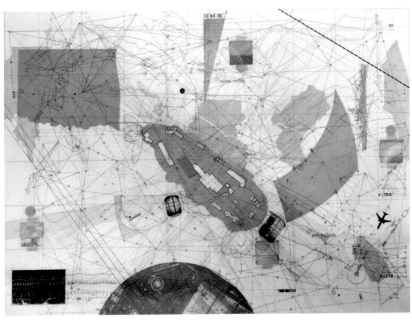

↑ DEPICTING MULTIPLE EXPERIENCES

This drawing depicts multiple representations simultaneously to express the experience of walking through a project called "House for Galileo: A Supposition on Earth, Sky, and Phenomena." The images overlay plan, section, and perspective in a single field, which, when observed intently, work together to give the observer a greater understanding of place and scale.

↓ ENTOURAGE

Entourage establishes scale. It is common in section and perspective drawings to populate the image with people interacting with the space, while furniture is often added to plans.

↑ COLOR AND PAGE COMPOSITION

The page composition of a single image can reflect design intentions. This page is elongated to emphasize the verticality of the architectural design. The marks of the pencil are visually apparent, reinforcing the vertical orientation and giving texture to the red sky. The building surfaces are rendered to evoke the quality of materials.

SLOWING DOWN: MOVING BETWEEN MANUAL AND DIGITAL

Debates about hand-drawn representations and those produced digitally continue in various firms and schools of architecture. Although advances in digital programs have provided new methods of representation, firms such as Lewis.Tsurumaki. Lewis (LTL) and Tod Williams Billie Tsien continue to utilize a combination of hand-constructed representations and digital models to further their architectural ideas. For them, the slowness (or as LTL describes it, the difference between speed and agility versus slowing down) equates with thinking.

The process of manipulation between manual and digital drawing might look something like this:

1. Sketch ideas.
2. Make quick three-dimensional model.
3. Print out—sketch over top.
4. Revise digital model.
5. Reprint and continue sketching.
6. Scan sketches.
7. Manipulate in Photoshop.

↓ Upside House by Lewis.Tsurumaki.Lewis (LTL).

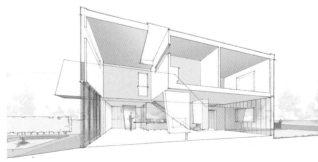

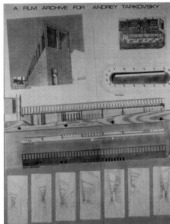

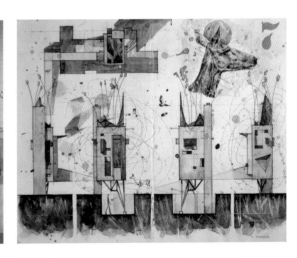

↑ EVOCATIVE GRAPHICS

Historical images can be added to imply relationships with other drawings or time periods. In this image, the scale, location, and color of the graphic lettering recalls the Russian Constructivist era. A turquoise sky and flying dirigible make references to innovation and evoke a sense of the future. The CHC and corresponding numbers indicate the name of the competition, "Capital Hill Climb," and the entry number K017.

↑ COLOR AND COMPOSITION

Color is added selectively in this pencil composition to both the sky of an exterior perspective and the background of the series of interior perspectives. In this case, dynamic color works as a compositional amenity that ties together elements on the page. Too much color could detract from the overall clarity of the board. More color does not equate with more dynamism. There is a clear hierarchy of images within the composition. The section model replaces the section drawing.

↑ TRANSFORMING LINES

These drawings depict plan and section renderings of a speculative dwelling titled "Domicile 07_Thunder Moon" by studio:indigenous. Pencil and watercolor transform the orthographic projections into dynamic representations.

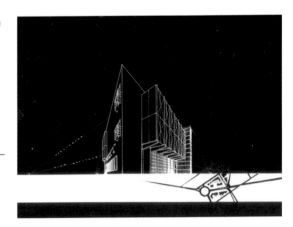

← BLACK-AND-WHITE DUALITY

This composition, a stark black-and-white image, powerfully conveys the cut in the earth and the horizontality of this idea. The project, for a political prisoner, employs the duality of the page to reinforce the single move in the project, a long platform.

↑ HYBRID DRAWING

This drawing combines a site plan and inverted perspective (white lines on a black background), giving a lot of territory on the page to a large, dark sky.

CASE STUDY 4 | DYNAMIC RENDERING

DESIGNERS
bauenstudio, Mo Zell and Marc Roehrle

Renderings have the power to change a well-executed line drawing into something dramatic and dynamic. Materials, textures, and the quality of light can be clearly communicated in these types of drawings.

PROJECT
The addition to a 1950s suburban house in the Providence District of Fairfax County, outside Washington, D.C., consisted of a dining room, mother-in-law suite, and master bedroom suite. The neighborhood is representative of typical 1950s development patterns, with single-family homes situated on small lots. Like many transforming neighborhoods, this one is experiencing the real estate phenomenon known as the "tear-down," whereby the original house is purchased for its land value, then demolished and replaced with a starter mansion. This not only has a socioeconomic effect on the characteristics of the neighborhood but also compromises its native architectural structures and spatial quality. In general, most new homeowners respect these existing housing-stock characteristics and create additions that are appropriate to the scale of the neighborhood. However, many of these additions do not reinforce the communal aspect of the neighborhood.

Traditionally, residential additions are realized as additive elements attached to an existing structure. But when an addition is larger than its host, what should it be called? In this design, the architects address the issue by conceptualizing the addition as an element that is not merely attached to its host, but rather as one that is integrated. They blur the new with the old. When a space has characteristics of both, a rich ambiguity follows.

Spaces that exhibit elements of old and new develop into various shades of gray. For example, a new bookshelf/storage unit defines the boundary of an existing space, becomes a new wood floor that flows into the dining room addition, and leads outside the house to become a terrace, ultimately terminating as a planter. This reorientation coincides with how the neighborhood is inverting the 1950s privatized realm, which traditionally opened the house to the rear.

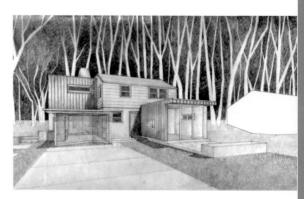

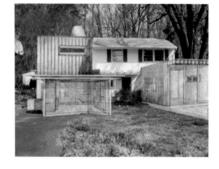

↓ **FLUID DIAGRAMS**
These diagrams indicate the fluid nature of the addition in relation to the existing house. Rooms that are new are given more detail, including floor patterns and furniture.

↑ **RENDERING FOR PURPOSE**
These perspectives show two different rendering techniques: material and sky rendering and photo collage. In each case, the perspective was constructed in pencil to show the formal characteristics of the addition. In the top example, the rendered materials are juxtaposed against an abstracted background, placing a greater emphasis on the transparent elements of the addition. A connection between the interior and exterior is clearer. The photo collage (bottom) makes what is old and new clearer.

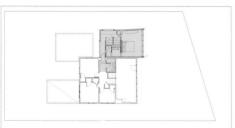

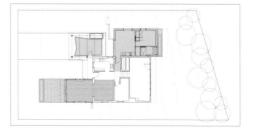

UNIT 34

ADDITION AND SUBTRACTION

The city street can be imagined as a spatial container and not only the result of the buildings that line it. This conceptualization of space—that is, the void between buildings or walls—can be applied to a variety of scales, including the city, a building, a room, or an object.

To facilitate this conceptualization process, space must be considered as a physical entity—a shapable thing that is concisely defined rather than residual. It is a medium to work with and within, rather than the resultant of walls, floors, and ceilings. Space can be visualized when carved out of a solid element, whether in a physical model or three-dimensional computer model, and when thought of as a cast of an interior space. The process of carving, which is ultimately a process of reduction, is very different from the more typical additive process of joining materials together to represent a space. This contrasts with the additive conceptualization of the earlier kit of parts assignment (see page 113).

READ THIS!

Chris Townsend and
Jennifer R. Cross
The Art of Rachel Whiteread
Thames & Hudson, 2004

DESIGN TIPS

Research/history: includes typology studies—see what others have done before you.

Existing conditions: know the site and context—what is the history of the site? Include the physical, social, economic, and cultural context.

← ↓ →SUBTRACTIVE QUALITY
Foam can be carved and manipulated. Its subtractive quality is reminiscent of figure-ground plans (see page 59), where contained and well-defined spaces are juxtaposed against well-defined solids.

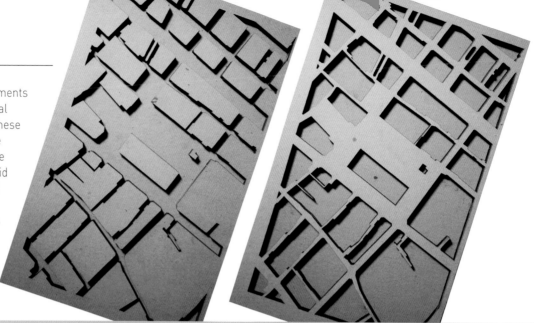

3-D FIGURE-GROUND MAPS →

Figure-ground maps of urban environments can be re-created as three-dimensional models. The methodology of making these models with a laser cutter enables the simultaneous construction of a positive model (left), in which buildings are solid additions, and a negative model (right) where the spaces between the buildings are solid, while the buildings themselves are subtracted. These models depict the buildings and spaces in the area around the Pompidou Center in Paris.

SPATIAL ANALYSIS

This sequence of studies created in SketchUp depicts a variety of spatial volumes defined by the design of an outdoor classroom. The outdoor classroom in the center, the rectangular form, intersects with other spaces at a variety of scales. Some volumes of space are defined by the cornice line of the perimeter buildings (see Image 2), while other spaces are defined by the adjacent buildings (see Image 4). Image 3 indicates a spatial connection between the site and adjacent circulation spaces.

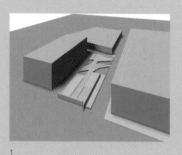

1

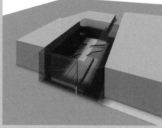

2

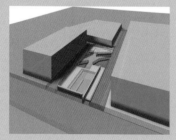

3

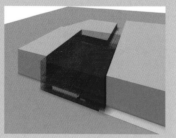

4

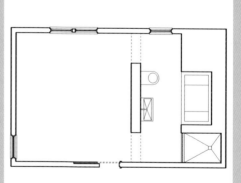

← SPACES

This plan and accompanying series of diagrams depict the overlap of a series of spaces. Alignments between rooms allows for one space to flow into another.

ASSIGNMENT 17 | SPACE FOR A TRAVELER

BRIEF

Design a temporary place for one person to stay at after an overnight flight. The room is located inside the airline's arrival lounge at Heathrow Airport in London, with a view of the tarmac, and can represent either:

- A middle room with only one exterior wall condition, or
- A corner room with two exterior wall conditions.

The room is for bathing, changing clothes, working, or relaxing. It should include a space for a suitcase and hanging clothes; a steam room or sauna; a toilet; a TV; a space for writing; and a place for rest, such as a chaise lounge.

PROCESS

Design an innovative, thoughtful lounge space for the traveler. Suspend any preconceived notions of familiar objects. Words like bed, bathroom, and shower have not been used to dissuade you from assembling familiar objects like these and simply arranging them in the space.

Reconceptualize the items that are typically found in a hotel room. What is the essence of a shower, bed, or closet? What is the scale associated with each? How does a person interact with each?

REM KOOLHAAS

Rem Koolhaas (Dutch, b. 1944) is a writer turned architect, theorist, and urban planner. In 1978 he wrote his seminal treaty, *Delirious New York*. In this manifesto, Koolhaas explores the history of New York City and the consequences of the 1807 matrix that divided the city into 2,028 blocks. In 1975 he established his office, OMA (Office for Metropolitan Architecture), which has built critically acclaimed structures around the world. Koolhaas's work is best typified by his interest in programming and diagramming. For his design of the Seattle Public Library, Koolhaas analyzed historical precedents coupled with speculations about the future uses of the library, the storage and display of information, and how future generations might socialize and interact.

EXPLORING RELATIONSHIPS→
This collage explores the acts of cleansing and viewing. The view becomes obstructed by the water.

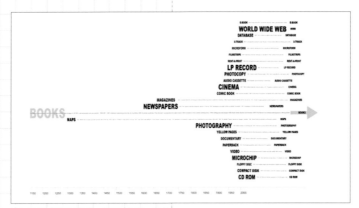

↑ **ANALYSIS DIAGRAM**
This analytic design diagram from the Seattle Public Library competition proposal by OMA integrates text, data, and architectural form.

HIERARCHICAL→ CONNECTION
Service elements are pushed to the edge of this "room for repose" space. All are kept to a low height to maintain a visual connection with the raised element at the end of the space— the bath.

Pragmatics alone will not be sufficient to solve this problem. Critically examine activities and associated rituals. Pay particular attention to body measurements, movement, routine, and scale. Due to the intimate nature of the space, consider materials carefully.

The overall area is limited to 240 sq. ft (23 sq. m); however, final room dimensions can vary. The smallest room dimension is 6 x 40 ft (1.8 x 12.2 m), with entry along the shorter wall. The view from the room will be to the south. A corner room occupies the southeast corner of the floor. The clear height in the room is 12 ft (3.7 m). The ceiling height may not be modified to less than 6 ft 8 in. (2 m). Assume a roof thickness of 18 in. (45.7 cm), a 12-in. (30.5-cm) block exterior load-bearing wall, and interior perimeter walls of the room at 6 in. (15.2 cm) minimum. Walls added inside the room may be of any thickness. You may change the floor topography, but entry into the room must be at one level. The floor is 42 in. (1.1 m) thick and can be carved into up to a depth of 36 in. (91.4 cm).

STARTING THE DESIGN PROCESS

TAKE ACTION

- Make a series of at least five sketches that represent the action of showering from the point of view of the person taking the shower. Think about movement and action, as well as the space required for bathroom activities.
- Define ritual, repose, procession, threshold, and routine.
- Research body proportions and the dimensions associated with bathing, relaxing, and minimal sleeping spaces.
- Ask questions: What is a good height for sitting, leaning, or standing under things?
- Measure and document the space the body occupies while performing activities such as sitting, lying down, and reading.
- Find historical precedents.
- Research bathrooms and hotel rooms. Consider other examples that deal with the challenge of a small space, such as submarines, train cars, ships, or RVs.

COME UP WITH IDEAS

Assess and analyze the research. Try to articulate your ideas from this research. Represent the ideas through drawing and modeling.

EXPLORE THE IDEAS

Consider how to separate or combine wet and dry spaces. How can a ritual be conveyed? Consider how the body moves through the space. Consider each element. For example: sink—what is a sink? How tall is it? Where does the water come out? What material? Why is it there? Do you need a basin? When do you use it? Upon entry? Apply these types of questions to every element in the room. Focus on the relationship between fixtures, walls, occupied space, and the body.

Make three study models at $1/8$ or $1/4$ in. scale, exploring different ideas. Create a series of sketch perspectives of views inside the spaces. Diagram the ideas. Keep them simple. Repeat these exercises throughout the process.

The final set of drawings should be completed at $3/8$ in. scale and include sections, a plan, and various three-dimensional representations, including a model.

↑ DESIGN IDEAS
Record design ideas in a sketchbook using a variety of representation techniques.

CASE STUDY 5 | VETERANS MEMORIAL COMPETITION

Design competitions are a means for architecture firms to acquire work and to achieve recognition. Emerging firms have the opportunity to compete for projects against more established ones. Competitions do not always provide the winners with the opportunity to build the winning project. Many are "ideas competitions" where potential solutions are prioritized over actualizing the winning design.

COMPETITION BRIEF

Design a veterans memorial for a university on its urban campus for up to 400 veterans who lost their lives in combat.

DESIGNERS

bauenstudio, Mo Zell and Marc Roehrle

CONCEPTS

Three parallel elements organize the site: two spatial and one vertical. A black granite wall, contemplative garden, and public plaza are situated in a manner that allows for multiple readings of the space.

Interwoven within the garden is a paved ground plane abstracting the American flag with 13 strips and 50 lights. Birch trees to the north and east act as framing devices. Orchestrated views ensure a balance between the spaces being visually protected, while being appropriately open for ceremonial activities.

The black granite wall is double-sided. Its southern elevation faces the campus and serves as a backdrop to campus life, while the northern, contemplative side reflects the intimate nature of war and loss. The public side features a laser-etched mural depicting images of conflicts. The private side is the focal point of the memorial, with each soldier represented by a single stainless-steel plate. The 278 plates, which reflect the faces of the visitors, unite the dead with the living. They are designed to be touched and lifted, representing each soldier's individuality and expressing the bond soldiers form. The plates are organized randomly; however, the physical search for names on the wall allows the visitor to engage with other fallen soldiers discovered through the personal information on the abstracted plates.

CAMPUS CONCEPTS

The design reclaimed residual space on an urban campus using two strategies:
- Creating a more formalized space.
- Orchestrating a visual sequence to create connections between campus circulation and place.

VISIT THESE

- Sir Edwin Lutyens' "Thiepval Memorial to the Missing," Thiepval, France
- Vietnam War Memorial, Washington, D.C.
- Jewish Memorial, Berlin
- World Trade Center Memorial, New York

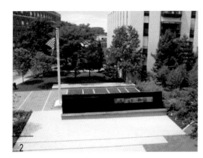
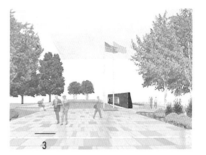

↑ RANGE OF REPRESENTATIONS

A basswood model (1) used during the design process to test the spatial clarity of the project can now be compared to the built project (2). The perspective representation (3), used for fundraising efforts to present a realistic image of what was to be built, emphasizes the space defined by the memorial wall.

CASE STUDY 6 | ARCHITECTURAL MOCK-UPS

Representations of architectural ideas through scale models and drawings have limitations. However, the construction of full-scale objects and building components can provide the translation of an idea into reality.

PHASE 1: TEMPORARY PLAN INSTALLATIONS

Take the plans from the 240 sq. ft (23 sq. m) Space for a Traveler (see page 128) and temporarily transfer them onto a flat surface using materials such as tape, chalk, string, cans, light, and people to create a full-scale installation. Once the installation is in place, walk through the designs to experience the relationship of one component to the next and begin to get a sense of the spaces created.

PHASE 2: FULL-SCALE MOCK-UP

Construct a full-scale mock-up of the Space for a Traveler project. Use string and paper or other temporary materials. Find a place that can accommodate this type of activity. This provides a translation of architecture as representation to architecture as real space. Structural, spatial, and material considerations become apparent in full-scale mock-ups.

↓MAKING SPACE
Students use the existing infrastructure of a building to construct the room for a traveler using rope and paper. This temporary space allowed students to look at the processes associated with construction, teamwork, and space making.

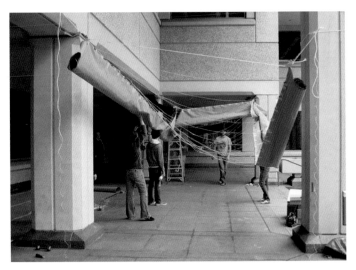
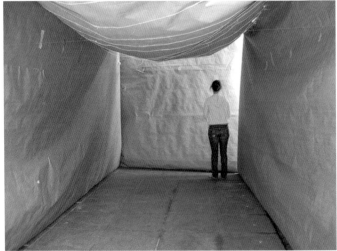

UNIT 35

MOVING BETWEEN REPRESENTATIONS

Hand-drawing provides the most direct way to transfer your thoughts onto paper. A knowledge of how to construct two- and three-dimensional images, as well as an ability to think through ideas by transcribing them through your hand onto paper and analyze ideas through sketches, provides the foundation for architectural design.

Although digital software has become more sophisticated, drawing by hand is still a necessary skill and asset. It provides the most direct connection between your ideas and the page. Digital programs are tools of design, just like the pencil. Learn when to use each and what their capabilities and limitations are, and determine which tools are best suited for each task. Knowing how to use the variety of tools available means staying in control of them.

One limitation in using digital tools is in the translation from screen to paper. The printer type and its capabilities will determine much of the color and resolution of printed images.

LEARN HOW TO:
- Draw by hand/sketch.
- Craft models.
- Use digital programs.
- Move between digital and manual platforms.
- Think and see three-dimensionally.

ZAHA HADID

The prominence of Zaha Hadid (Iraqi, b 1950, d. 2016) on the international architectural scene is notable, not only for the significance of the body of work she produced (both conceptual and built), but also because of the culture in which she did it. Zaha was a lone woman in a field of men. She was the first woman to receive the Pritzker Prize (in 2004) and the first woman to be awarded the Royal Gold Medal from the Royal Institute of British Architects (in 2015). Her prominence in both male-dominated academe and the profession is a testament to the relevance of her work. Zaha's collaborative practice with artists, designers, and engineers has resulted in internationally recognized projects that rigorously integrate architecture and landscape with cutting-edge technology.

↑ INTERPRETING SITE AND CULTURE
Zaha Hadid's design for the Heydar Aliyev Center in Baku, Azerbaijan, blurs the interior and exterior, wall and ceiling, floor and wall. With one continuous surface, the building and landscape merge through the undulations, flows, and folds of spaces. The structure is managed through advanced computation.

CASE STUDY 7 | SINGLE SPEED DESIGN—FROM DIGITAL TO FABRICATION

DESIGNERS

Single Speed Design, Jinhee Park and
John Hong

Advances in digital technology allow architects
to visualize complex geometries quickly. This
large-scale model, called the ACC Bench, was
developed using the software CATIA. Factors
such as the flexural ability of plywood were input
as generative rules for developing the curves.

Finally, the three-dimensional form was
converted into a two-dimensional projection
so that pieces that were curved in two axes could
be cut from perfectly flat material. Interestingly,
the orthographic projection became most
important in making the leap from digital
to reality.

↓ FROM 2-D TO 3-D
The 2-D plywood forms were
bent into the 3-D volumes:
full-scale digital templates
allowed the simple translation
from 2-D to 3-D.

← DIGITAL MODEL
This screenshot of the
CATIA model shows the
construction components
in 3-D form.

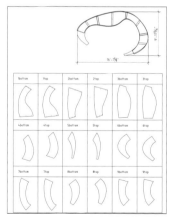

← 3-D BECOMES 2-D
The curvilinear
forms were
converted into
2-D projections
for templating.

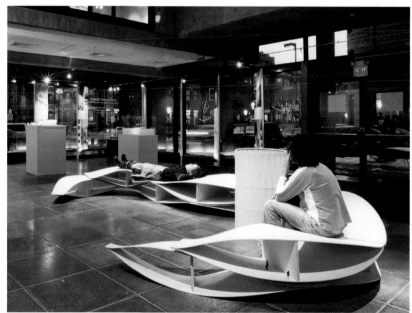

MODEL AS FURNITURE →
By bending a thin material into
a honeycomb structure, the
structural concept was tested
at a larger scale.

CHAPTER 7

ACCESSING THE PROFESSION

This chapter will clarify the various options for joining the profession, the current degrees available from architecture schools in the U.S., and the different types of programs. Mysteries and myths about the architecture profession will also be dispelled. Television shows, lay people, and the media often perpetuate these myths.

UNIT 36

A CAREER IN ARCHITECTURE

Architects must be both creative and practical. Their imaginative designs are based on technical knowledge, while their communication skills are necessary to correspond effectively with clients, contractors, and local councils.

A career in architecture suits anyone who is passionate about changing the world. Architects leave their mark on the built environment through thoughtful interrogations of site, context, society, cultures, and politics. Architects work on a variety of project types, including private dwellings, adaptive reuse (the redeveloping of existing structures into new programs), and large-scale commercial or industrial commissions. The process of design can be applied to any scale of project, whether it's small-scale, as in the case of furniture, or large-scale, such as a city.

Architects can work in large or small practices in both the private or public sector and for local or national government agencies. No matter which type of practice an architect chooses, collaboration is a critical component of practice. This might include discussions with clients, consultants, engineers, local communities, and subject-matter experts.

Before architects can be licensed, or call themselves architects, they typically have to complete three phases: education, practical experience, and examination.

EDUCATION

Education, with an eye toward licensure, involves studying at an accredited program of architecture. Schools offer a variety of different areas of interest, so make sure to find a school that meets your needs, interests, location, and price tag. Given the variety of options available in schools, it is best to verify current education requirements at one of the registration and licensing websites.

Architecture school prepares graduates to be critical thinkers, to analyze problems, and to generate multiple solutions to problems. There is no one single solution

WEBSITES

Architecture sources:

www.archinect.com
www.archdaily.com
www.architizer.com
www.imadethat.com
www.archpaper.com

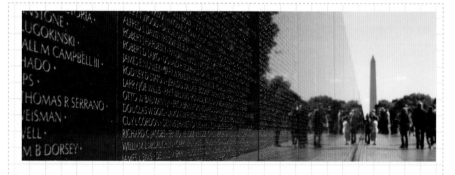

MAYA LIN

Maya Lin (American, b. 1959) is best known for designing the Vietnam War Memorial in Washington, D.C. (above). Her projects, which include installations, sculpture, land art, and architecture, possess the same spatial clarity and cultural relevance of that seminal monument. Lin is an environmental artist whose works foreground the cultural and physical alliance and interdependency between mankind and nature, while offering a lens through which we can better understand this relationship. Her process includes a strong verbal and written component to allow her to explore the projects' intentions and meaning. Lin's extensive body of work reflects changes in the normative notions of the profession.

to an architectural question. Skills that are learned while in school offer a graduate a multitude of career opportunities, which include pursuing practical experience and licensure in architecture, but also professions such as:

Animation
Community engagement
Construction
Construction management
Engineering
Fashion design
Film
GIS analysis
Graphic design
Industrial design
Interior design
Landscape architecture
Law
Lighting design
Marketing
Music
Photography
Real estate development
Set design
Teaching
Urban planning
Web design

EXPERIENCE

Experience in an office is an excellent way to see how professional practice works. These experiences can take the form of very short externships, summer internships, or full-time employment as an intern.

Externship

Students participating in short immersive externships in a design firm, typically for one to two weeks, can discover and explore various career opportunities. Externships are considered short, practical experiences. While participating in externships, students mix classroom knowledge with real-world experience. They broaden their network, gaining professional contacts that serve as mentors during the experience. In many cases, the externship helps with the transition from school to professional practice. Hands-on activities during the externship include conducting research, doing scripted exercises, attending city planning or client meetings, and visiting construction sites. Most students experience some form of job shadowing during their time with the host firm. Firms offer a variety of experiences, changing the daily activities in such a way that externs see almost every facet of the firm's undertakings over a five-day period.

Internship

Graduates or students can immerse themselves in all phases of design when participating in an internship. These longer experiences mirror activities in professional practice and provide opportunities to develop the necessary proficiencies to become a licensed architect. Internships provide the opportunity to explore, develop, and refine the wide range of skills necessary to practice architecture.

EXAMINATION

At the completion of the educational requirements and practical experiences, many municipalities require you to take an exam to become a registered architect.

WEBSITE

For more information, visit:
www.studyarchitecture.com/an-

MYTHS

To be an architect, you have to be good at math.
Knowing basic geometry, algebra, and calculus is helpful in the study of architecture. But more important than having high-level math skills is having a creative and open mind.

To be an architect, you have to be a good artist.
Though knowing how to draw is certainly a valuable skill, it is not necessary when entering architecture school. More important is a willingness to learn and practice. Sketching and drawing are skills that can be learned.

Architects make a lot of money.
The starting salary from graduate school might be anywhere between $34,000 and $52,000, depending on location, market, construction cycle, economy (local, national, and global), experience, and the type of firm. Passion for changing the world—not money—should be the motivation for becoming an architect.

You should have an area of specialization.
Design is a skill that is applicable to all scales and projects. Specializing in one area over another is not required. Firms develop expertise in designing certain types of projects, but it takes an educated client to understand that architects who are well trained can design anything from furniture, to a building, to a city.

DESIGN PORTFOLIO

A portfolio is a carefully curated visual record of design work. It is not necessarily a collection of all work, but a collection of projects that demonstrates a specific aspect of design. It is also a high-quality representation of the design process. Consider carefully which projects to include in your portfolio and how much of each project to include.

PORTFOLIO PRESENTATION →
The presentation of the content and the organization of the booklet should be a reflection of you, your skills, and your aesthetics. Be concise; edit your work. Summarize project information in a clear, concise manner.

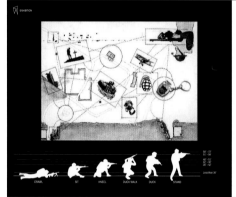 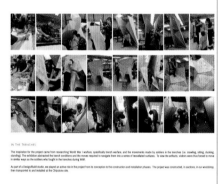

Portfolios are needed for various audiences:

ENTRY INTO ARCHITECTURE SCHOOL
This portfolio includes images that express your creativity and thought processes. Undergraduate admissions committees are not expecting architectural images in this portfolio.

STUDENT PORTFOLIO
Includes academic design projects and any additional relevant course work, such as photographs, paintings, or sculpture.

COMPETITION/GRANT/FELLOWSHIP
Depending on the brief, this may emphasize one particular aspect of your work over another.

PROFESSIONAL PORTFOLIO
Includes finished images of your completed built work to show to potential clients.

CUSTOMIZE EACH PORTFOLIO
Portfolios should reflect your ability to think through problems—that is, highlight your process of design. With digital drawings and models becoming so ubiquitous, it will typically be your problem-solving skills that set you apart from others. For process images, include sketches, study models, process models, and diagrams. In addition, the process representations need to be supported by beautiful, well-crafted final presentation drawings and models. Show a variety of work in the portfolio, including orthographic drawings, as well as

three-dimensional images and models.
 Everything about your portfolio should be carefully considered: the page size, layout, number of images per page and per project, the location and size of the images, and the amount and size of text. Fix or modify any drawings that do not meet an "excellence criteria" before including them in your portfolio. Establish a pattern for your portfolio—a system that is flexible but recognizable from page to page. Look at how books and magazines are organized. Consider creating a two-page spread versus a single-page layout. Think graphically about the booklet itself. The design of the portfolio parallels all other design projects. It is an iterative process that takes time and multiple edits.

READ THIS!

Margaret Fletcher
*Constructing the Persuasive Portfolio:
The Only Primer You'll Ever Need*
Routledge, 2016

John Kane
A Type Primer
Laurence King, 2nd edition, 2011

Ellen Lupton
*Thinking with Type: A Critical Guide
for Designers, Writers, Editors,
& Students*
Princeton Architectural Press, 2010

↓DYNAMIC LAYOUT
This full-bleed spread is used strategically to introduce a project, while these 32 small serial images aggregate into a singular field, representing one large image.

TEXT AND FONTS
Text is visual information that is a part of the composition. Keep text short. Pick fonts that support the narrative of the portfolio and the images. In general, don't center text; align it with the edge of an image. Never stretch text. Limit your use of bold and italics. When flipping through the portfolio, if you notice the layout before the content of a page, then you should rework it. If you see the font before you see the content, find a new, less dominant font.

ORGANIZATION
Place your best work at the beginning of the portfolio. You need to capture your audience's interest with your best design and best representations. Usually the first project should also be one of your more complex projects. In general, provide 1–4 pages for each project. This will depend on the complexity of the project, the type of representations you have for the project, and your audience.

BINDING
There are several binding options available, including perfect bound, spiral, and wire. Do not use cheap plastic binders or clear covers. There are excellent durable binders made of leather or metal, although these can be cost-prohibitive when sending out multiple copies of your portfolio. Making your own binding with tape and fasteners is another option. If you will be changing your portfolio often, make sure to consider how that works with your binding options. Print-on-demand is the most common method for printing portfolios. Sites such as www.lulu.com or www.blurb.com are worth visiting.

PATTERN
Place repetitive elements in the same location on each page. For example, in this book, each chapter has a number associated with it that is located in the same place, on the first page of the chapter, on the same side of the spread. Do not let the organization of your book disrupt its content.

PAPER
Make sure to use high-quality paper. Buying the right paper brand for your printer makes for better printing. Heavyweight, coated matte, or glossy paper is often used for portfolio printing.

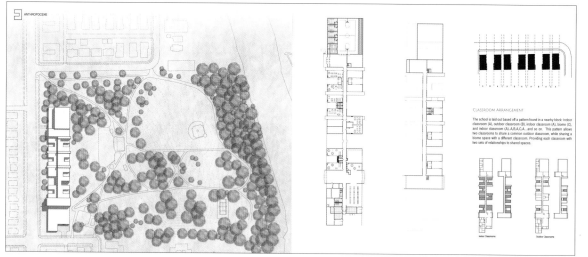

←HIERARCHY OF IMAGES
Make sure to include both big and small images. Each page or spread should have a "most important" image. This image should be the largest, in color, or identified in some way as being the most important.

DIVERSITY OF WORK

In academic portfolios, it is helpful to show a variety of high-quality design work. Do not allow personal feelings or sentiment to sway your decisions in this area. For example, include photographs and artwork that are critical and compelling, but not because they contain an image of your favorite pet. In general, you can include images of photography, graphic design, painting, sculpture, drawing, and furniture.

As you gain experience in the profession, start to include professional work in your portfolio. Remember to credit the appropriate firm, and state your role in the design, drawing, or development of the images presented.

Details from construction document sets are good to include, especially if you worked on, designed, or contributed to them in some way. Make sure you understand the content of the detail, and be prepared to explain it to someone else during an interview.

DOCUMENTATION

Do not include original work in your portfolio. You should either scan or photograph your artwork.

To document models and charcoal drawings, you will need a high-quality digital camera. If you shoot inside, use lights and a black or white sheet as a backdrop. If you shoot outside, use the sun as your light source. Models cast shadows in the sun,

↓ USING THE PAGE
Your portfolio pages are similar to your drawing sheets. Use the white of the paper as part of your composition strategy.

so align your model to its solar orientation. Be aware that white materials have a tendency to get a little washed out in sunlight. Overcast days provide a gentle, flat light that is best for shooting. Minimize background clutter from photographs.

To document flat work, use a scanner. Small-format scanners work well in case you do not have access to a large-format scanner. Copy stores charge a range of prices for large-format scanners, usually based on square feet or the area of paper to be scanned. Scan images at a minimum of 300 dpi in grayscale or color. Save the images as a jpeg or tif.

Document final design images and the design process for each project so that in the future you have a greater selection of images from which to choose. Include idea sketches, study models, and process models as documentation.

Digital programs such as Adobe Photoshop are used to clean up images, while Adobe InDesign can be used to organize your page layouts.

RESUMÉ
Your resumé is another form of design representation. It will be visually assessed in the same way as your portfolio. Therefore, it is critical that you select a good font. Font choice for your resumé should be consistent with your portfolio. Be descriptive and clear about your previous jobs and your roles related to each job. Include all relevant work experience. Treat the resumé like a design problem: assess the existing logic and common formats, learn from them, and modify as needed. Update your resumé and portfolio often.

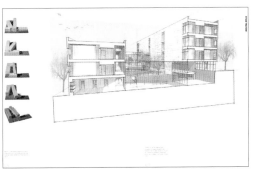

←OTHER EXAMPLES OF DESIGN WORK
This series of pages shows the introduction and follow-up pages for a series on furniture design produced for an academic graduate portfolio.

1 Introduction to the new project

2 Title page of the project

3 Project details

←HIERARCHY OF ELEMENTS
This portfolio spread uses a large sectional perspective and a series of small massing models to emphasize the courtyard space as being important.

UNIT 38

WORK EXPERIENCE

Work experience is an important part of an architectural education. A position in a firm allows you to see first-hand how different practices create and think about architecture. Office experiences provide opportunities to work on all phases of a project, from schematic design to construction administration. Given that there is a range of firm sizes and types, it is important to figure out which is best for you.

↓ THE INTERN'S ROLE
Working in a design office usually entails collaboration with colleagues, consultants, communities, and clients. Activities can vary from drawing and modeling to attending client and consultant meetings.

One thing you might discover when working in an office is the diversity of activities performed by everyone. While on the job, absorb everything, ask lots of questions, listen, and don't be afraid to give an opinion.

COMMUNITY ENGAGEMENT
Working in architecture means working in and with various communities. Community engagement is about building relationships with local stakeholders so designers can better understand the needs of a community, examine those in collaboration with community members (as a form of research), and then interpret or translate those ideas into spaces and places that serve the community.

WEBSITE

Check out the Buildings-Landscapes-Cultures Field School at *http://thefieldschool.weebly.com* for more on community engagement.

← COMMUNITY RELATIONSHIPS
Tools and outcomes from a community engagement process.

CASE STUDY 8 | WORKING FOR A NONCONVENTIONAL OFFICE

DESIGNERS
Design Corps (www.designcorps.org)

CAUSE
North Carolina is home to one of the largest farmworker populations in the U.S. According to the National Center for Farmworker Health, migrant farm labor supports a $28 billion fruit and vegetable industry in the U.S., the majority of which is hand harvested. Despite their integral role in the food economy, farmworkers are some of the most economically disadvantaged people in the U.S.—many earn less than $10,000 annually, and over 60% of families have below-poverty-level incomes. Low income correlates with poor housing conditions, which are often substandard or nonexistent. Even "Gold Star" growers, who are providing some of the best housing options, only meet state codes that require only one wash tub for every 30 workers, one shower for every 10 workers, and one toilet for every 15 workers, and do not require mattresses or telephone access in case of emergency. Overcrowding, inadequate sanitation, and unsafe structural defects are just some of the realities of farmworker housing.

Design Corps has developed the Farmworker Housing Program to build quality new housing on farms. The program is a partnership that involves the farmers and workers in the process of developing the design and making it affordable through the assistance of federal funds. This project, a pilot for housing in North Carolina, is designed for former farmworkers who have lived in the challenging farmworker housing conditions and are determined to set higher standards for farmworker housing.

METHOD
Design Corps' vision is realized when people are involved in the decisions that shape their lives. This design process involves a synthesis of ideas from three major stakeholders: the farmer, the farmworker, and the State Housing Finance Agency. This participatory process is composed of meetings, surveys, and discussions, and is integrated with material and manufactured housing research to provide housing options that are affordable, durable, and sustainable.

DESIGN CORPS DESIGN PROCESS COMPONENTS

1. Participatory process
Farmworker surveys, site visits, and research are key components.

2. Healthy housing
The ambition is to improve the lives of farmworkers through design that responds to principles of decent and healthy housing, consideration for cultural customs, and daily routines.

3. Manufacturing process
This project makes use of the benefits of manufactured housing, including economy, speed, and minimization of waste. In recognition of some of the limitations of manufactured housing, including standard dimensions and material options, this project is a synthesis of a manufactured unit and a site-built portion that integrates the manufactured unit into the site. Addressing issues of solar orientation, cross ventilation, and square footage, the site-built portion is completed by a ceneral contractor. Working with a general contractor allows for modifications to the manufactured portion and introduction of as many energy and sustainable material strategies as possible.

4. Sustainability
The design integrates strategies that respond to issues of sustainability, economy, and durability. Some strategies include passive solar, light-colored enclosure systems; cross-ventilation; and low-flow fixtures. An outdoor garden is designed to assist with solar gain and also to address and ameliorate conditions of food insecurity in farmworker populations.

5. Impact
The project outcome addresses the cause in a significant manner: How does the solution function in context? What changes or resulting outcomes were documented in participants, communities, and/or audiences?

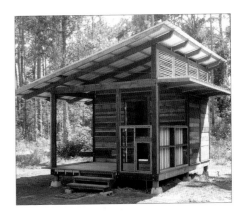

↑ DESIGN FOR OTHERS
This shed for FEMA trailer residents on the Gulf Coast was designed and built by Design Corps after Hurricane Katrina in 2005.

UNIT 39

MAKING AT FULL-SCALE

Many design/build projects can be categorized as exhibitions, installations, and pavilions. They can be temporary or permanent, which in turn reflects material choices, budgets, and methods of construction.

The translation of abstract representations into full-scale construction is an important part of an architect's education. Typically described as the design/build project or studio, these form a powerful and effective method of teaching architecture students about a broad range of issues. These include, but are not limited to, tectonic construction, material inquiry, and community engagement. Design/build is a way to move students out of the classroom. Design/build projects negotiate between architecture as abstraction and architecture as construction, where design intent becomes full-scale constructions with all of the attendant risks and rewards.

READ THIS!
S. Bonnemaison & Ronit Eisenbach
*Installations by Architects:
Experiments in Building and Design,*
2009

Markus Miessen and Shumon Basar, eds.
*Did Someone Say Participate?
An Atlas of Spatial Practice,*
2006

WEBSITES
www.dbxchange.eu
www.archdaily.com/category/installation

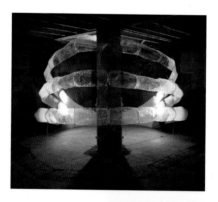

↓ ←NONTRADITIONAL EXHIBITION
A series of cast epoxy panels warp into a curved space to surround a stoneware pitcher in this nontraditional exhibition. The panels are lit to emphasize their transparency against the backdrop of the dimly lit room.

EXHIBITIONS
Architectural exhibitions are typically public displays of work in association with museums, galleries, or other places of exhibition. Exhibitions often use the museum collection as a context in which to research, question, and construct narratives. An exhibition has internal and external roles: operational roles within the context of a collection, the context of the museum (or the holder of the collection); physical roles within the context of material investigations and user experience; societal roles that challenge public perceptions, invoke knowledge creation, and question the art.

EXAMPLES:
- Venice Bienniale
- Chicago Architecture Biennial
- 5x5: Participatory Provocations (an exhibit of 25 architectural models by 25 young American architects)

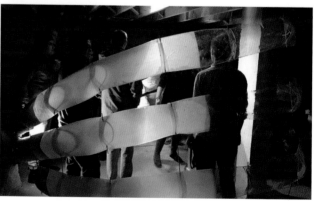

CASE STUDY 9 | BLENDING EXHIBITION AND INSTALLATION

PROJECT

(Un)making the museum—the museum exhibition was used as a vehicle for questioning and provoking issues relevant to architecture, culture, and society. The project exploits the connection between pleasure and necessity as they relate to objects (collection), installation (form and materials), and culture (society). The museum is not a neutral context in which to display a collection of art. The exhibition's size, shape, color, text, frame, material, and narrative influence the reading of art. Objects are not presented in their original contexts and require interpretation and explanation. Design a room that provokes new ways of seeing, understanding, and experiencing art.

PARTNER

The Chipstone Foundation

DESIGNERS

UWM SARUP architecture students: Kelsey Dettmann, Kayla De Vares, Sarah Grieve, Garett Tomesh

PROCESS

1. Object research What is the collection? How are the objects handled?
2. Exhibition research What objects are on display? What scale are the objects?
3. Prototyping and material research Preliminary design. Develop the site; model different design ideas; project an attitude about exhibitions; inquiry.
4. Installation

BUILD THE INSTALLATION

WWI porcelain souvenirs, seen as "trophies" from the battlefield, represent people's pride in architectural achievements and the sadness of personal and national loss. Through the abstraction of a trench, this installation explores how the artifacts relate to each other and the visitors, via their placement and the position of the body relative to the artifacts.

INSPIRATION

The exhibition abstracted the trench conditions and the moves required to navigate them into a series of tessellated surfaces. To view the artifacts, visitors are forced to move in similar ways to the soldiers who fought in the trenches during WWI.

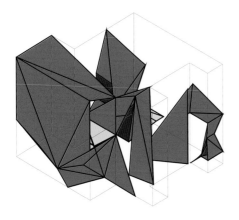

↑ TEST DIAGRAMS
Diagrams were used to test the sloped panels in this exhibition for a series of souvenir ceramic toys from World War I.

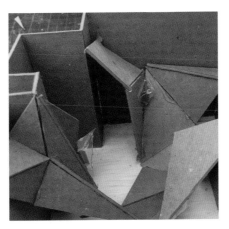

↑ STUDY MODELS
Initial design ideas were tested using study models.

↑ ENGAGING EXHIBIT
The souvenir toys are "hidden" from view unless visitors move and engage with the exhibition. The space is dimly lit to mirror the uncertainty of life in the trenches.

INSTALLATIONS

An installation is a temporary form of architecture that typically does not distinguish between interior and exterior. For installations, experience is the currency—with no assigned programming—with the power of human agency changing the unprogrammed to one that empowers the individual with control of the space.

Installations offer critique. They require a critical stance, one that provides opportunities, not only to solve problems, but also to ask questions. Their temporality requires a plan for both construction and deconstruction, which in turn raises ethical questions about materiality and waste. They typically operate at a scale that is larger than a piece of furniture, but smaller than a room.

Installations (works that eschew the permanence of building enclosure) operate at the confluence of art, architecture, performance, and technology. Installations explore the breadth of architecture, not as building, but as space and experience—by creating human interactions that negotiate between new spaces and the surrounding context in a manner that provokes dialogue, response, and discussion. Installations can serve as a catalyst for action.

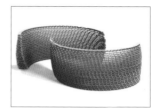
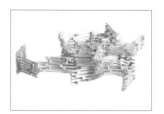

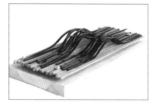

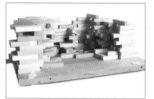
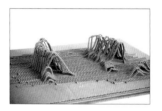

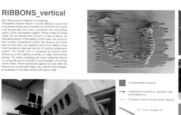

EXO_skeleton

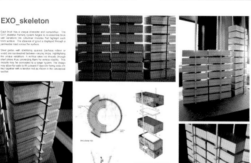

RIBBONS_vertical

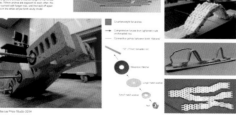

↑ **STUDY MODELS**
The design process included making study models to test form and aggregation.

← **SHEET STUDIES**
These sheets depict early studies that were used to test material, assembly, and component parts.

CASE STUDY 10 | TEMPORARY BRICK PAVILION I

PROJECT

Create a temporary pavilion using masonry. Traditional assumption: Masonry is only for permanent structures.

DESIGNERS

UWM Marcus Prize Studio co-taught with Sou Fujimoto and Associate Professor Mo Zell

STUDENTS

Laura Gainer, Robert Guertin, Bradley Hopper, Jared Kraft, Travis Nissen, Aubree Park, Ben Penlesky, Dustin Roosa, Damian Rozkuszka, Jimmy Sequenz, Nathan Waddell, and Kelly Yuen

PROPOSAL

Rethink brick to create a new masonry-construction assembly that acts as a lightweight and short-term material by exploring new options for the joint.

PROCESS

Students researched brick and its historic significance in Milwaukee. Bricks weigh 4–5 lb (1.8–2.27 kg), depending on their core pattern, the number of cores, and the aggregate material. Students generated study models, drawings, and full-scale mock-ups (portions of a building assembly system) to test their ideas about material, assembly, human interactions, and space.

SITE

This undeveloped property sits on a bluff near Lake Michigan.

SOLUTION

Through material explorations, this studio designed a method of linking bricks into what appear to be soft, billowing arches (using no mortar), giving the traditionally heavy material a feeling of lightness and playfulness. These arches combine to form a rippling brick carpet that invites human interaction. In doing so, the traditional pavilion is subverted. The installation engages conventional ways of how the body might utilize a pavilion, but those experiences are aggregated in a new way. Though the brick and wood are both familiar building components, it is the assembly of those parts that changes our expectations of the pavilion.

Plywood gaskets measuring ½ in. (1 cm) replaced mortar joints. These gaskets were predrilled and positioned between five-hole bricks (measuring 3⅝ x 2¼ x 8 in./9.21 x 5.72 x 20.32 cm) and strung together with a ⅜-in. (95-mm), steel-threaded rod, capped with one steel nut and one acorn nut.

The openings between the brick links allow for grass to grow up in between and light to filter through. The brick ribbon references Thomas Jefferson's garden walls at the University of Virginia, rotated 90 degrees horizontally. The arches hover above the ground and nest into the earth, and at times appear to float.

Funding for the project was provided by the Marcus Foundation Corporation through the UWM SARUP Marcus Prize. Use of the site was donated by Mandel Group, Inc.

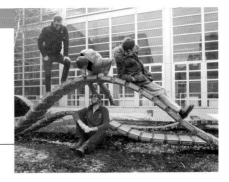

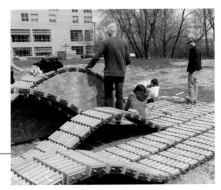

1

2

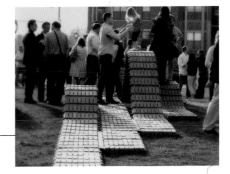

3

↑ INSTALLATION PROGRESS
Several mock-ups were made to test the constructibility and durability of the assembly system (1). On-site construction required a series of wooden frames (2). The final installation (3) allows for human occupation, as well as for nature to grow through the brick fabric.

ARCHITECTS WORKING AT THE SCALE OF INSTALLATION:

- Amanda Williams
- MOS Architects (Hilary Sample and Michael Meredith)
- Casagrande & Rintala (Marco Casagrande and Sami Rintala)
- Höweler + Yoon Architecture (Eric Höweler and J.Meejin Yoon)
- Lewis Tsurumaki Lewis Architects (Paul Lewis, Mark Tsurumaki and David Lewis)
- Diller Scofidio + Renfro Architects (Elizabeth Diller, Richard Scofidio and Charles Renfro)
- SPORTS (Molly Hunker and Greg Corso)
- bauenstudio (Mo Zell and Marc Roehrle)
- is-office (Kyle Reynolds and Jeff Mikolajewski)
- studio:indigenous (Chris Cornelius)
- RAAAF (Ronald and Erik Rietveld)

PAVILIONS

Typically, pavilions are a form of occupiable site-specific installation. Whereas an exhibition may be something to look at and experience as an observer, a pavilion is a type of installation that exudes participation. It's typically something to go into and walk around, and to engage in various sitting, standing, and laying scenarios.

Examples of site-specific pavilions include:
- The Serpentine Gallery summer pavilion
- The Ragdale Ring Competition
- The City of Dreams Pavilion 2017

AGENTS OF CHANGE

The design and construction of installations provides valuable lessons in how to consider spatial experience, how design responds to a specific context, how users interact with the built environment, and how designs benefit from the careful consideration and inclusion of specific relevant contexts. Additionally, working within a specific context redefines how to interact with those spaces, places, and users, as well as how to define those areas within which change can be affected.

Installations can empower new types of change-makers. Bringing vision and synthesis to bear on the built environment and working in collaboration with the community offers the designer a powerful role as an agent of change.

Academic institutions that are change-makers:
UWM Buildings-Landscapes-Cultures Field School and UWM Community Design Solutions
Auburn University Rural Studio
University of Virginia's Studio reCOVER
LSU Coastal Sustainability Studio

Other venues to find local change-makers:
ACSA Community Design Directory
Imagining America SEED (Social Economic Environmental Design) certification

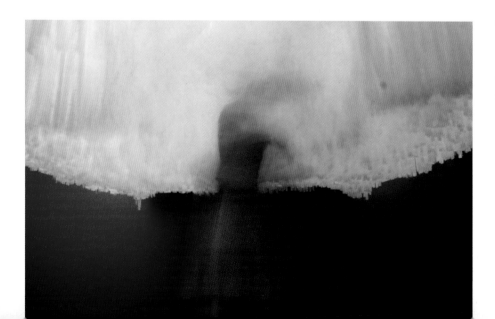

←INTERACTIVE INSTALLATION
Colored light diffuses through strips of plastic cut from standard kitchen garbage bags. Within this installation, vision is suspended while the haptic conditions of the moving plastic interplay with the human body.

CASE STUDY 11 | TEMPORARY SUKKAH

PROJECT
Competition entry for Sukkahville 2015 in Toronto

DESIGNERS
Nikole Bouchard, Milo Bonacci, and Julien Leyssene

SOLUTION
"The Canvas Cocoon" is a temporary, reusable structure that enables users to relax, rest, and recreate during (and after) the festival of Sukkot. A traditional Sukkah is a temporary structure built during the Jewish festival of Sukkot.

The design team wrote the following about their work:
"The space is constructed with three primary materials: wood, cotton canvas, and jute. Large sheets of canvas are suspended from the wooden structure. These canvas sheets are fastened to the jute cables at the top of the structure to create a series of flexible walls. The arrangement of the canvas sheets creates a cloak that provides a sense of security and comfort for the user(s), as if being wrapped in a warm blanket. An oculus provides stunning views of the sky above."

In an effort to think sustainably and ethically about their design, the team plans to disassemble and reuse the materials to create other public artwork.

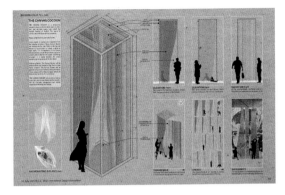

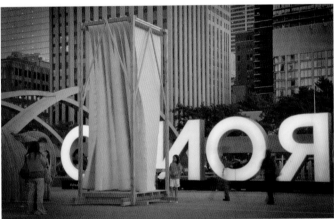

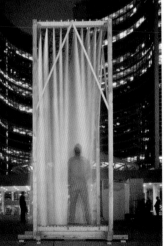

←SUKKAHS
Winning competition entry, titled "Canvas Cocoon," works at the scale of an installation—a small place of occupation.

←CONSTRUCTION
Construction on the Toronto City Hall Plaza required scaffolding to erect the wooden columns.

←MOVEMENT
The movement of the canvas is captured when activated by people of all sizes.

CASE STUDY 12 | TEMPORARY ART PAVILION

PROJECT
Create a site-specific installation for the sculpture garden at the Haggerty Art Museum.

DESIGNERS
bauenstudio, Mo Zell, and Marc Roehrle

SOLUTION
Breaking Ground is a site-specific, temporary architecture that elevates the experience of the users to see and reconsider an existing context—a sculpture garden—while testing the phenomenal qualities of building materials and tectonics. Capitalizing on the 30th anniversary celebration at Marquette University's Haggerty Art Museum that brought the original Keith Haring construction fence mural out of storage, Breaking Ground sought to transform readily assembled materials like 2 x wood lumber, plywood, and polycarbonate panels into a new type of aperture for being viewed, viewing the sky, viewing others, and occupying a new ground—the tree canopy.

MATERIAL
The overlapping of the two polycarbonate systems, one ⅓ in. (8 mm) and the other ¾ in. (20 mm), becomes evident when the outer layer is relatively more transparent. The inner polycarbonate panels tower over the user on entering the space, establishing a datum at 9 ft (2.7 m) and then becoming railings at the other end. This expanding, horizontal datum accentuates the incline of the ramp and frames the sky. The transparency of the polycarbonate panels changes throughout the day depending on the sun and its relative position/angle to the piece.

PROGRAM
Breaking Ground served as an inspiration and backdrop for an improvisational dance piece, choreographed by Joélle Worm. The dancers, musicians, and audience interacted with one another and with Breaking Ground by engaging with the pathways and landscape through the changing elevations and layers of intimacy, which were enhanced by the changing transparency of the polycarbonate.

SPONSOR
Amerilux International and UWM SARUP.

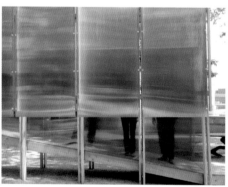 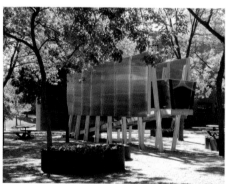

↑ NEW POSITIONS
The installation captures the body through compartmentalization. The body is seen in new positions relative to the existing ground—feet are transposed from ground to eye level, while heads disappear into the tree canopy.

↑ SHIFTS IN THE LIGHT
The transparency of the polycarbonate panels changes throughout the day depending on the sun and its relative position/angle to the piece. The polycarbonate is simultaneously reflective, opaque, and transparent.

CASE STUDY 13 | PERMANENT PAVILION

DESIGNERS

studio:indigenous:

Chris Cornelius, associate professor of architecture at the University of Wisconsin-Milwaukee, is the founding principal of studio:indigenous, a design and consulting practice. An enrolled member of the Oneida Nation of Wisconsin, he dedicates studio:indigenous to serving American Indian clients. His research and practice focus on the architectural translation of culture—American Indian culture, in particular.

SWEATLODGE CHANGING ROOM

Stones are an integral part of the sweatlodge ritual. This outdoor changing room for the sweatlodge at the Indian Community School of Milwaukee takes its inspiration from stones found on site. The structure was intended to appear as if it had emerged from the Earth and had always been there, as opposed to an alien structure that had been placed there. The stick frame construction is wrapped with plywood.

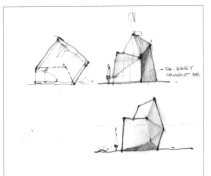
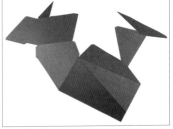
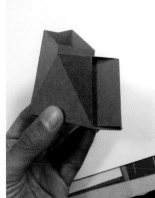

Concept sketches

←STUDY MODEL
A study model (folded and unfolded) is used to test the form and panelization of the exterior skin.

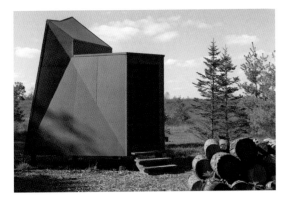
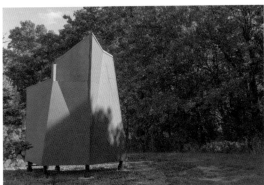

← MULTI-FACETED BUILDING
Sunlight reflects in various ways off the faceted surfaces of the completed sweatlodge.

TIMELINE OF ARCHITECTS

RENAISSANCE TO INDUSTRIAL REVOLUTION

| 1300 | 1400 | 1500 | 1600 | 1700 |

Filippo Brunelleschi 1377–1446

Leon Battista Alberti 1404–1472
Leonardo da Vinci 1452–1519
Albrecht Dürer 1471–1528
Michelangelo 1475–1564

Andrea Palladio 1508–1580

Gian Lorenzo Bernini 1598–1680
Francesco Borromini 1599–1667

The design of St. Peter's is credited to the architects Bramante, Michelangelo, Maderno, and Bernini.

Claude-Nicholas Ledoux 1736–1806
Thomas Jefferson 1743–1826
Sir John Soane 1753–1837
Karl Friedrich Schinkel 1781–1841

INDUSTRIAL REVOLUTION TO PRESENT

| 1800 | 1850 |

Joseph Paxton 1801–1865
E.E. Viollet-le-Duc 1814–1879
Henry Hobson Richardson 1838–1886
Otto Wagner 1841–1918

Antoni Gaudí 1852–1926
Louis Sullivan 1856–1924
Frank Lloyd Wright 1867–1959
Charles Rennie Mackintosh 1868–1928
Adolf Loos 1870–1933
Pierre Chareau 1883–1950
Eileen Gray 1878–1976
Lois Lilley Howe 1864–1964
Julia Morgan 1872–1957
Walter Gropius 1883–1969
Sigurd Lewerentz 1885–1975
Ludwig Mies van der Rohe 1886–1969
Le Corbusier 1887–1965
El Lissitzky 1890–1941
Alvar Aalto 1898–1976

The construction of Sagrada Familia, designed by Antoni Gaudí, is anticipated to be completed by 2030.

Frank Lloyd Wright's Guggenheim Museum shocked the world in 1959.

1900

1925

1950

Louis I. Kahn 1901–1974
Marcel Breuer 1902–1981
Giuseppe Terragni 1904–1943
Anne Tyng 1920–2011
Natalie de Blois 1921–2013
Charles (1907–1978)
 and Ray (1912–1988) Eames
Oscar Niemeyer 1907–2012
Eero Saarinen 1910–1961
Paul Rudolph 1918–1997

The Whitney Museum was
designed by Marcel Breuer
in 1966.

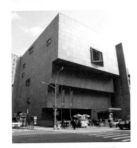

Sou Fujimoto won the commission to
design the Serpentine Gallery Pavilion
in 2013

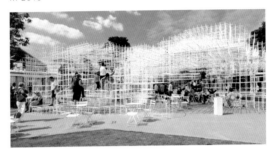

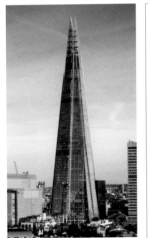

Piano's Shard dominates
the London skyline.

Norma Sklarek 1926–2012
Beverly Willis 1928–
Frank Gehry 1929–
Denise Scott Brown 1931–
Aldo Rossi 1931–1997
Peter Eisenman 1932–
Richard Rogers 1933–
Alvaro Siza 1933–
Richard Meier 1934–
Norman Foster 1935–
Raphael Moneo 1937–
Renzo Piano 1937–
Tadao Ando 1941–
Peter Zumthor 1943–
Rem Koolhaas 1944–
Steven Holl 1947–

Zaha Hadid 1950–2016
Jacque Herzog 1950–
David Chipperfield 1953–
Annabelle Selldorf 1960–
Carme Pinos 1954–
Kazuyo Sejima 1965–
Douglas Darden 1954–1996
Brad Cloepfil 1956–
Brigitte Shim 1958–
Nader Tehrani 1963–
Francis Kéré 1965–
David Adjaye 1966–
Paul Lewis 1966–
Hilary Sample 1971–
Sou Fujimoto 1971–

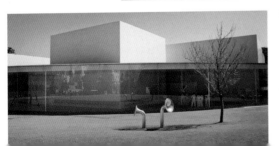

SANAA,
established by
Kazuyo Sejima,
opened the 21st
century Museum
of Contemporary
Art in 2004.

GLOSSARY

ADDITIVE DESIGN
The joining of two planar elements to create space.

ANALYSIS
A reductive process; a simplification of one idea in isolation.

ASSISTING PLANES
Planes created in perspective construction to facilitate the transfer of height measurements to non-coplanar surfaces.

AXIAL
A strong single relationship between parts that are aligned with one another along an axis. Radial and linear are two types of axial relationships.

AXONOMETRIC
An objective three-dimensional representation that combines plan and elevation information on a single, abstract drawing. It depicts a view that cannot ever be perceived in real space. The axon is measured along three axes in three directions and its ease of construction is due to the fact that parallel elements remain parallel. There are many types of axonometric drawings, including paraline projection, (plan) oblique projection, and isometric.

COMPOSITION
The arrangement of parts including their placement, quantity, geometry, and scale in relationship to themselves and to the whole.

CONE OF VISION
The conical volume of 60 degrees taken from the eye of someone located at the station point in perspective construction. Distortion begins outside the 60-degree cone.

CONSTRUCTION LINES
The lightest lines in a drawing, used to ensure alignments between elements in a single drawing or between two drawings such as plan and section. Typically these lines are visible when viewed up close but disappear at a distance of 3 ft (90 cm) or farther.

CUT LINES
In plan or section these are the darkest lines representing cut elements.

DIAGRAM
The process of visually abstracting a building or object into its main ideas.

ELEVATION
A two-dimensional drawing depicting a vertical cut outside of an object, looking toward its face. Imagine a plane perpendicular to the ground that does not intersect with the building or object. Elements outside of the object, for example the ground, are rendered as a cut line. The object or building itself is not cut through; all of the lines related to the building are elevation lines. Elevation lines vary with distance from the projected picture plane. Elements farther away are lighter than those that are closer.

ELEVATION LINES
These delineate between spatial edges. Typically elevation lines farther away from the cut are constructed with a lighter lineweight than those surfaces closer to the cut. All elevation lines are lighter than cut lines.

ENFILADE
The alignment of openings between rooms that provides a view along the length of the adjacent rooms. The Shotgun, a typical U.S. vernacular-style house, is an excellent example of the enfilade condition.

ENTOURAGE
Elements like people, cars, trees, bushes, and other landscape elements added to drawings to provide scale, character, and texture.

FIGURE-GROUND PLAN
A diagram of the building fabric which uses black and white to depict buildings and space, respectively. No other delineations are made—no streets or pavements, for example. It provides a method to understand patterns of the built environment and the relative size and shape of figural spaces.

HIDDEN LINES
These are dashed lines that depict objects or planes that are technically not visible in a drawing. For example, hidden lines are used to show objects above the cut line in plans.

HIERARCHY
The emphasis of one element over all others; useful for diagramming and portfolio layouts.

HORIZON LINE (HL)
In perspective construction, the horizon line is the height of the viewer standing at the station point.

ISOMETRIC
A type of axonometric projection that provides a lower-angle view than a plan oblique. Equal emphasis is given to the three major planes. The isometric does not allow for construction to be extruded directly from the existing plan but requires the reconstruction of the plan with its front corner being drawn at 120 degrees instead of 90 degrees. Vertical information is typically true to scale. The measurements are transferred along the receding 30-degree axes.

MEASURING LINE (ML)
In perspective construction, the vertical line established from the intersection of the picture plane and the plan. All measurements must be taken from this line.

NEGATIVE SPACE
The residual, or leftover, space outside of an object or building. Negative space should be considered as a design opportunity.

ONE-POINT PERSPECTIVE
A type of perspective construction with a single vanishing point.

ORTHOGRAPHIC PROJECTIONS
Two-dimensional abstractions of three-dimensional objects; orthographic projections include plan, section, and elevation.

PARTI
The graphic depiction of the main idea, or concept, of a project.

PERSPECTIVE

Perspective construction is a subjective representation that aims to translate the experience of a three-dimensional space, building, or object onto a two-dimensional surface. It is a prescriptive single point of view. A perspective cannot mimic the complexity of the human eye, which perceives peripheral and binocular vision, but it is an acceptable representational tool.

PICTURE PLANE (PP)

In perspective construction, a transparent plane, intersecting the cone of vision, that receives the projected perspective image and is perpendicular to the viewer. In the two-dimensional construction of perspective its location helps to determine how large the perspective image will be.

PLAN

A horizontal cut through an object, building, or space, typically directed down. Imagine a plane, parallel to the ground plane, intersecting a building or object. The cut represents those elements sliced by the plane and is rendered with the darkest lineweight. There are a number of types of plan drawings including site plan, floor plan, roof plan, reflected ceiling plan, and figure-ground plan.

POCHÉ

This word comes from the French pocher meaning "to make a rough sketch." It is typically understood to be the solid elements in a building rendered in solid black.

PROFILE LINES

These define the edges between an object or plane and open space in axonometric drawings.

PROGRAM

The uses of a building or space.

PROPORTION

The compositional relationship between parts.

SECTION

A vertical cut through an object, building, or space. Sections describe vertical relationships and help define the spatial characteristic of the building. Imagine a plane, perpendicular to the ground plane, intersecting a building or object. As in the plan, the information that is cut by the plane is rendered using the darkest line weights.

SIGHT LINES (SL)

In perspective construction, the projected lines connecting the eye to the object being viewed. The perspectival image occurs where the sight lines cross the picture plane.

STATION POINT (SP)

The location of the viewer in perspective construction.

SUBTRACTIVE DESIGN

The method of carving into a solid element to create space.

THRESHOLD

The point at which two spaces or elements join together.

TWO-POINT PERSPECTIVE

A perspective construction with two vanishing points.

VANISHING POINT (VP)

The point (or points) at which parallel elements in a perspective converge.

RESOURCES

Bibliography

Brown, G. Z., and Mark DeKay. *Sun, Light & Wind Architectural Design Strategies.* 2nd ed. Hoboken, NJ: John Wiley & Sons, Inc., 2001

Ching, Francis D. K. *Architecture Form, Space, and Order.* 2nd ed. Hoboken, NJ: John Wiley & Sons, Inc., 1996

Ching, Frank. *Design Drawing.* John Wiley & Sons, Inc., 1997

Fraser, Iain, and Henmi, Rod. *Envisioning Architecture: An Analysis of Drawing.* Hoboken, NJ: John Wiley & Sons, Inc., 1994

Laseau, Paul, and Tice, James. *Frank Lloyd Wright: Between Principle and Form.* New York, NY: Van Nostrand Reinhold, 1992

Uddin, M. Saleh. *Hybrid Drawing Techniques by Contemporary Architects and Designers.* Hoboken, NJ: John Wiley & Sons, Inc., 1999

Yee, Rendow. *Architectural Drawing: A Visual Compendium of Types and Methods.* 2nd ed. Hoboken, NJ: John Wiley & Sons, Inc., 2003.

Pressman, Andrew: Editor-in-chief. *Architectural Graphic Standards.* Hoboken, NJ: John Wiley & Sons, Inc., 2007

Clark, R. and Pause, M. *Precedents in Architecture.* Van Nostrand Reinhold, 1996

Bell, Victoria Ballard and Patrick Rand. *Materials for Design.* 1st and 2nd ed. NY: Princeton Architectural Press, 2006 and 2014

Bonnemaison, Sarah and Ronit Eisenbach. *Installations by Architects: Experiments in Building and Design.* NY: Princeton Architectural Press, 2009

Carpenter, William. *Learning by Building: Design and Construction in Architectural Education.* NY: Van Nostrand Reinhold, 1997

Corner, James. *Taking Measures Across the American Landscape.* New Haven, CT: Yale University Press, 1996

Curtis, William J. R. *Modern Architecture Since 1900.* NY: Phaidon, 1996

Dean Andrea O., *Rural Studio: Samuel Mockbee and An Architecture of Decency.* NY: Princeton Architectural Press, 2002

De Oliveira, Nicolas. *Installation Art in the New Millennium.* NY: Thames and Hudson, 2003

Eisenman, Peter. *Ten Canonical Buildings.* NY: Rizzoli, 2008

Erdman, Jori and Thomas Leslie. "Introduction," *Journal of Architectural Education 60:2* (2006): 3

Hayes, Richard W. *The Yale Building Project: The First 40 Years.* New Haven: Yale University Press, 2007

Mayne, Thom. *Combinatory Urbanism.* Culver City, CA: Stray Dog Café, 2011

Miessen, Markus and Shumon Basar, eds., *Did Someone Say Participate? An Atlas of Spatial Practice.* Cambridge: The MIT Press, 2006

Moussavi, Farshid. *The Function of Form.* Barcelona: Actar, 2009

Trachtenberg, Marvin, and Isabelle Hyman. *Architecture, from Prehistory to Postmodernity.* NY: Routledge, 2010

Tufte Edward. *The Quantitative Analysis of Social Problems.* Reading, MA: Addison-Wesley, 1970

White, Mason. *PA 30: Coupling: Strategies for Infrastructural Opportunism.* NY: Princeton Architectural Press, 2011

Williams, Tod and Billie Tsien. *WorkLife: Tod Williams, Billie Tsien.* NY: Monacelli Press, 2000

Zumthor, Peter. *Thinking Architecture.* Basel: Birkhauser, 2010

Websites

www.archetypes.com
www.archinect.com
www.bustler.net
www.sectioncut.com
www.studyarchitecture.com

Architecture Organizations

THE AMERICAN INSTITUTE OF ARCHITECTS (AIA)

The professional organization that represents American architects. With over 80,000 members, the AIA supports high professional standards (code of ethics) and provides access to resources, education, and advice.
1735 New York Avenue, NW
Washington, DC 20006-5292, USA
1-800-AIA-3837, www.aia.org

AMERICAN INSTITUTE OF ARCHITECTURE STUDENTS (AIAS)

This nonprofit, student-run organization is the voice of architecture and design students. The AIAS promotes education, training, and professional excellence.
1735 New York Avenue, NW
Washington, DC 20006, USA
202-626-7472, www.aias.org

ASSOCIATION OF COLLEGIATE SCHOOLS OF ARCHITECTURE (ACSA)

Founded in 1912, over 250 schools in the U.S. and Canada now make up the membership association of the ACSA. The promotion of quality architectural education is the main focus of the body.
1735 New York Avenue, NW
3rd floor
Washington, DC 20006, USA
202-785-2324, www.acsa-arch.org

NATIONAL ARCHITECTURAL ACCREDITING BOARD (NAAB)

NAAB is the accrediting agency for professional architecture degree programs.
1735 New York Avenue, NW
Washington, DC 20006, USA
202-783-2007, www.naab.org

NATIONAL COUNCIL OF ARCHITECTURAL REGISTRATION BOARDS (NCARB)

The mission of NCARB is to safeguard the health, safety, and welfare of the pubic. NCARB works on professional practice standards as well as applicant registration standards.
1801 K Street, NW, Suite 1100-K
Washington, DC 20006-1310, USA
202/783-6500, www.ncarb.org

Related Organizations

THE AMERICAN ARCHITECTURAL FOUNDATION (AAF)

The AAF educates the public about the importance of architecture and design on improving lives.
1799 New York Avenue, NW
Washington, DC 20006, USA
202-626-7318, www.archfoundation.org

WWW.ARCHCAREERS.ORG

This website, part of the AIA, lays out the procedures to become an architect. They highlight the three Es of the process: Education, Experience, and Examination.

STATE ARCHITECTURE BOARD OF REGISTRATION

www.ncarb.org/stateboards/index.html
Individual state boards will provide the requirements for licensing in that state. Registration, examination, and practice requirements are regulated by this agency.

INDEX

Entries in bold refer to terms included in the glossary

CREDITS

Quarto would like to thank and acknowledge the following for supplying the illustrations and photographs reproduced in this book. All images listed in italics have come from Shutterstock.com.
Key: a above, b below, c center, l left, r right.

While every effort has been made to credit contributors, Quarto would like to apologize should there have been any omissions or errors—and would be pleased to make the appropriate correction for future editions of the book.

Pp 12: Charles Bowman/Robert Harding World Imagery/Corbis. **Pp 13: al** Richard Einzig/arcaid.co.uk. **Pp 16:** Seattle Art Museum: Olympic Sculpture Park, Michael Manfredi and Marion Weiss, Weiss/Manfredi Architecture. **Pp 17:** Library of Congress. **Pp 18: ar** Bettmann/Corbis, **cr** Grand Buildings, Trafalgar Square, 1985, Zaha Hadid Foundation, **b** Library of Congress. **Pp 19: al** Alinari Archives/Corbis, **ar** ©2017 Eames Office, LLC (eamesoffice.com), Foster + Partners. **Pp 20: b** bauenstudio. **Pp 21: bl & br** bauenstudio. **Pp 22: bl & br** bauenstudio. **Pp 24: bl & bc** Patkau Architects Inc. **Pp 25: br** bauenstudio. **Pp 26: r** bauenstudio. **Pp 27: a** bauenstudio, **al & ar** Eli Liebnow and Jonnie Nelson. **Pp 30: a & b** bauenstudio. **Pp 31: a & b** Johnsen Schmaling Architects. **Pp 34: b** Johnsen Schmaling Architects. **Pp 35: a & b** Johnsen Schmaling Architects. **Pp 36:** *Coprid.* **Pp 37:** *Laborant, ImagePixel, Picsfive, exopixel, Andrey Emelyanenko.* **Pp 38:** *Oleksandr Kostiuchenko, BonD80.* **Pp 39:** *Igorusha, Jiradet Ponari, Amnartk.* **Pp 44: r** Library of Congress. **Pp 45: br** Álvaro Siza. **Pp 46: b & br** David Gamble. **Pp 49: br** Courtesy Steven Holl. **Pp 50: l** Rembrandt Harmensz. Van Rijn Graphische Sammlung Albertina, Vienna, Austria/The Bridgeman Art Library. **Pp 55: al &ar** Aqua Tower. Sketch by Jeanne Gang, courtesy of Studio Gang. Photograph by Steve Hall © Hedrich Blessing. **Pp 58: br** bauenstudio. **Pp 59: bl** bauenstudio. **Pp 62: r** bauenstudio. **Pp 67: r** bauenstudio. **Pp 69: bl** bauenstudio. **Pp 71: br** studio:indigenous. **Pp 72:** Bettmann/Corbis. **Pp 80: a** is-office. **Pp 81: ar** Courtesy Eisenman Architects. **Pp 83:** Martha Foss. **Pp 85:** Louisiana Pavilion construction diagrams © selgascano+helloeverything. **Pp 86:** bauenstudio. **Pp 88:** Eileen Tweedy/Victoria and Albert Museum London/The Art Archive/©DACS 2007. **Pp 92:** Bettmann/Corbis. **Pp 104: ar** Alamy. **Pp 107: l** Brian Andrews. **Pp 108:** Edifice/Corbis/©FLC/ADAGP, Paris, and DACS, London 2007. **Pp 109: ar** Melbourne School of Design © John Horner Photography. **Pp 111: br** Dennis Gilbert/Esto/View, **br** Jeff Goldberg/Esto/View. **Pp 116: bl** bauenstudio, **br** © 2007, Estate Douglas Darden. **Pp 117: bl & br** bauenstudio. **Pp 120: a** bauenstudio. **Pp 122: br** studio:indigenous. **Pp 123: bl** bauenstudio, **br** Lewis.Tsurumaki.Lewis, Upside House, 2001 sectional perspective. **Pp 124: al, bl &br** Drawings by Marc Roehrle, **ar** studio:indigenous. **Pp 125:** bauenstudio. **Pp 128: c** Seattle Diagram, Office for Metropolitan Architecture. **Pp 130: b** bauenstudio. **Pp 132:** Heydar Aliyev Center, Zaha Hadid Architects; photograph by Hufton+Crow. **Pp 133:** Single Speed Design, www.ssdarchitecture.com. **Pp 136:** Alamy. **Pp 142: a** Engberg Anderson, **b** Nikole Bouchard. **Pp 147: br** Nick Zukauskis. **Pp 149:** Nikole Bouchard. **Pp 150:** bauenstudio. **Pp 151:** studio:indigenous & Nick Zukauskis. **Pp 152: l** *Samot,* **ar** *tuulijumala,* **br** *Tinnaporn Sathapornnanont.* **Pp 153: tl** *pxl.store,* **bl** *cowardlion,* **c** *Osugi,* **r** *Ron Ellis.*

The author would like to thank and acknowledge the following for supplying other illustrations reproduced in this book. Bob Allsop, Brian Andrews, Javier Barajas-Alonso, Milo Bonacci, Nikole Bouchard, Andrew Cesarz, Joe Creer, Jimmy Davenport, Kelsey Dettman, Kayla De Vares, Tyler Dudley, Steve Fellmeth, Laura Gainer, David Gamble, Ben Gilling, Sarah Grieve, Robert Guertin, Therese Hanson, Bradley Hopper, Alisa Huebner, Jared Kraft, Lauren Kritter, Julien Leyssene, Eli Liebenow, Jared Maternoski, Ryan Neidenger, Jonnie Nelson, Travis Nissen, Aubree Park, Ben Penlesky, Amber Piacentine, Robin Reedy, Paul Rhode, Marc Roehrle, Dustin Roosa, Damian Rozkuszka, Justin Sager, Thomas Schneider, Jimmy Sequenz, Sam Smith, Di Tang, Garrett Tomesh, Melissa Torres, Ryan Tretow, Nathan Waddell, Jake Walker, Dominque Xiong, Tommy Yang, Kelly Yuen, Mo Zell, Nick Zukauskis.

I remain grateful to my colleagues in Boston who helped frame the original book. This includes Michael MacPhail, Andy Grote, Mary Hughes, Mark Pasnik, Lucy Maulsby, and Chris Hosmer. Given that I now live in Milwaukee and am surrounded by fantastic new colleagues, I want to thank Nikole Bouchard and Kyle Reynolds for sharing their expertise in design and representation (along with office space). Thanks to Janet Tibbetts for helping with the edits.
I dedicate this book to my husband and design partner, Marc Roehrle, who is a passionate teacher and architect and always supportive of my aspirations. As with most of the things that I try to accomplish related to architecture and in life, I couldn't have done them without Marc. Thanks also to my family for their constant support and love. This book would not have been completed without the dedication and hard work of the many students I've been privileged to teach over the years at Northeastern University and at the University of Wisconsin-Milwaukee. The original book gave special thanks to my Spring 2007 manual representation class: Allison Browne, Hokchi Chiu, James Mcintosh, Renee McNamee, Karina Melkonyan, Lauren Miggins, Kathleen Patterson, Brett Pierson, Stephanie Scanlon, Tony Wen, Tiffany Yung, and Kornelia Znak. This revised edition reflects much of the work and many of the discussions I have had with my students at UW-Milwaukee in my (un)making of the museum studio, including Joe Creer, Kayla De Vares, Kelsey Dettmann, Tyler Dudley, Ben Gilling, Sarah Grieve, Eric Hurtt, Andrew Huss, Adam Oknin, Robin Reedy, Sam Smith, Jake Stuck, Di Tang, and Garett Tomesh. I also want to give a special thanks to Jonnie Nelson, an exemplary student, who served as my research assistant.